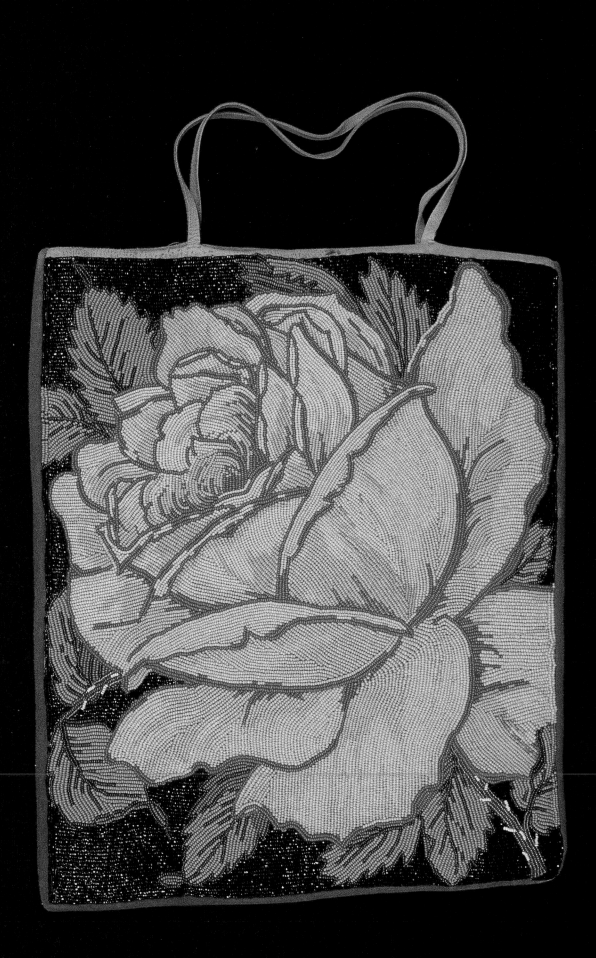

NATIVE ARTS OF THE COLUMBIA PLATEAU

THE DORIS SWAYZE BOUNDS COLLECTION

Edited by Susan E. Harless

THE HIGH DESERT MUSEUM
Bend, Oregon

UNIVERSITY OF WASHINGTON PRESS
Seattle and London

In honor of DONALD M. KERR,

founder and past president of The High Desert Museum,

without whose vision this book would not exist

Library of Congress Cataloging-in-Publication Data

Native Arts of the Columbia Plateau : the Doris Swayze Bounds collection / edited by Susan E. Harless
 p. cm.
 The collection is housed in The High Desert Museum, Bend, Or.
 Includes bibliographical references and index.
 ISBN 0-295-97752-3 cl.; 0-295-97673-X pbk. (alk. paper)
 1. Indians of North America—Columbia Plateau—Material culture.
2. Indian art—Columbia Plateau. 3. Indians of North America—Antiquities—Collectors and collecting—Columbia Plateau. 4. Columbia Plateau—Antiquities. 5. Bounds, Doris Swayze—Ethnological collections. 6. High Desert Museum (Bend, Or.)—Ethnological collections. 7. Bounds, Doris Swayze. I. Harless, Susan E. II. High Desert Museum (Bend, Or.)
E78.C63N37 1998 97-43827
979.7—dc21 CIP

Unless otherwise noted, all object photographs in this book are courtesy of The High Desert Museum and were taken by photographers Jack Harris and Chuck Sipman.

(*page i*) Plate 1 Cornhusk bag, Umatilla, ca. late nineteenth century. This bag was made by Sadie Joe, who lived on the Umatilla Reservation. Height: 24.5 in. Width: 19 in. Date collected: 1964. (5.1.80)

(*page ii*) Plate 2 Beaded bag, Plateau, ca. 1945–1967. Doris Bounds used this bag whenever she went to Indian events; it was her personal favorite. The design is from an embroidery transfer pattern adapted for beadwork. Height: 15 in. Width: 17.75 in. Date collected: 1968. (2.6.30)

(*opposite*) Plate 3 Rawhide rattle, Nez Perce, ca. 1860–90. This rawhide and mink fur-wrapped rattle with a buckskin wristband was purchased from the Evans Museum, Spalding, Idaho. Bounds was told that the rattle had supposedly belonged to Chief Joseph (Nez Perce). Length: 16.5 in. Date collected: 1958. (4.6.3)

Contents

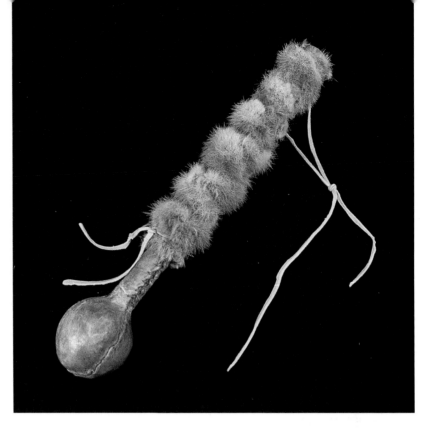

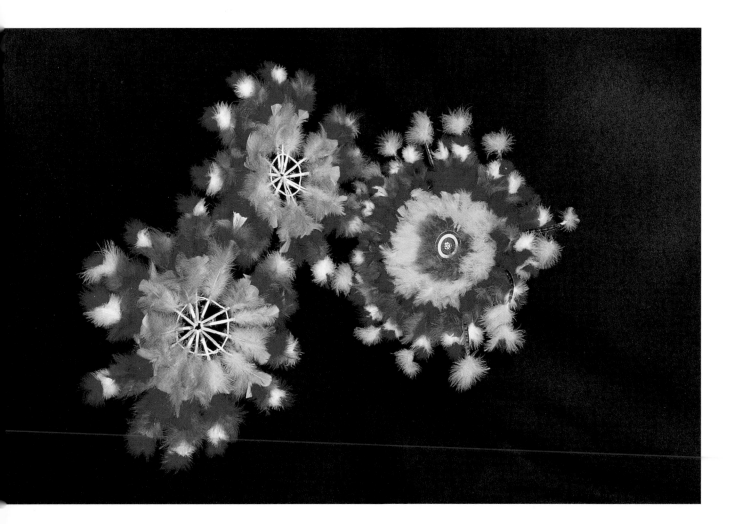

Plate 4 Dance bustle, Plateau, mid-twentieth century. Made by Matt Green (Nez Perce). Diameter: 25 in. Date collected: 1969. (6.6.18a/c)

Illustrations

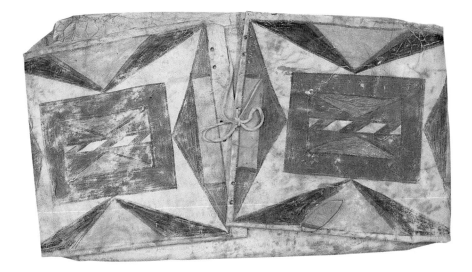

Plate 5 Parfleche, Warm Springs, ca. 1900. Height: 28 in. Width: 15 in. Depth: 2 in. Date collected: 1962. (13.1.7)

Plate 6 Mirror bag, Cayuse or Crow, ca.
1880–1920. Beaded area height: 10 in.
Width: 6 in. Date collected: 1956. (2.4.9)

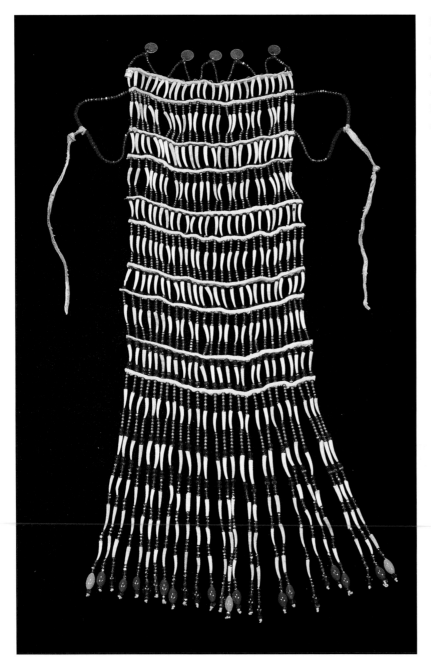

Plate 7 Bridal veil, Columbia River area, mid-twentieth century. Modeled after an older tradition, this veil is made from dentalium shells from the Puget Sound area of western Washington. Length: 28.5 in. Width: 9 in. Date collected: unknown. (6.13.1001)

Acknowledgments

A story like this cannot be written by one person alone. Doris Swayze Bounds's world was made up of lifelong friendships and worldwide contacts, along with intimate relationships with many people of Native American heritage. That this story is now being told is largely thanks to Teresa Moncrief, who for twenty-two years acted as Bounds's administrative assistant at the Inland Empire Bank in Hermiston, Oregon; as a director for the Roger J. Bounds Foundation; as secretary to the board of directors of the Inland Empire Bank; and, in her own favorite role, as private curator of the Bounds Collection while it was stored in the bank's basement vault. Doris Bounds's son, Roger Swayze Bounds, now president of the Roger J. Bounds Foundation and the collection's steward on the board of trustees of The High Desert Museum, has been helpful throughout. My deep thanks are extended to past museum president Donald M. Kerr and his wife Cameron, whose continuing support often renewed my energy to bring this project to closure. A warm welcome to now museum president Arthur H. Wolf, under whose guidance and vision the Bounds collection will become a reality.

My colleagues Dick Conn, Kate Duncan, Barbara Hail, Barbara Loeb, and Mary Schlick, who joined in the production of this volume, have been a pleasure to work with and have made me feel so fortunate. This warm accolade also must be extended to photographers Chuck Sipman and Jack Harris, volunteers at The High Desert Museum, whose fine work is seen in the photographs of the Bounds Collection items.

A special thanks is due to the Native Americans who joined us in this project. Vivian M. Adams (Yakama) now has the joy of curating the forthcoming exhibits at The High Desert Museum.[1] Maynard White Owl Lavadour (Cayuse, Nez Perce) and Lillian "Sis" Moses (Nez Perce, Yakama, Cayuse) of the Umatilla Reservation in Pendleton, Oregon, have shared their knowledge of these objects and also, in a sense, given them back to their people through their participation in this book.

Many of Doris Bounds's friends gave generously of their time to bring some of her stories to light. They include, in Washington, Earl Robarge of Walla Walla, who photographed her collection in 1985; and in Oregon, Fern Cramer and Eddy Sene of Hermiston; Jack and Kate Mills of Mt. Hood; Mary Anne Normandin of Portland; Norma Paulus, Joanne Rains, and David Rhoten of Salem; the late Robert W. Chandler of Bend; and Mrs. Samuel S. (Becky) Johnson of Redmond.

Inland Empire Bank employees, especially Larry Clucas and Serena MacPherson (Yakama), had many anecdotes about Doris Bounds, including numerous stories not included here. Bounds's friends, and finally her caretakers, Gloria Cornwell and Elsie Jones, were able to fill in many missing details as well.

Willing librarians make research such a pleasure. Those who helped the most were interlibrary loan specialist JoAnne Cordis of the Central Oregon Community College Library and the research staff of the Deschutes County Library, both in Bend. Diane Berry of the Echo City Hall in Echo, Oregon, and Umatilla County Historical Society executive director Julie Reese and her volunteers from Pendleton also helped locate valuable resources on the history of the region.

The staff and volunteers of The High Desert Museum saw to it that the book would become a reality, in the process realizing one of their goals as stewards of the collection and of the Doris Swayze Bounds legacy. Jack Cooper shepherded the project through the intricacies involved in producing a publication of this magnitude, a first for both of us. Also on behalf of the museum, Dr. Alice Parman provided editing and formatting for the manuscript, guiding and teaching throughout the process. It is largely thanks to her careful eye and wisdom that the book has come together in its current form. A special thank you to indexer Sherry Smith for her thoughtful, expert approach to her task.

From my first contact with the staff at the University of Washington Press—Naomi Pascal and the entire production team—I have stood in admiration of the professionalism and pleasure they mutually shared in their fine work. I thank in advance those I have had the opportunity to work with and those I have not yet met.

Funding for the development of the manuscript was generously provided by grants from the Samuel S. Johnson Foundation of Redmond, Oregon, and the OCRI (Lamb) Foundation of Lake Oswego, Oregon. A special note of appreciation goes to the Roger J. Bounds Foundation, which has supported the project from the onset and has generously underwritten the publication costs.

To my own family is reserved the warmest gratitude for the strength and confidence they gave when it was needed most. Without the encouragement of my husband, Keith, our children, Wendy and Brian, and our parents, this book would not have happened.

Introduction

KATHRINE S. FRENCH

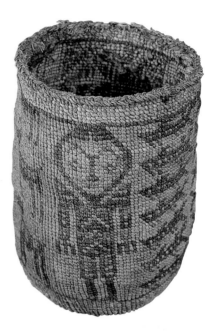

Plate 8 Wasco twined "sally" bag, ca. 1920–1930s. Stylized human figures from The Dalles region. This is a form unique to this region; it is seen in carving as well as in twined basketry. From the collection of Jimmy James (Cherokee), an Indian activist from The Dalles. Height: 7 in. Diameter: 4.75 in. Date collected: 1971. (3.4.40)

The donation of the Doris Swayze Bounds Collection of Native American artifacts into the permanent care of The High Desert Museum in Bend, Oregon, inspired the creation of this volume; in turn, the book is an exploration of Bounds's life as a collector and of the collection itself.

Doris Swayze Bounds was no ordinary collector. Most museums have guidelines that determine what they acquire, but private collectors such as Bounds are freer to express their own personal interests and tastes in what they accumulate. In essence, a collection demonstrates an individual's view of his or her interest area. Doris Bounds's eye was highly selective, and she had a passion for accumulating Native American objects at a time when it was not fashionable to collect them. In addition, a significant number of items in the Bounds Collection were given to her as gifts; thus, the collection reflects not only her determination to preserve these special objects but also her relationships with people of American Indian descent, and it presents us with an insight into some of their choices in the items they selected for preservation.

The area from which Bounds preferred to collect was the area in which she was raised, the Columbia River Plateau (map 1). Anthropologists have for many years used the idea of "culture area" (defined as a geographical region characterized by certain ethnographic features) to help describe American Indian cultures. Aboriginal America has generally been divided into ten such areas, and the Plateau is one of the smaller regions. It extends south from interior British Columbia to central Oregon and east from the Cascade Mountains to the Rockies, and it is drained by the Columbia and Fraser Rivers.

In early culture area descriptions, the Plateau tended to suffer by comparison with other regions. The complexity and vividness of the cultures of the Southwest, the Northwest Coast, and the Great Plains, and a lack of adequate information, led to the Plateau's being represented as a pale reflection of surrounding areas, characterized mostly by what was

absent. In fact, as later became clear, the Plateau peoples were rich in economic resources, with abundant fish, game, and wild plants as staple foods. They were villagers who had efficient techniques and implements for gathering, preserving, and storing food, providing shelter, making clothing, engaging with the spirit world, and governing themselves democratically. They also had their own unique artistic traditions.

In the southern part of the Plateau, most people spoke a version of Sahaptin, a language family that includes Nez Perce, Umatilla, Yakama, and Warm Springs. The people living on the western edge, near and in the Columbia Gorge, spoke Chinookan, and people in the northern Plateau spoke Salishan languages. Thus, multilingualism was common, and trade languages (especially versions of Chinook Jargon) facilitated wide communication within and beyond the area.

People identified themselves in terms of their home villages, but families and larger groups traveled widely—long ago on foot, and later on horseback. They moved from fishing sites on the rivers to root-digging areas on the flats and open hills, and on to berry-picking and hunting places in the mountains. They gathered food both for immediate consumption and to preserve for survival during the winter months. They also gathered plants for fibers, with which they made bags and baskets, and for medicines to heal the sick. They visited nearby trading centers and other villages, drawn by socially important events such as weddings

Plate 9 Man's pony-beaded shirt, Plateau, mid-1800s. Bounds got this shirt from Carrie Sampson of the Umatilla Reservation. She recorded that it once belonged to Wa-Tas-Ti-Ma-Ni, father of old Chief Joseph; however, it has undergone many transformations over time and it is now difficult to ascertain the original age of its parts. Height: 19 in. Width: 53 in. Date collected: 1964. (6.19.2000) (See fig. 2.11, page 39.)

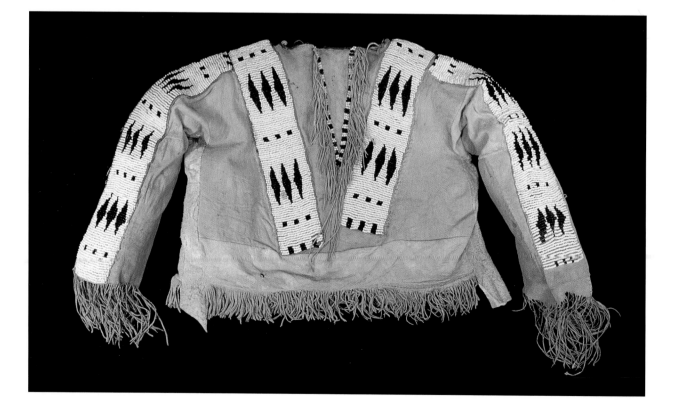

and funerals and by opportunities to meet people with whom they socialized, traded, and intermarried. Across the Plateau region lay an immense, intricate social network of long-lasting reciprocal relationships, through which many kinds of products moved.

Peoples in some areas of North America were affected by Euro-Americans soon after the voyages of Columbus; others, like the Plateau peoples, had no direct contact with the newcomers for centuries, although long-distance effects such as the spread of horses preceded actual sightings of Euro-Americans. Horses reached the Plateau Indians early in the 1700s, greatly increasing their mobility, and they rapidly borrowed, developed, and elaborated paraphernalia to utilize these valuable animals.

When Euro-Americans finally did arrive in the early 1800s, a long period of change began. These Indian peoples, whose morale was shaken both by the diseases that decimated them and by the domination of a national regime new to them, nevertheless managed to retain many of the strong social and aesthetic aspects of their culture.

Among Plateau Indians, hostilities were not unknown, but reciprocity and generosity characterized interpersonal relationships. Trading partners, often living hundreds of miles apart, provided each other with access to goods and credit. Marriage established exchange relationships among members of extended families; these were maintained for the duration of the marriage and often beyond. Transitional events in a person's life (for example, receiving a name, producing food for the first time, returning from war, and death) were recognized as occasions for a family to give gifts to relatives, neighbors, and friends. In these Indian cultures, acts of giving maintained relationships; goods were acquired to be given away. To a large extent, this tradition survives today. Doris Bounds became a part of this network of reciprocity because of her friendships and her contributions to these people's lives. Her Indian friends responded, according to their tradition, with gifts.

The Bounds Collection, which is focused on the century from the 1870s to the 1960s, documents both the maintenance of old skills and the flowering of aesthetic traditions in response to increasing communication with other Indians and non-Indians. Four of the contributions to this volume analyze the aesthetic traditions represented in the Plateau portion of the collection. Two additional chapters increase our understanding of Doris Bounds herself, her collecting methods, and her relationships with Indians. All are enriched by beautiful color photographs of the objects she collected.

This book not only is a recognition of past traditions and change but also, together with the exhibits at The High Desert Museum, will inspire Indian artists who are today reviving, maintaining, and expanding the artistic traditions of their peoples.

(*overleaf*) Plate 10 Pony-beaded tail dress, Yakama, mid-1800s. The fur-covered tail is visible front and back. Height: 50 in. Date collected: 1959. (6.8.1000)

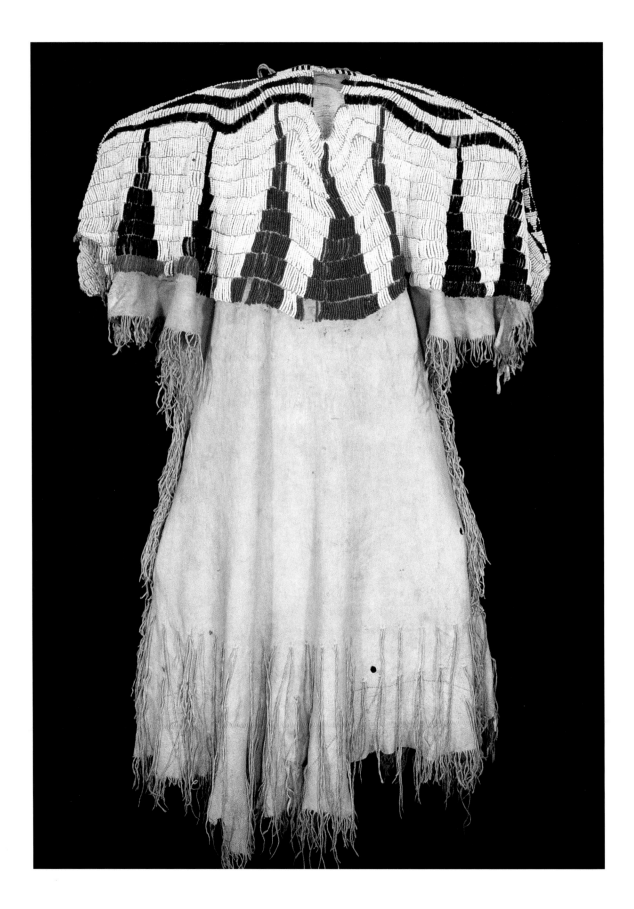

Native Arts of the Columbia Plateau

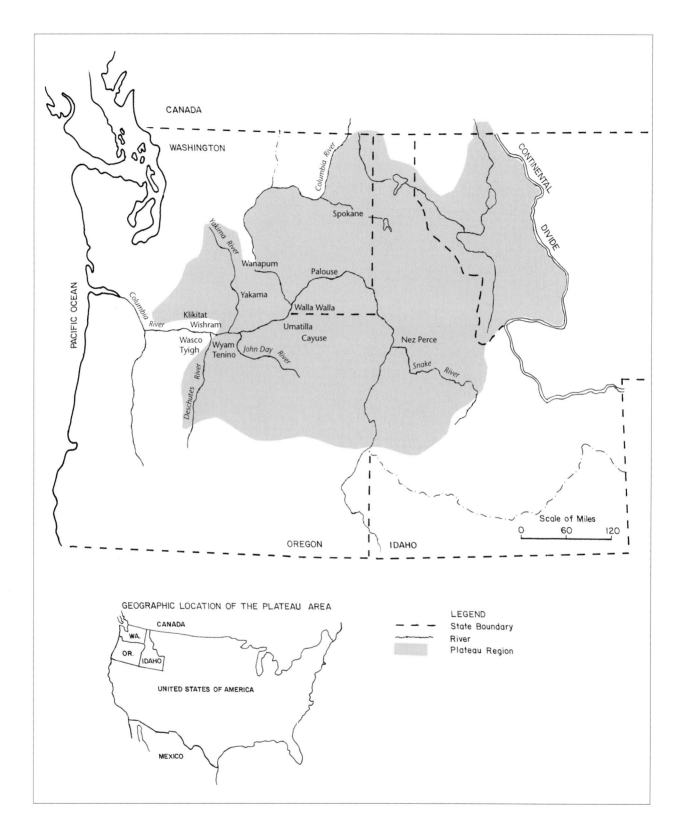

CANADA

WASHINGTON

PACIFIC OCEAN

Columbia River

Spokane

CONTINENTAL DIVIDE

Yakima River

Wanapum

Palouse

Yakama

Walla Walla

Klikitat
Wishram

Umatilla
Cayuse

Nez Perce

Wasco
Tyigh

Wyam
Tenino

John Day River

Snake River

Columbia River

Deschutes River

OREGON

IDAHO

Scale of Miles

0 60 120

GEOGRAPHIC LOCATION OF THE PLATEAU AREA

CANADA

WA.

OR. IDAHO

UNITED STATES OF AMERICA

MEXICO

LEGEND

——— State Boundary

River

Plateau Region

Map 1 The Columbia River Plateau culture area. Map by Michael Kelly

Doris Swayze Bounds

Collector of Objects, Collector of Friends

SUSAN E. HARLESS

There is a calm in the evenings along the Columbia River, just at the time the heat-driven upstream winds give way to the cooling downstream nighttime winds, following a cycle as old as the river itself. Life in the twentieth century along this river has the same timeless quality, an endless rhythm of intertwined cultures and lives. Doris Swayze Bounds was a daughter of this landscape and the cultures that inhabit it. It was the land in which she was raised as a child and to which she returned to live out the later years of her life. Her homelands were the river's domain and the adjoining open reaches of northeastern Oregon, close to the Umatilla Indian Reservation and not far from the Wallowa Mountains, ancestral home of the Wallowa band of the Nez Perce and the legendary Chief Joseph.

Many have struggled to depict this exceptional woman, prematurely widowed, then cast into dual roles of leadership and "firsts" in a world that belonged mostly to men. Her gentle, cheery exterior was a thin veneer for the tough, scrappy businesswoman who into her late eighties was still expertly overseeing a multimillion dollar banking business from her basement office in the Inland Empire Bank in Hermiston, Oregon. Her once elegant body, by then bent with age, was always topped by freshly coiffed silver-blonde hair. The ready cigarette on her desk harkened back to a time when women gauged their freedom by such "unfeminine" habits.

Her nationally known collection of Indian art and artifacts grew out of her friendships with the Native people of the area. Bounds collected in a very personal, one-on-one fashion, primarily from the people and the region she knew best. The Doris Swayze Bounds Collection of Native American art and artifacts, consisting of more than 2,700 ethnographic objects, 350 items of Southwestern jewelry, 4,000 archaeological items, numerous pieces of art, and a library of 1,200 volumes of reference materials, has many tales to tell.

Any attempt to place Bounds's collection and her methods of collecting in historical context must include more than a recitation of biographical facts. Collectors leave not only the unique legacy of the items they have selected to represent their personal vision of their field of interest but also an unspoken statement about what has not been chosen—what has been left behind. In addition, a collection taken as an entity may also make an implicit statement about the collector's level of knowledge, whether it be shallow or highly informed.

Thus, a biography of a collector continues to inform future scholars, helping to place specific items in the collection within a broader context. For example, a researcher might ask, is the item exactly what it is thought to be? Was the collector choosing the item with an informed eye? Is the item's documentation supported by the collector's knowledge of the field? Were the item and its accompanying history acquired firsthand from a reliable source or secondhand from a trader who might have had no stake in the authenticity of the tale?[1]

It is in this spirit of understanding that this biography of Doris Swayze Bounds is offered. Widely known and quoted, audiotaped and videotaped, and often reported in print, her highly visible life has many documented narratives, which people interested in her collection may study. The present compilation of stories is just a portion of the rich legacy she left behind. It does, however, provide readers with a context for her life, an overview of the nature of her relationships with her Native American friends, and a look at the critical events that affected her collecting.

The items Bounds collected speak to the age-old relationships among Plateau peoples and to their newer contacts with Euro-American travelers and occupiers of the region. They also speak to Bounds's deep friendships with many Native Americans. If collections really do have an internal composition that is determined by the "collector's eye," then this collection certainly has that integrity. For example, as Kate Duncan shows in chapter 6, Bounds's collection of more than three hundred Plateau bags covers the entire range of styles and transitions that have occurred over time in this one art form. Mary Schlick, in chapter 4, traces similar transitions in form over time in the cornhusk bag collection. Bounds knew the Plateau and its arts so intimately that she could discern which pieces would add depth to an overall understanding of each form and each type of object she sought to collect.[2]

Doris Bounds always described herself as having the "happy providence of being undiscriminating." Despite this self-effacement, she had an exquisite eye for artistic composition and finely executed handwork. Her collection provides a chronicle of her increasingly sophisticated judgment. She also had an acute memory for stories, backed by years of friendship with Native Americans that gave these stories context

1.1 Charlotte Kanine (Umatilla) at tipi entrance during Fourth of July celebration, early twentieth century. Courtesy Bounds Foundation.

(figs. 1.1–1.5). With compulsiveness, she and her assistants recorded as many of the details of each acquisition as they could.

In addition, her demeanor was warmly receptive and appreciative of any gift, and as a result, she was frequently rewarded by expressions of affection. The gifts she received remained a link to her friends. Some items came to her in times of crisis: for example, a beautiful 1840s Plateau shirt decorated with quill-wrapped horsehair (plate 29) arrived in the middle of the night with pleas from family members for Doris to protect it within the Roger J. Bounds Foundation from being sold "off the reservation." Other items were held as security for the personal loans she occasionally offered to her Indian friends. Few of the loans were ever repaid, so, after holding the items in trust for sometimes up to twenty years, she protected them under the umbrella of the foundation for posterity.[3] Several items were received at giveaway ceremonies held after the death of a beloved Indian friend; others were given as gifts of respect and love. An interwoven theme of all of these objects is the care and stewardship they received at Bounds's hand. She felt her role was to preserve the items her Indian friends entrusted to her, and it was in that role that she wished to be remembered.

1.2 Motanic family (Umatilla), ca. early twentieth century. These young Plateau Indians are dressed in finery, with beads and bags. Major Lee Moorhouse photo. Courtesy Bounds Foundation.

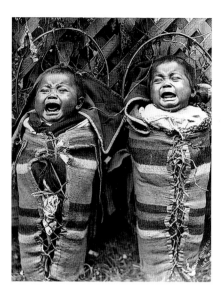

1.3 Emma and Edna Jones, also known as the Cayuse twins, ca. 1897. Major Lee Moorhouse photo. Courtesy Howdyshell Collection, Pendleton, Oregon.

1.4 As adults, the twins, Emma Jones Luten Burke and Edna Jones Moore Crawford, were favorite friends of Doris Bounds. 1970s. Courtesy Bounds Foundation.

1.5 Amy Halfmoon Webb (Nez Perce), wife of Sol Webb, ca. 1980s. Courtesy Bounds Foundation.

The Early Years

It was into the ancient but rapidly changing northeastern Oregon land-scape that Bounds's father, Franklin Benjamin Swayze, stepped as He dis-embarked in 1906 from the Oregon Railroad and Navigation Company train at Maxwell's Siding to assess the area's prospects for development. The little settlement, soon to be renamed Hermiston, had fewer than one hundred houses and lay along the once heavily traveled Oregon Trail (map 2).[4]

Swayze was traveling west to establish a new home for his family, looking for financial opportunities along the way. Born on January 12, 1878, in McComb, Illinois, to Henry and Mary Elizabeth (Hendershot) Swayze, he left school after the seventh grade and went to live with an older brother who worked as a lumberman. He married Anna Abby Miller, an elementary school teacher, on May 31, 1902.

After working for several years in the lumber business as general manager for the R. A. Long Lumber Company[5] in Kansas City, Kansas, he moved with his new wife to pursue lumber activities on the Five Nations Indian Reservation in what was then known as Indian Territory, near today's Muskogee, Oklahoma. It was there that Doris Christine Swayze was born on October 26, 1904 (fig. 1.6). Doris later recalled with pride

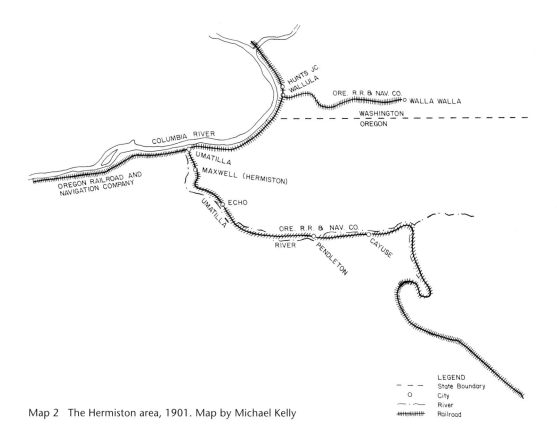

Map 2 The Hermiston area, 1901. Map by Michael Kelly

1.6 Anna Miller Swayze with baby Doris on the porch of their house in Indian Territory, 1903. Courtesy Roger S. Bounds.

that her name was chosen by a Native American neighbor who knew it meant "daughter of God."

Frank Swayze was twenty-eight when he accepted an offer from the Weyerhaeuser Company at Longview, Washington. He traveled west by train, leaving his wife and young daughter in Oklahoma until he was ready to have them join him. Banks didn't transfer money easily in those days, so he brought $25,000 cash with him that he carried in a money belt to buy into the lumber business. On the train, he became acquainted with several Bureau of Reclamation staff members from Washington, D.C., who were involved with the Cold Springs Reservoir then being constructed in the hills near present-day Hermiston. From their description, it was evident to Swayze that the area would soon be irrigated and was ripe for growth. He stopped to look at the settlements that were being developed, and he didn't get back on the train.[6]

Swayze soon began cashing local workers' payroll checks; then weekly he traveled the forty-five-mile round trip by train or wagon to a bank in Pendleton to deposit them. The First Bank of Hermiston was born out of this first check-cashing service. Swayze opened a small office, keeping the money in its iron stove until his first bank building was completed. A federal bank charter was granted soon thereafter. On January 14, 1907, when the new First National Bank of Hermiston opened its door, "every man in Hermiston, and several women as well" opened accounts there.[7]

Anna Miller Swayze, pregnant with her second child, and daughter Doris were summoned to join Frank in the fall of 1906. Young Doris Swayze arrived in Oregon with the baby gifts that had been given to her by a Nez Perce nurse employed by her mother when they lived in Indian Territory. Her first Indian gifts were a Nez Perce cornhusk bag (see fig. 4.1) and a pair of tiny moccasins. Indeed, moccasins were her footwear of choice as a youngster until she began school at six, when she reluctantly shed them for what she referred to as "real shoes."

As a young child, she recalled watching the local Indians who would come to the mouth of the Umatilla River near her home to get eels. On their treks, they would pass by the corner of the bank building, and her father would go out to visit with them, forming many lasting friendships. Frank Swayze's years of association with Indians, both in Indian Territory and in Oregon, left him with an unusual caring for Native people that was generously transferred to his daughter. The Indian women gave Doris gifts of beaded necklaces, which she was forbidden to wear to school. However, she smuggled them in her bloomers and wore them anyway, to the dismay of her teachers, who referred to them as "heathen things." "I thought I was the prettiest girl ever when I had them on," she often related, with evident disappointment that her love for Indian things was not universally shared.[8]

Frank Swayze, who was by then known affectionately as "Pop,"[9] enjoyed horses and traded with the local Indians for many of their finest animals. His two ranches near Hermiston furnished many horses for the army remount service and for ranchers in the vicinity. Doris filled her summer days and after-school hours with trips on her "Cayuse" pony, a spotted gelding bred by the local Indians. She would stop by her father's bank on her way home from school, offering to run errands for him on horseback. As a young student, she would load her saddlebags with a sifting screen and tools for digging, mount her pony, and head to the banks of the Umatilla River to hunt for streamside arrowheads and carved stone items to add to her small collection of artifacts (fig. 1.7).

Long summer camping trips with her parents and brother to the lush Metolius area of central Oregon near the Warm Springs Indian Reservation were made by horseback and wagon. Her father also wanted her to experience the big city, so trips to Portland were often undertaken for cultural activities. "If there was anything in Portland of any stature at all, somebody was giving a concert or something there, we were all loaded on a train and taken to see it."

Fall days were reserved for huckleberry picking with their Indian friends in the nearby Blue Mountains, or for taking the train to the Pendleton Round-Up. "When huckleberry season came along, we would get our blankets sewed together to make a sleeping bag, get on the little trolley car, go to Pendleton, go to the livery stable, get a horse and

1.7 Stone knife collected by Eugene Field on the Columbia River. As a young woman, Bounds collected worked stone, arrowheads, and knives from the banks of the Umatilla and Columbia Rivers. Though she saved this knife, her personal collection was lost over time, the result of her family's many moves. Width: 2 in. Length: 7 in. Date collected: 1958. (1.2.51)

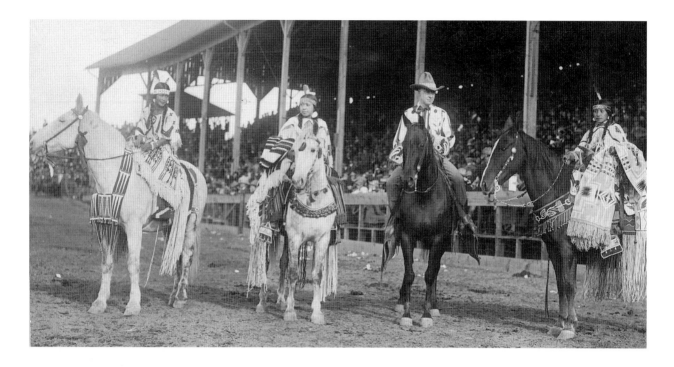

wagon, and go out with the Indians to where they had the huckleberries and hot springs, every summer."

After its beginning in 1910, she only once missed the annual Pendleton Round-Up (figs. 1.8, 1.9). "The whole city of Hermiston" reserved seats in the grandstand.[10] Along with other area businesspeople, Pop Swayze would close the bank and take his young daughter with him, leaving a sign on the bank window saying, "Gone to the Round-Up, You Should Too." She grew up with stories of buckaroos such as Jackson Sundown, a Nez Perce Indian. At the Round-Up, the Swayze family struck up lifelong friendships with James Sturgis, who was then livestock director for the event, and with "Poker Jim" and his son Clarence Burke, who later became chief of the Umatilla Tribes.[11] In Bounds's later years, the Round-Up commission honored her for her long association with the Round-Up by naming her Grand Marshal in 1969 and inducting her into its Hall of Fame.[12]

Poker Jim taught young Doris how to use a hackamore bridle and how to stop a runaway horse, a technique she would rely on throughout her life. She also learned how to ride in an awkward-looking Indian saddle and found it more comfortable than she had imagined (see fig. 5.8).

1.8 Three winners of the beauty contest for Indian girls at the Pendleton Round-Up, ca. 1920s. Melissa Par on far left; Liza Bill on far right; others unidentified. Doubleday photo. Courtesy Bounds Foundation.

Stanford and Beyond

After graduating at the head of her class at Hermiston High School in 1922,[13] Doris Swayze was accepted at Stanford University. She was overwhelmed at the different life she encountered on campus, as she was one

of only five hundred women in a school with two thousand men. At first she complained to her father that she felt unsophisticated and under-dressed compared with all the others. She was soon thriving, however, in the challenging academic environment. In 1926, Cap and Gown, the senior women's honorary society, inducted her as one of twelve so honored that year. She graduated near the top of her class with a degree in history, specializing in political science. Only in later years was she heard to lament, "If I'd known then what I know now, an anthropologist is what I should have been."

Her college summers were consumed by other forms of education. Her father insisted that a history degree provided no way for a young woman to make a living; he paid for a summer at Oregon State College (now Oregon State University), where she took such practical courses as bookkeeping, typing, and secretarial studies. Pop Swayze was also of the opinion that his young western tomboy "needed finishing." Following graduation from Stanford in 1926, Doris was sent to Miss Spence's Finishing School in New York City. She lasted, by her account, four hours. Instead, she promptly enrolled in Columbia University's graduate business school and finished the core requirements for a Master's degree in business administration.

A period of working for a bond house on Wall Street followed her graduation, with intermittent modeling assignments for Garfinkel's department store (fig. 1.10). It was during that time that an acquaintance introduced Doris to George Heye, founder of the Museum of the American Indian. She was able to spend several long afternoons seeing his massive collection and hearing his philosophies about collecting arti-facts from around the world.[14] Meanwhile, she assumed her own small collection of Plateau items remained safely stored in the attic of her parents' Home in Hermiston.

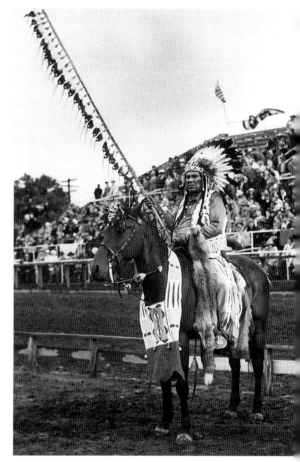

1.9 Jim Kanine (Umatilla) stands on parade at the Pendleton Round-Up, early twentieth century. Courtesy Howdyshell Collection, Pendleton, Oregon.

The Washington Years

In the fall of 1927, Fred Steiwer, a Republican senator from Eugene, Or-egon, offered Doris a job in Washington, D.C., as part of his four-person staff. As his top aide, her title was administrative assistant, and she found herself thrown into a variety of tasks including writing speeches, handling technical correspondence, and running errands. She loved Washington and stayed for twenty years. Among other activities, she availed herself of the rich resources of the Smithsonian Institution's vast ethnographic holdings to further her knowledge of Indian culture.

Several years after moving to Washington, she was introduced to Roger Jackson Bounds, a Washington College graduate who was teaching at Severn Academy, a preparatory school for the Naval Academy.[15] De-spite their concerns about finances during the Great Depression, they

were married on September 15, 1931. "It had to be on a payday for both of us," she remembered. Roger soon began working for the U.S. Chamber of Commerce and later worked in the Federal Bureau of the Budget and the Federal Bureau of Investigation. The Boundses eventually moved to a suburban home in Maryland.

For Roger and Doris Bounds, these were not easy years, in part because of the depression. Doris worried privately about her father's bank in Hermiston, even though she knew it was fiscally sound. Since it was a nationally chartered bank, he was required to comply with Roosevelt's edict of 1933 instructing all banks to close their doors. He circumvented the order by posting a sign on the front door that read, "Bank Closed. If you need assistance, please go to the side door." That door, and the bank, remained open for the duration of the crisis, one of only two banks in all of eastern Oregon to survive the depression era.[16]

On a more personal note, tragedy struck multiple times for the young couple. Pregnancy after pregnancy failed, several times as late as the middle trimester, and Doris suffered at least ten miscarriages. At long last, a pregnancy was successful and Roger Swayze Bounds was born on February 21, 1942, just weeks after the bombing of Pearl Harbor.

As the pace of World War II escalated, both parents were called to action. Roger was working as budget director on a secret project with the White House, later to be known as the Manhattan Project—the effort that built the atomic bomb. Doris worked in the War Department and in 1945 served as a secretary at the highest level of security during the final international peace negotiations. On at least one occasion she was flown to Europe in a blacked-out plane, her "trusty typewriter on her lap." The war was exhausting to both Roger and Doris Bounds, however, and after its conclusion they were ready for a change.

1.10 Doris Swayze posed as a model while in New York City, 1920s. Courtesy Roger S. Bounds.

Back to Oregon

In the spring of 1947, Pop Swayze offered Roger and Doris an opportunity. McNary Dam was being built on the Columbia River, and he thought someone should open a bank in nearby Umatilla to provide local banking services for the estimated five thousand workers and their families. Would they be interested? Their answer was yes, and they quickly began packing the household for the move.

The new bank, called the Inland Empire Bank of Umatilla, opened in March 1948, with Roger as president. The Boundses purchased a beautiful home on an eighty-acre ranch in an area just south of Umatilla. Inside the house, formerly owned by an Indian agent from Alaska named Charles Robinson, Doris found a small collection of Alaskan Indian items, which she faithfully saved and added to her own collection. Upon her return to Hermiston, however, she found that many of the items she

had so carefully stored in her parents' attic before heading east after college were missing, and in frustration she resolved never again to sell or part with an item.

The early years in Umatilla and Hermiston provided a wonderful respite for the young family. Doris and son Roger often traveled to meet and learn about Indians as he involved himself in Boy Scout activities. As his skill in Indian dancing increased, she had a dance outfit specially made for him by a Umatilla Indian friend, complete with a feather dance bustle and the porcupine and deer-hair ceremonial headpiece known as a roach (fig. 1.11; plate 4).

Doris traveled frequently to the Willamette Valley and Portland, passing through The Dalles en route, where she stopped to shop for Indian items and visit with friends such as Chief Tommy Thompson and his wife, Flora, two of the last surviving Wyam tribe members (fig. 1.12).[17] "I used to find two places in The Dalles that had Indian things," she said. "They also had large amounts at the local Goodwill Industries store, so many it was often hard to choose. To me these things were beautiful. Here was something that needed to be saved, not thrown out. I really felt an obligation to spare as many things as I could afford and would represent them. Nobody was collecting Indian things that I knew of. I knew I couldn't help each individual Indian, but I did what I could to

1.11 Child's dance roach of porcupine guard hair and deer hair, Cayuse, mid-twentieth century. This dance roach was made by the Jones family (Cayuse) from the Umatilla Reservation near Pendleton, Oregon. Height: 12 in. Width: 4 in. Date collected: 1960. (6.17.2)

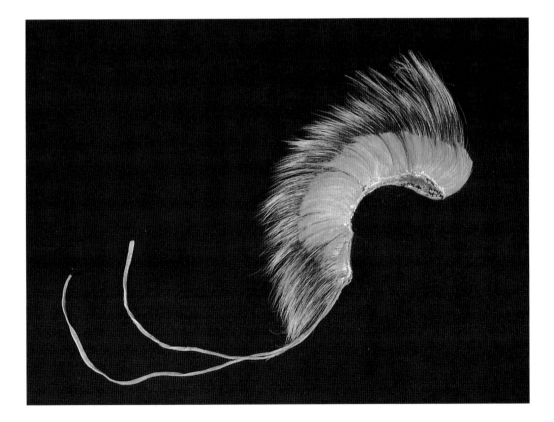

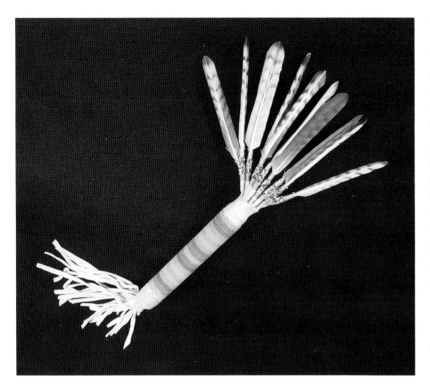

1.12 Peyote fan, Plateau, Wyam, ca. 1950s. Given to Doris Bounds by Henry Thompson, who made it for his father, Chief Tommy Thompson, for the dedication of The Dalles Dam. According to Moses Thompson: "The star beading at the base of the feathers was used only at certain ceremonial times of the year. Some similar fans are now used at dances and powwows, but they are not really the same as a peyote fan. On this fan, the feathers are all tied individually, coming from the center where the heart is. When you make a feather dance by itself, the spirit power has come to help you and guide you." Length: 22 in. Width: 7 in. Date collected: 1963. (4.5.2a)

1.13 The Inland Empire Bank, ca. 1920s. This was one of the early bank buildings in Hermiston owned by Frank Swayze. *EUCA Sidelights* photo. Courtesy Umatilla County Historical Society.

1.14 Doris and Roger J. Bounds during opening of the new Hermiston Branch of the Inland Empire Bank, 1959. Courtesy Bounds Foundation.

save an entire culture." This "salvation ethic," or "salvage ethnology," was widely accepted during these years, and it fit naturally into Bounds's approach to her Indian collection.[18]

During these years, Doris Bounds assumed the role of secretary to her father in his First National Bank of Hermiston, while her husband's bank, the Inland Empire Bank, prospered in Umatilla, seven miles away (figs. 1.13, 1.14). On December 6, 1950, Pop Swayze died; he was seventy-two. Several years after Swayze's death, the bank was sold to the U.S. National Bank of Oregon with the pledge that the family would not reenter banking in Hermiston for a period of five years as a condition of the sale.[19]

Bounds turned her abundant energies toward community activities (fig. 1.15). She was one of the biggest supporters of the Hermiston Community Club and remained active in many philanthropic pursuits. But her focus remained with her Indian friends, and her collection once more grew rapidly.

Gradually, the collection items began to adorn her husband's bank in Umatilla. "Banking walls are such a deadly bore. There just isn't anything interesting about them. I began putting up arrowheads in Umatilla, to make it at least different. The guys on the Board were not as happy as I thought they'd be, but they couldn't stop me," she said with a twinkle in her eye. The bank, with its unique decor, soon became a visitor's landmark for the city (fig. 1.16).

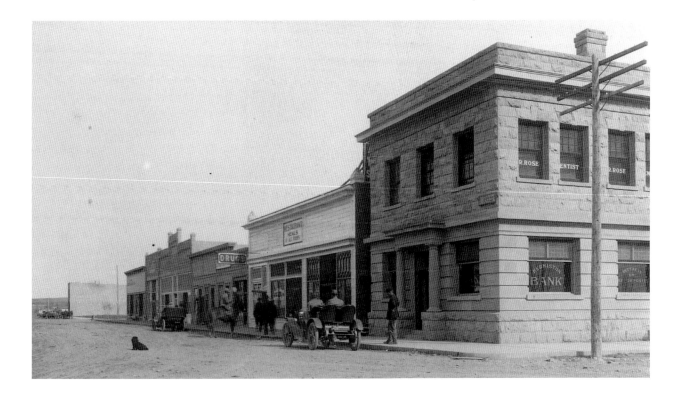

Doris's eastern friends and their daughters also benefited from her generosity. She had cradleboards made for them by beaders on the Umatilla Reservation. "One tiny girl who lived in New York used the cradleboard I had made for her for all five of her children, and she would take walks in Central Park with each new baby happily tied into the board, generating much conversation."

In 1958, Bounds was approached by the Oregon Centennial Committee to display her collection's "costumes, weapons, and handiwork" at the centennial exposition in Portland. It was to be the first exhibition of the complete collection, at this time totaling 1,021 objects. The display was set up at the entrance to the Indian Village, the Native American section of the exposition, in an eighty-by-twenty-foot wooden building. Also exhibited in the building were Harold Churchill's historic gun collection and forty paintings of locally famous Indians that had been created, through Bounds's patronage, by the Hermiston artist Edward Rowe.

Twenty-seven Indians, including many dancers from the Umatilla Reservation, were encamped at the Indian Village in a cluster of seventeen tipis. Doris's friend Jim Sturgis of Pendleton acted as centennial Indian coordinator, contracting with the Indians for their daily performances and seeing to their needs. By August, an average of 13,400 people a day were seeing the exhibit, with total visitorship of more than one million for the one-hundred-day run.[20]

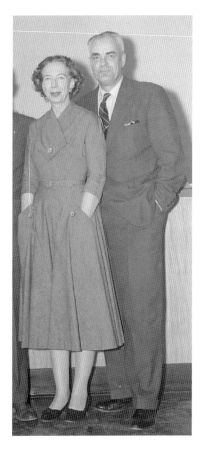

Bounds recruited her new friend Fern Cramer of Lake Oswego to help staff the centennial exhibit during most of its summer-long run, while she shuttled back and forth between her responsibilities in Hermiston and the exhibit in Portland. The two women made many life-long friendships with Indians that summer, especially with Nora and Bill Spanish from Cardston, Alberta, which led them to a long association with the Blackfeet tribe.

Despite her activity with the Indian collection, Doris knew she missed banking and with her husband was brewing a plan to gain back what she felt had been wrongly sold away from the family. When the five-year noncompete clause from the sale of her father's bank was about to expire, she began a campaign to reestablish the Swayze-Bounds name in Hermiston banking.[21] In the spring of 1959, the couple opened the Hermiston branch of the Inland Empire Bank. To house it, they acquired the vacant and unfinished Oregon Hotel structure in downtown Hermiston. A basement-level concrete vault was poured as a storage area for the ever-expanding Indian collection, while an upper-level vault was prepared for the bank's monetary assets.

January 1960 was the coldest month Hermiston had ever experienced, and two weeks of below-freezing weather had taken their toll. For reasons Doris was unable to understand, Roger Bounds took his own life at the family home on January 28. Though her friends and family rallied around her, it was her Indian friends who took over after his death, taking turns staying with her day and night. She felt that she never fully repaid her Indian friends for their care during her first weeks of widowhood.

Collecting and Banking Years

With Doris's father and husband both gone, the two branches of the bank badly needed leadership and direction. Doris Bounds began to realize that it would fall to her either to sell the banks or to provide the necessary guidance for them to be successful. Her son, Roger, was about to graduate from Hermiston High School and would head to Stanford University in the fall of 1960. At fifty-six, a widow and single parent, Doris Bounds assumed control of one of Oregon's largest privately held banks. She had full responsibility as chairman of the board and as a director of the Inland Empire Bank's two branches in Umatilla and Hermiston. She studied banking and economics during the day; at night, she pursued her second career, that of Indian artifact collector, studying Indian cultures and preparing presentations to various local groups.

In addition, she continued a vigorous round of civic activities. In June 1960 she helped with the PEO state convention in Pendleton,[22]

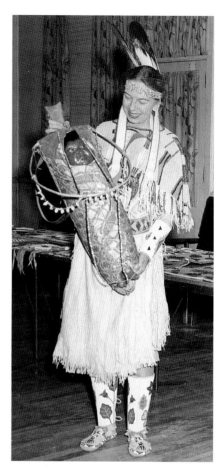

1.15 Doris Bounds wearing dress, cuffs, belt, leggings, and moccasins for a presentation to a local civic group, ca. 1960s. Carved Indian baby and cradle-board by Lelooska. Courtesy Bounds Foundation and Lyons Studios.

where she served as a page. She took great pains to dress the other hostesses for the convention in Indian costumes from her own collection.

She was also chosen that year as a member of the first panel of judges for the Junior American Indian Beauty princess selection, a new contest for Indian girls twelve and younger. In addition, she agreed to become the Happy Canyon Princess chaperone, an assignment she continued for the next sixteen years. Later, she served for four years on the judges' panel of the Miss Indian America Pageant at the All American Indian Days in Sheridan, Wyoming. She continued to develop her Indian contacts and friends through these activities while immersing herself in the cultures from which she was collecting (figs. 1.17–1.22).

Spurred by Bounds's eagerness to put her collection on display and by the local pride generated by the 1959 Oregon centennial exhibits, the community began to call for a public exhibition venue. An editorial in the *East Oregonian,* the local paper in Pendleton, called for the construction of a Umatilla County Museum, suggesting the Round-Up Municipal Stadium in Pendleton as the site and proposing that a large area under the grandstand be sealed off for displays of both Bounds's collection and the Round-Up Museum collection.[23] Good ideas from the community, however, did not translate into action, and Doris began to develop exhibits on her own.

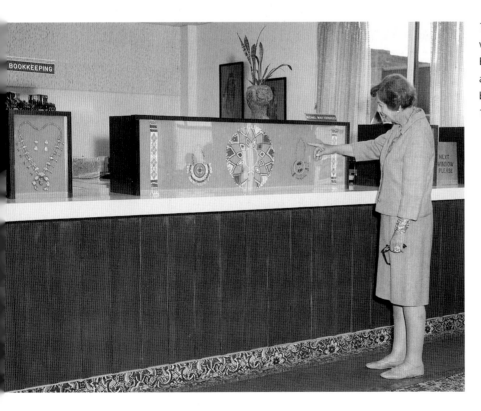

1.16 The Boundses' banks were decorated with Indian things from Doris's collection. Bounds was proud that visitors from around the country would stop to see her bank decor when in Hermiston. Photo ca. 1960s. Courtesy Bounds Foundation.

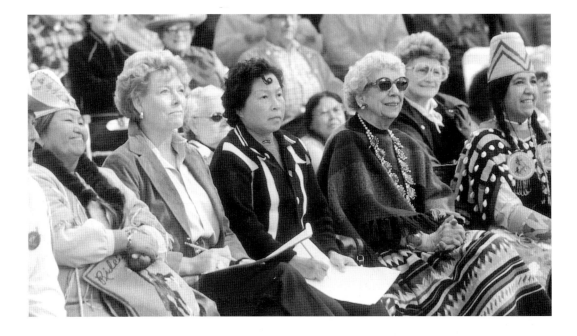

1.17 Doris Bounds judging the Junior Indian Beauty Contest in 1985 at the seventy-fifth anniversary of the Pendleton Round-Up. From left are Tessie Williams, Norma Paulus, an unidentified visitor from China, Bounds, and Marie Alexander Dick. Courtesy Bounds Foundation.

1.18 Indian princess Sophie Bearchum during a trip to Portland with Doris Bounds, 1966. Courtesy Bounds Foundation.

1.19 Cathy Sampson and Jeri Murr, Happy Canyon princesses, with Doris Bounds, Happy Canyon chaperone, and Emile Holeman, president of Happy Canyon, at the annual introduction party for Happy Canyon and Pendleton Round-Up royalty, 1970. Courtesy Howdyshell Collection, Pendleton, Oregon.

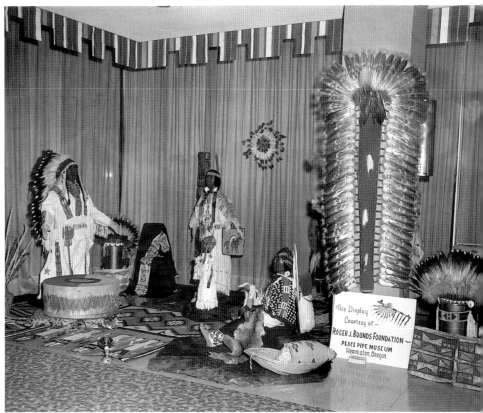

1.20 Mary Lou Webb (Umatilla), ca. 1960s. Photo Arts Studio photo. Courtesy Bounds Foundation.

1.21 Frances Bearchum and Judy Burke in a pre-Round-Up parade, with Bounds as chaperone, 1966. Courtesy Howdyshell Collection, Pendleton, Oregon.

1.22 *(below)* Exhibit mounted in Portland in 1966 for the luncheon of the Sixty-Second Annual Convention of the Pacific Northwest Hardware and Implement Association. "Feathers, Beads, and Buckskins" was the title of Bounds's presentation. Notice in front center of photo the cornhusk bag full of roots. Courtesy Bounds Foundation.

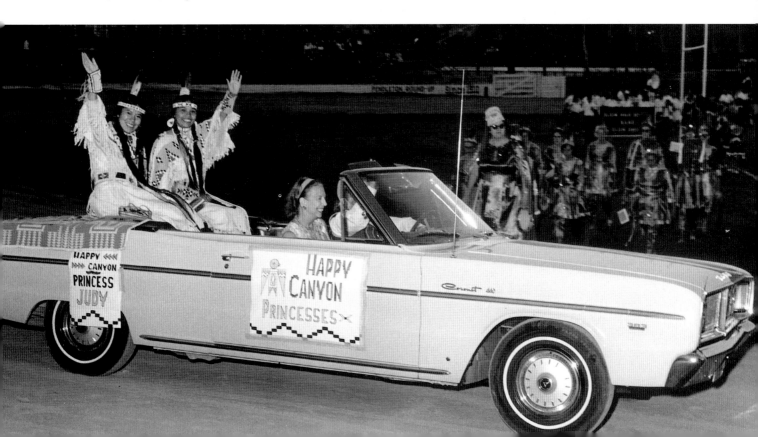

In the summer of 1961, Bounds and her longtime friend Jim Sturgis were able to arrange a small display of artifacts on Pendleton's courthouse grounds. Throughout the next winter, the two collectors designed exhibits, chose objects and photos, and wrote interpretive text, planning for a more formal presentation the following year (figs. 1.23, 1.24).

On May 15, 1962, the Peace Pipe Museum opened in Hermiston at the Umatilla County Fairgrounds.[24] It featured a large portion of the collection that Bounds now honored with the name of her late husband as the Roger J. Bounds Collection, along with one hundred selections from Sturgis's historic photograph collection. Sturgis was named "curator" of the museum. For five summers he and Bounds kept the museum open, and it was eventually featured in Ralph Friedman's *Oregon for the Curious* and in several other regional promotional publications.[25]

But by 1968 the museum was defunct, plagued by recurrent moisture and overheating problems. Bounds's Christmas letter that year lamented, "This year the Indian Collection was not on exhibition as there was no suitable place for it, and the damage to various treasures over the past several years in the old location was really cataclysmic." The lessons that Doris Bounds learned about trying to operate a private museum on her own firmed her resolve to continue to seek a permanent home for the items.

Adoption into the Blackfeet Tribe

Doris Bounds and Fern Cramer deepened the warm friendships they had established during the centennial exhibition with Nora and Bill Spanish and with Blood Indian medicine man Bill Heavyrunner and his wife, Josephine (fig. 1.25). Cramer and her husband, Walter, traveled to Browning, Montana, in 1960 to visit the Blackfeet Reservation during the North American Indian Days celebration, promising to return the following year with Bounds.

During the next four summers, Bounds and Fern Cramer made annual treks to the festivities in Browning. Over time, they were invited to take part in many tribal ceremonies. In 1964, the Spanish family initiated formal tribal adoption procedures for the two women. On July 7, 1965, Bounds and Cramer were inducted into the Blackfeet tribe during their four-day encampment. Prior to the adoption ceremony, they were invited to attend a medicine pipe ceremony in a rare enactment of the Medicine Lodge, or Old Sun Dance, of the tribe.[26] During the adoption, a ceremony performed entirely in the Blackfeet language, Doris Bounds was given the name Na-Do-E-Kaw-Kaw-Do-Saki, "Sacred Star Woman." Fern Cramer was given the name Fe-Na-Ka-Monee-Saki, "Little Otter Woman." The two women held the trust of their newly acquired Blackfeet association very close to their hearts, afterward signing letters to

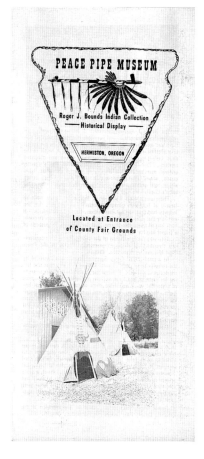

1.23 Peace Pipe Museum brochure, 1962. Courtesy Bounds Foundation.

1.24 Peace Pipe Museum display, 1960s. By 1960, Doris Bounds already had more than one thousand catalogued items in the collection. Courtesy Bounds Foundation.

1.25 Josephine and Bill Heavyrunner, Blackfeet, ca. 1980s. Bounds met the Heavyrunners through her association with and her adoption into the Blackfeet tribe in 1965. Many of the items of Blackfeet provenience in her collection were acquired though the friendships she made during her travels to Montana. Courtesy Bounds Foundation.

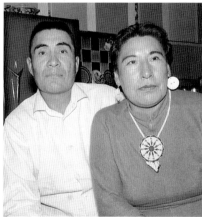

each other with their new initials, "L.O.W." or "S.S.W." For several more years they continued their annual trips to Montana for the summer celebrations, keeping their new friendships alive and providing Bounds with additional collecting opportunities.

It was during the early days of the Vietnam War, "that awful, useless war," as she decried it, that Bounds felt she benefited most from her Blackfeet affiliation. Her son, Roger, joined the army in 1966 and served a three-year term. When Roger left for the service, medicine man Bill Heavyrunner blessed the young pilot. For fifteen months Roger flew missions into North Vietnam and Laos, and in South Vietnam next to the DMZ, while he was stationed with the I Corps. He flew as a forward air controller, and his unit did reconnaissance and controlled the air strikes by other pilots. At that time, he was in the only existing army flight reconnaisance unit, flying the fully acrobatic, O-1 "Bird-Dog" single-engine plane in very risky territory. Every day while Roger was gone, Heavyrunner prayed with his medicine bundle for him. Twice during Roger's service, he called Doris Bounds with great concern and urgency, having "lost touch with Roger." She carefully obeyed the instructions Heavyrunner gave her until he notified her that he had reestablished spiritual contact with Roger. She always ascribed Roger's safe return from the war in large part to Heavyrunner's spiritual intervention.

A Strong Foundation

The collection continued to grow as Bounds nearly doubled the pace of her purchasing through her network of Indian traders. Her favorite items, however, continued to come as gifts from her Indian friends. Several non-Native collectors, seeking a nonprofit shelter for their small collections, asked if they could donate or sell their items to her. In 1965, she established the Roger J. Bounds Foundation, dedicated to increasing the knowledge and appreciation of Indian art and culture, as a memorial to her late husband. At that time, Bounds reported that the collection, the foundation's sole asset, was valued at $100,000.

An astute student of Plateau culture, Bounds recognized before many acknowledged scholars that tribal attribution of Plateau styles was a difficult puzzle. She knew firsthand that the friendship and kinship associated with an item were significant, but the tribal origin of the style featured in any one object's decorative elements was not. She had heard from her Indian friends how many of the traditional patterns had been forbidden by reservation policy and how the floral beadwork that replaced the banned native geometric designs had spread rapidly after the 1890s. Through cultural ceremonies and giveaways for births, weddings, funerals, and other celebratory events she was invited to attend, Bounds

realized that items traveled swiftly between tribes, regardless of origin. On the Plateau, transfer of items between tribes was an established social custom, entwining the tribes, as the anthropologist Eugene Hunn so aptly described it, in a "network of ties among individuals and families forged of two strands, a warp of kinship and a weft of exchange."[27]

Doris Bounds was asked by Father Wilfred Schoenberg of Gonzaga University in Spokane, Washington, to loan some of the collection for exhibition at its new Museum of Native American Cultures (MONAC) in 1967. She also was appointed to its board of directors. The *Hermiston Herald* reported: "Mrs. Bounds hopes to retire . . . and devote full time to getting the collection ready for permanent display at the proposed Pacific Northwest Indian Center on the Gonzaga University campus in Spokane. Her main aim is to get the collection out so the public can enjoy it."[28] She had more than two thousand items at that time. Though she eventually did loan a tipi and several other items, the institution struggled, and she ultimately resigned from the board in 1983.

In 1969, her hopes for a building with security and proper exhibit space were again ignited. "The Foundation was gifted with an old stone school house, which is several miles from Hermiston. . . . This building is beautifully designed for a museum with 6,500 square feet, but it needs EVERYTHING," she wrote in her Christmas letter. It was not long before she realized she could not provide the "everything" it required, and the dream once again faded as the cost estimates became overwhelming.

In 1968, Oregon's then governor, Tom McCall, appointed Bounds to serve as the eastern Oregon representative to the newly created Oregon Arts Commission (OAC), which was to serve as the state's liaison with the National Endowment for the Arts. When she joined the commission it was chaired by David Rhoten of Salem, also a McCall appointee.

Not all went smoothly with her introduction to the commission in its early years. Friend Jack Mills recalled that "the board was affronted by the political appointee process, and was not at all enthralled with her vision of art."[29] Those on the commission later learned to see Indian art through Bounds's eyes and began to appreciate the intrinsic value of the art she chose to collect. Bounds served two four-year terms on the Oregon Arts Commission board and was later appointed for a third term by Governor Victor Atiyeh.

When she was at home in Hermiston, visitors and vendors, people wanting loans, and others wanting to sell collections all kept her daily schedule packed. She took long collecting trips with her friends Fern Cramer and fellow OAC commissioners Mary Anne Normandin and Norma Paulus, following leads to new sources of art and artifacts throughout the West, the Southwest, and the Northwest Coast. She shared the collection with her friends, the community, and her family, including

Roger, along with his wife, Karen (Bisgaard) Bounds, and her grand-
children, Lorissa Marie, Ryan Wesley, Tucker Swayze, and Hillary Anne
Bounds.

Increased recognition of the importance of the collection also pro-
vided the impetus for Bounds to carry out additional work in curating
and documenting the objects during the 1970s and 1980s. Guided by
professionals from several regional museum facilities, she began an in-
tensive process of having each item recatalogued, photographed, and
documented. Bank employees, especially Teresa Moncrief of the Hermis-
ton branch, who acted as curator of the collection, were charged with
rehousing and inventorying the collection, overseeing appraisals, and
leading guided tours of the bank vault for school groups.

In 1975, Bounds loaned two dozen artifacts to the Maryhill Mu-
seum in Goldendale, Washington, including Columbia River stonework
and bead- and shell-decorated objects from the Plateau (fig. 1.26). The
next exhibit of Bounds Foundation objects was "Feathers, Beads, Quills,
and Buckskin," mounted at the Boise Art Museum in 1981. Both exhibits
brought new visitors seeking to discuss the collection with her.

One incident in particular was memorable for Bounds. In Novem-
ber 1959 she acquired from Arthur Sanders of Custer, South Dakota, a
Sioux peace pipe purported to have belonged to Crazy Horse. She pre-
sented it to son Roger as a gift that fall. In 1981, however, after the Boise
exhibit where the pipe was displayed, Phil Lane, Jr., a Sioux medicine
man, visited her to inquire whether the pipe might be returned to his
tribe. He convinced her the pipe was sacred and was needed for tribal
ceremonies, and she agreed to the repatriation. When Bounds and Lane
went into the cramped vault to locate the pipe, it could not be found in
the box of other pipes in the storage area where she expected it to be.
"Phil, I can't believe it isn't here," she later recounted telling him. They
both looked in vain until Lane asked her if he might "call the pipe."
After a few moments of song, he was able to locate it in a sealed metal
army box in a far corner of the vault. Upon opening the box, the two
found the pipe safely stored with several other Sioux items that belonged
to Roger.[30]

For the following decade, though she was officially retired from the
bank staff, Bounds maintained an office in the bank basement close to
the collection—but perhaps too close to the banking action. She found
herself more than once unretired and back at the helm of the growing
banking empire. Age was beginning to take its toll, though, and a series
of medical troubles plagued her. It was clear to Bounds and the other
foundation directors that a decision needed to be made soon about the
final disposition of the collection.[31] Bounds maintained that she "minded
terribly every time I went in there that it wasn't out where people could

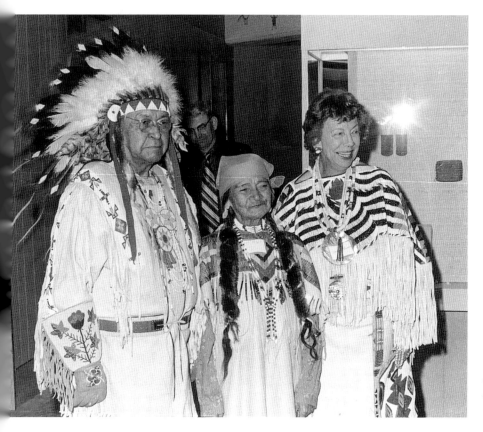

1.26 Doris Bounds with friends Art Montanic and Flora Thompson at the opening of the Maryhill Museum exhibit in Goldendale, Washington, 1975. Courtesy Bounds Foundation.

see it. It was tragic to have it back in the vault—lids on boxes instead of things out on view in cases. . . . It's the heritage of this country that I felt very strongly should be shared."

Bounds was thrilled when the foundation board was approached in 1989 by George Horse Capture (Gros Ventre), then curator of the Plains Indian Museum at the Buffalo Bill Historical Society in Cody, Wyoming, to loan items for a display of Plateau Indian art and artifacts. The exhibit, entitled "The Plateau," was shown from November 1989 to January 1990. A catalogue, the first published work on the Plateau portion of her collection, accompanied the exhibit.[32]

Portions of that exhibit were subsequently shown at The High Desert Museum in an exhibit entitled "Treasures of the Plateau," which ran from April 7 to October 2, 1990. A few items were also on display from July 24 to October 13, 1990, in an exhibit entitled "Indian Children at Play" at the Umatilla County Historical Society Museum in Pendleton. Following the Bend venue, the Sheehan Gallery at Whitman College in Walla Walla, Washington, exhibited portions of the collection as "The Columbia and the Plateau," from October 16 to December 9, 1990. A small catalogue bearing the same title was published to accompany the exhibit.[33]

A Final Choice

After the "Plateau" exhibit, the Buffalo Bill Historical Society proposed an acquisition and exhibition plan for the Bounds Collection. In short order, similar proposals were also put forth by Whitman College in Walla Walla; by Lewis and Clark College, the Portland Art Museum, and the Oregon Historical Society in Portland; and by The High Desert Museum in Bend.

The Bounds Foundation directors unanimously insisted that the collection stay in Oregon, where most of it had been collected. The suitors then decreased to three: the Portland Art Museum, the Oregon Historical Society, and The High Desert Museum. When negotiations were concluded in December 1990, ownership of the collection and the library went to The High Desert Museum, with an agreement to share educational access with the Oregon Historical Society and make the objects available for local events and museum facilities in the Hermiston area.

The transfer of the first selection of objects occurred four weeks later, in January 1991. "It was weeks before we could go back in the vault," reminisced Teresa Moncrief. Bounds, however, continued to purchase items when she could, including a rare pair of cornhusk saddlebags that she "just couldn't resist." She was appointed to the museum's board of trustees and made several trips to Bend for meetings and exhibit openings. Her last visit was in the spring of 1993, when the collection was blessed by Horace Axtell (Nez Perce) and Armand Minthorn (Umatilla) (fig. 1.27).

Doris Bounds passed away at home on April 21, 1994, at age eighty-nine. The day before she died, her Umatilla medicine man friend, Carl Sampson, called to confide to Moncrief that he was aware she was dying and had been talking to her "on the other side." Her memorial service was as interwoven with her friends as her life had been. Speeches from bank employees and community neighbors were followed by eulogies from her Indian friends, an Indian burial song, and drumming by Umatilla tribal members as they prayed for her safety on her next journey.

The Legacy

Doris Bounds began to collect Native American items at a time when to do so was neither fashionable nor respected. Her collection, one of Oregon's largest, preserved local Indian items that might easily have been more widely dispersed or lost forever. It was Bounds's deep love for the Indian people and culture that heralded a change in acceptance of ethnographic items as art forms worthy of admiration among her acquaintances. She would enthuse over each new item, recounting the

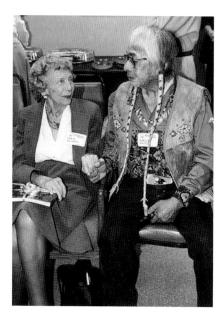

1.27 Doris Bounds and Horace Axtell (Nez Perce) at the blessing for the collection at The High Desert Museum, 1993. Photo by Jack Cooper.

wonderful providence that brought it to her care. Eventually, through her educational efforts, exhibitions, and public outreach, Bounds's zeal for Native arts spread to others, broadening the acceptance of the items she collected and prized.

The Doris Swayze Bounds Collection includes some of the finest and rarest examples of Plateau cultural objects and a wide selection of indigenous items from throughout the world. Though its strength is in its representation of the cultures of the Columbia River Plateau, it includes many important items from the Great Plains, the Pacific Northwest Coast, and Subarctic and Woodlands cultures. Both pre- and post–European-contact examples of objects and styles are represented. There is a significant collection of Southwestern rugs and jewelry. Bounds collected what she considered to be "beautiful things," including objects to wear, use, celebrate accomplishments, and honor friendships.[34]

On a few rare occasions, Bounds's enthusiasm for a good story exposed her trusting nature. The collection contains an assemblage of recently crafted Native American carved items that look unnervingly similar to precontact Columbia River and Northwest Coast stone, antler, wood, argillite, and bone artifacts. They were created by Ivan Sherk, a Cherokee Indian originally from Oklahoma and later from Rogue River, Oregon. His careful attention to detail extended to the exquisite "patination" of the stone, making it appear thousands of years old. Sherk estimated that he made more than nine thousand pieces. Unfortunately, only a few of the more recent pieces were signed by him with his Indian name, "Coyote." Over a number of years, Bounds spent more than $17,000 for these items, which she purchased from a trader who sold them as authentic (fig. 1.28).[35] Her collecting activities nearly ceased for several years after this deception.

To Bounds's credit, all items in her collection were available to researchers and for exhibit. She aggressively attempted to authenticate the Sherk items, as well as any other confusing items in the collection, exposing them to many knowledgeable scholars, archaeologists, and collectors in the region to verify their status.

The Bounds Collection assumes a unique position in the realm of private collections acquired by public museums. It was amassed in part with the financial resources made available by Bounds's banking empire, but more importantly, it was accumulated primarily through the lifelong friendships she nurtured and enjoyed throughout the years. From 1947 to 1970, Doris Bounds spent more than $100,000 on Indian artifacts. The *Oregon Journal* reported: "She called herself a white woman with an Indian soul" (fig. 1.29).[36]

Scholars will examine the Doris Swayze Bounds Collection and Bounds's acquisition methods through many different lenses over time, and certainly much more critically than they will evaluate her business

1.28 Owl mortar, basalt, manufactured by Ivan Sherk, 1950s. Purchased from Joe Bob Winstead. Height: 6.5 in. Diameter: 11 in. Date collected: 1968. (1.2.26)

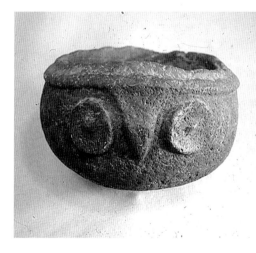

or personal life. What seems important to report now will perhaps seem as awkward to future generations as the 1960s photos of Doris Bounds dressed in Indian clothing seem in today's context. Nor will my biases be the same as those of scholars who will follow. This account of her life and this description of her collection sources will, it is hoped, allow for the material to be revisited in the context of future times, to be reinterpreted again and again.

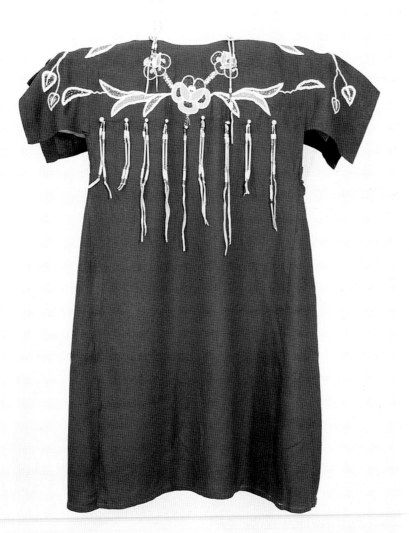

1.29 Green wing dress, Umatilla, 1960s. Doris Bounds's favorite dress, purchased from Julian Smith's Indian Trading Post in The Dalles, Oregon. Height: 46 in. Width: 39 in. Date collected: 1960s. (6.8.1011)

In a Spiritual Way

A Portrait of Plateau Spirituality in Traditional Art

VIVIAN M. ADAMS (Yakama)

My ancestors have lived on this part of the earth for thousands and thousands of years. In the last couple of hundred years we have sustained our existence through many drastic and dramatic changes primarily because of our beliefs and our ability to adapt. Our inherent trait of living in harmony with our environment and our fellow creatures provided us a balance of life that was beneficial to all that lived on the earth. The peoples of the Warm Springs, Umatilla, Yakama, Colville, and Nez Perce Reservations in Oregon, Washington, and Idaho live in the part of the world that our families claim as our mother country. We are called the Columbia River Plateau culture of Native Americans by those who study us (figs. 2.1, 2.2).

I am part of the Yakama people, whose reservation is located in central Washington State. Educating others about Plateau art and culture has been my goal since my early days as curator at the Yakama Nation Museum in Toppenish, Washington. My path has led me to the discipline of art history and the medium of museums in attempting to accomplish that goal. I originally had artistic aspirations, but my path brought me in this direction, which my elders advised me to follow. As a student, I discovered that there were volumes of information about Southwest, Northwest Coast, and Great Plains Native American art. Yet I found it very difficult to gather information about Plateau art, which possesses beautiful and unique characteristics that define it as separate from the art of other Native cultures.

As curator of Native heritage at The High Desert Museum in Bend, Oregon, one of my primary responsibilities is inviting Native people to visit the museum. During our gatherings we tell stories of our past and present lifeways; our beliefs and the ceremonies and rituals that serve

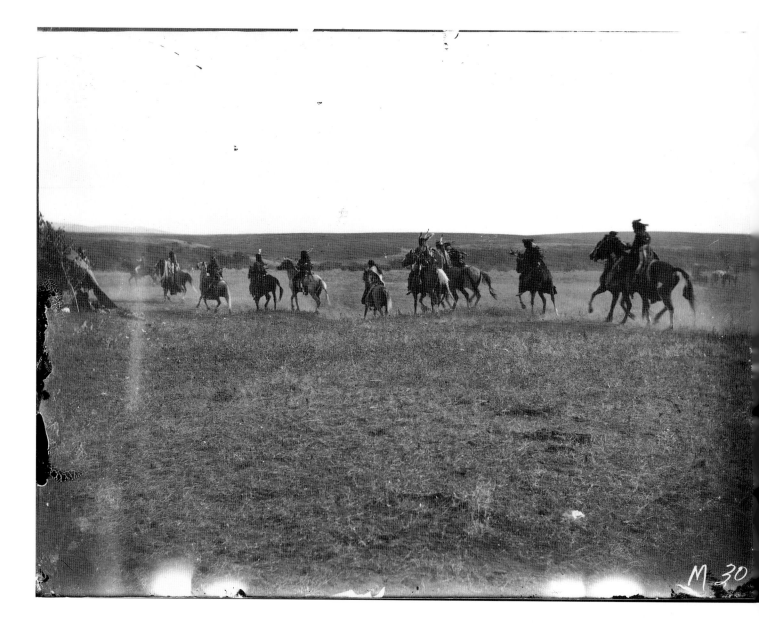

2.1 Riders on the Umatilla Indian
Reservation near Pendleton, Oregon, ca.
1884. Courtesy Howdyshell Collection,
Pendleton, Oregon.

those beliefs are the catalysts for producing our material expression (fig. 2.3). I want to share with you the beliefs that have sustained us through these changing circumstances and have guided us in decorating our lives.

It is amazing to consider the length of time that Euro-Americans and Native Americans have lived side by side as neighbors, and yet to the non-Indians of this country, Native American cultures remain some-what exotic and misinterpreted. In order to create a greater knowledge and understanding of who Native people are, it is essential that we pro-vide some insight into our worldview and philosophy of life.

Plateau people believe that natural objects, natural phenomena, and the universe itself possess spirits or souls; this belief is called animism. The ancient societal values that remain vitally important for Native communities today are defined within the concepts of spirituality, one's relationship to the natural world, the role of kinship and extended fam-ily, trade and exchange, the flow of time (including treaties and how they affect Native lives), and the continuity and adaptation of tradi-tional Plateau art (figs. 2.4, 2.5).

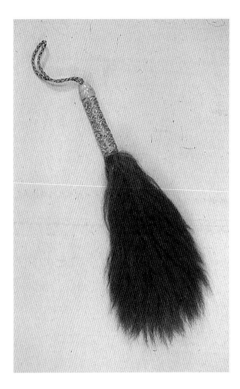

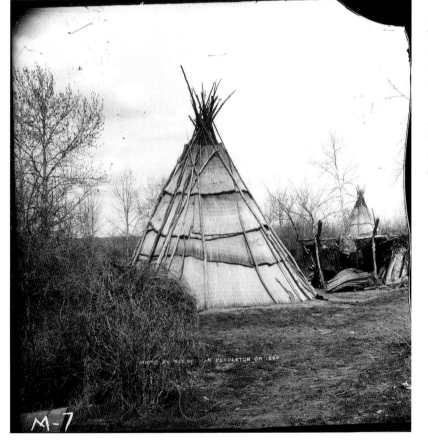

2.3 Dance stick, Umatilla, date unknown. This ceremonial buffalo-fur dance stick belonged to Willie Wocatsie (Umatilla). Length: 22 in. Width: 10 in. Date collected: 1958. (4.1.8)

2.2 A tule mat-covered tipi on the Umatilla Reservation, ca. 1896. W. S. Bow-man, photographer. Courtesy Howdyshell Collection, Pendleton, Oregon.

Spirituality

The Plateau connection to the earth and her creatures is from time immemorial and remains an ongoing philosophy today among tribal peoples in each of the Plateau cultures, from the Okanogan tribe of northern Washington to the Tenino tribe of south-central Oregon. These beliefs are not part of a Hollywood movie sentiment invented to romanticize the Native American. We live this philosophy every day through our gathering rituals and seasonal ceremonial feasts of thanks.

The following excerpt from a Plateau oral myth reflects this belief: "The earth was once a human being, made by the Creator to be the mother of all people. Her soil is flesh; the rocks are her bones; the wind is her breath; the trees and grass are her hair."[1]

Once some insight into Plateau beliefs is gained, traditional art may be appreciated not only for its aesthetic beauty but also for its intrinsic spiritual meaning. In Euro-American culture, there is a distinction between "fine art" and "traditional art," but the art produced by Natives throughout North America has never been separated from the functional. It has never been made as art for art's sake. Rather, these artifacts have always been, and continue to be, decorated to serve the aesthetics of beauty just as they serve the practical and the spiritual (plates 1, 16).

There are several aesthetics that guide Plateau art, but until recently, academic scholarship did not consider spirituality as part of the stylistic analysis when researching traditional artwork. The inseparable element of spirituality ingrained within Plateau artifacts went nearly unnoticed by early art historians and was not fully considered when they examined design concept, form, or technical production. Within the last few decades, however, a new art history has begun to be developed by progressive scholars who are asking new questions about the artistic process within the changing context of culture.

The Washington State centennial exhibition titled "A Time of Gathering," which was a temporary installation at the Thomas Burke Memorial Washington State Museum (now the Burke Museum of Natural History and Culture) in 1989, is a prime example of such scholarship. The exhibit development team's outreach to Native nations for cultural assistance, facilitated by the curator of the exhibit, Robin K. Wright, is a testimony to successful, progressive research, providing new information not only about the objects exhibited but also about their historical context. The authors of this book also have a long history of interaction with Native communities of the Plateau area. Their friendships with and knowledge of Native people of the Plateau include much insight into spirituality.

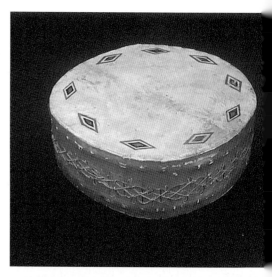

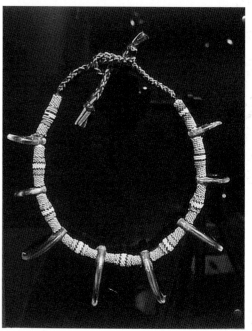

2.4 Drum, Nez Perce, mid-twentieth century. This large circular drum was made by Dan Broncheau (Nez Perce). Diameter: 30 in. Height: 10 in. Date collected: 1968. (4.2.15)

2.5 Bear-claw necklace, Umatilla, ca. early twentieth century. Made by Pendleton Round-Up Chief Clarence Burke, this necklace has eight bear claws. Length: 28.5 in. Date collected: 1958. (11.4.66)

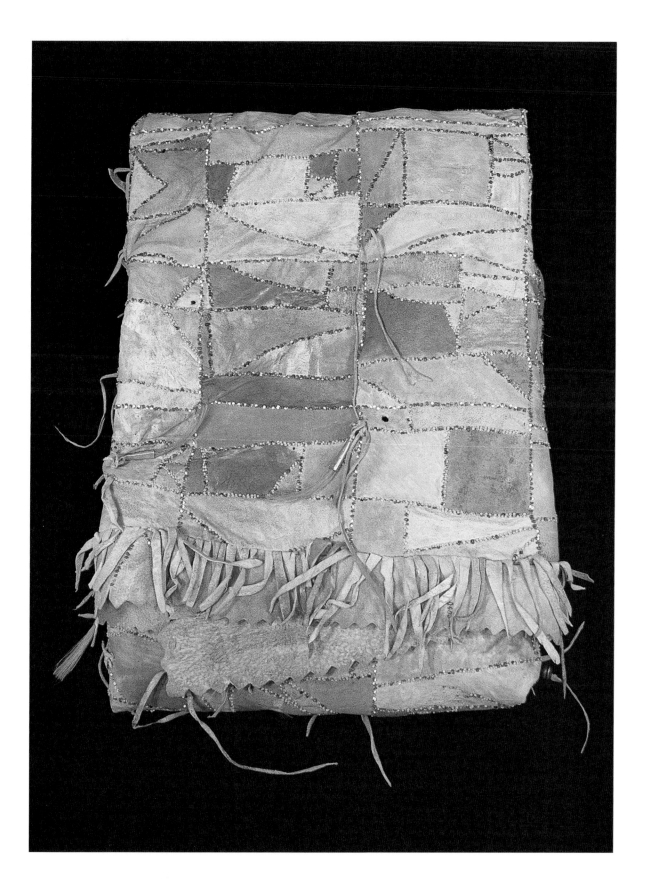

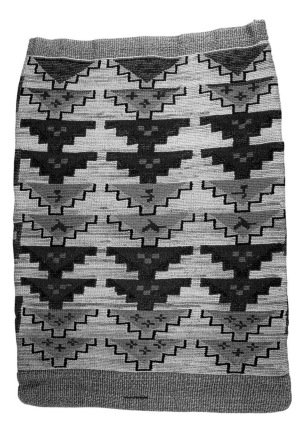

(*overleaf*) Plate 11　Crazy quilt, South Dakota Sioux, early twentieth century. This unique buckskin crazy quilt was collected from the Charles Antoine family of the Umatilla Reservation. Often, after Doris Bounds admired items, she would find them later presented to her as gifts. Height: 63 in. Width: 39.5 in. Date collected:1965. (9.3.12)

Plate 12　(*front and back*) Cornhusk bag, Plateau, ca. 1920. Large twined storage bag of the type described as having been purchased by Anna Swayze to carry her baby's diapers. Height: 20 in. Width: 15 in. Date collected: 1960. (5.1.27)

Plate 13　Beaded bag, Plateau, ca. late 1880s. This fully beaded Plateau handbag displays contour-beaded designs. Height: 14.5 in. Width: 11.5 in. Date collected: 1952. (2.6.7)

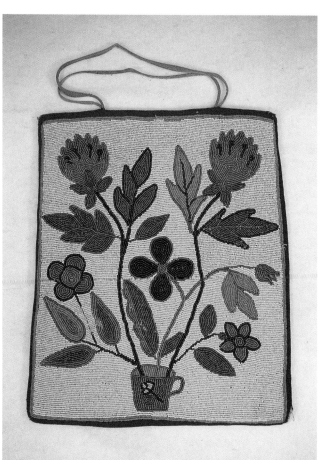

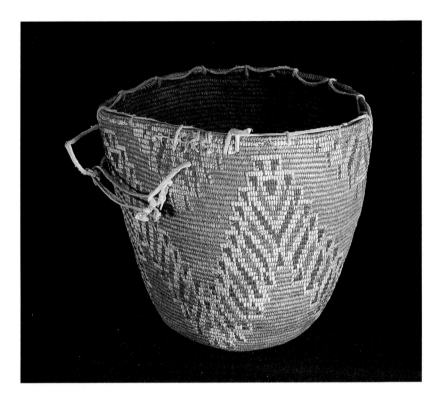

Plate 14 Coiled cedar-root basket, Umatilla or Salish, ca. 1890–1910. The imbrication on this basket is in beargrass and wild cherry bark. From Liza Cowapoo Bill's family. The most likely use for this basket was for berry harvesting in the fall. Height: 14 in. Width: 12 in. Date collected: 1968. (3.3.14)

Plate 15 Gauntlets, Nez Perce, ca. early twentieth century. These gloves belonged to Chief Moses, a Nez Perce from Lapwai, Idaho. They were a gift to the Bounds Foundation. Length: 15 in. Width: 8 in. Date collected: 1978. (6.10.9a/b)

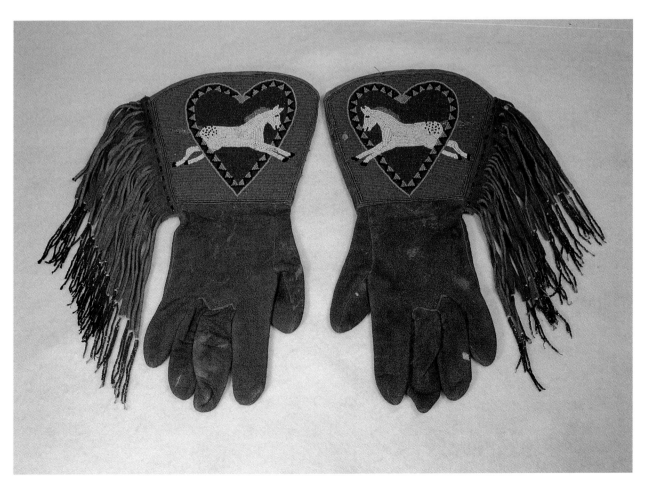

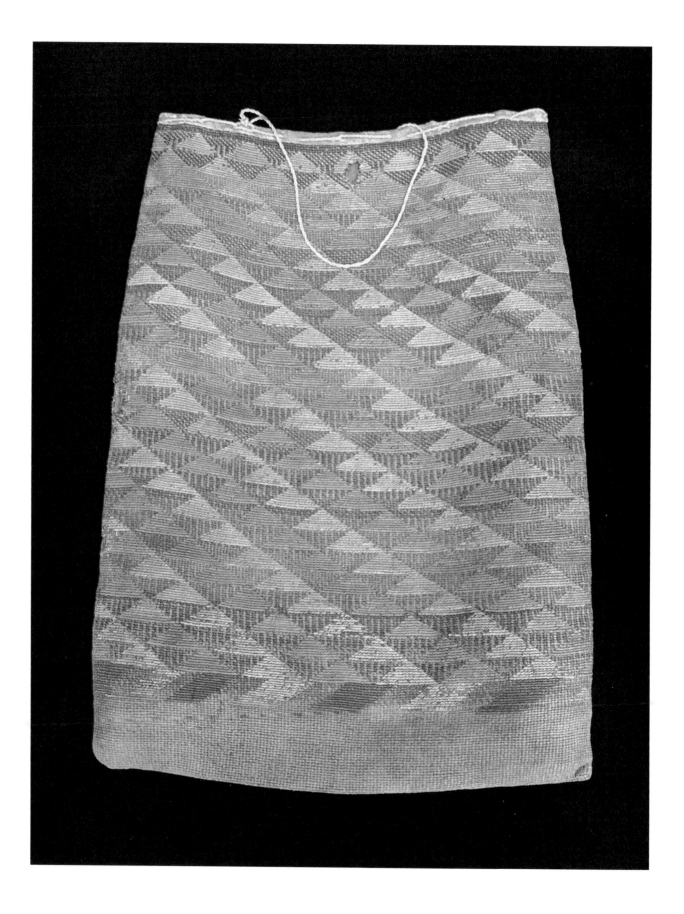

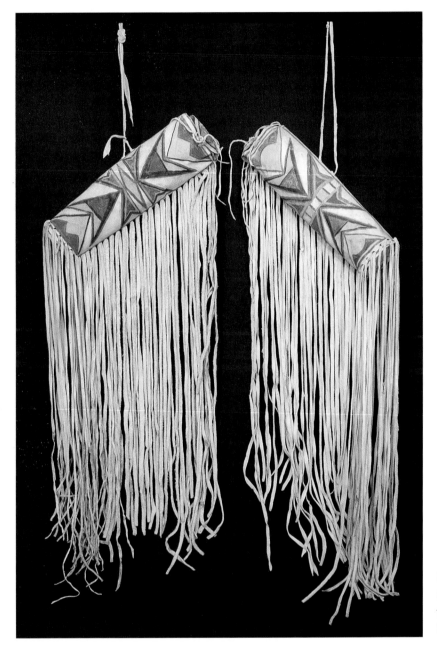

Plate 17 Parfleche bonnet carriers, Sahaptin imitating Crow design, ca. early twentieth century. Height: 19 in. Width: 6 in. Date collected: unknown. (8.6.4a/b)

Plate 16 Cornhusk root bag, Warm Springs, ca. 1880s. This bag illustrates the beauty inherent in everyday objects. It served to store roots for use in the winter. Height: 28.5 in. Width: 22.5 in. Date collected: 1954. (5.1.13)

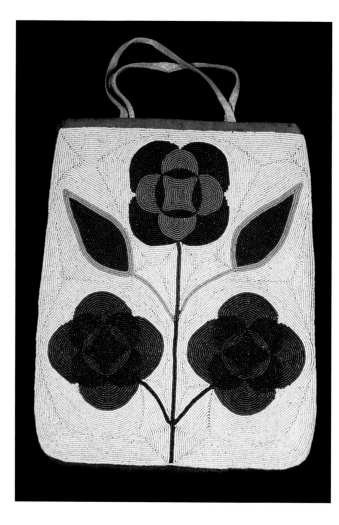

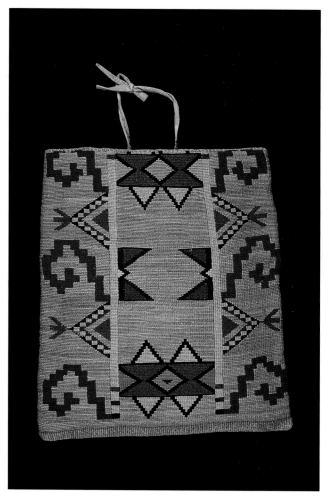

Plate 18 Woman's handbag, Yakama, 1890–1900. Fully contour beaded. In this process, the figures are first completed and the background is then applied in concentric lines following the outlines of the central figures. The fully contoured background in the light blue beads is typical of the era. Height: 17 in. Width: 11 in. Date collected: 1904. (2.6.242)

Plate 19 Cornhusk bag, Umatilla Reservation, ca. 1930. The unusual dyed cornhusk background adds liveliness to this handbag's design. Height: 11 in. Width: 12 in. Date collected: 1964. (5.1.70)

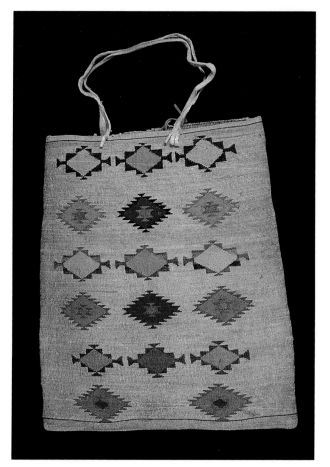

(*left and overleaf*) Plate 20 Cornhusk bag, Nez Perce, ca. 1920. Large, finely twined handbag showing bold design arrangement. Height: 15.75 in. Width: 12.3 in. Date collected: 1960. (5.1.49)

Plate 21 Cornhusk bag (*front and back*) , Plateau, ca. 1920. A colorful banded design enlivens this twined storage bag attributed to a Nez Perce weaver. Height: 22 in. Width: 15.5 in. Date collected: 1960. (5.1.19)

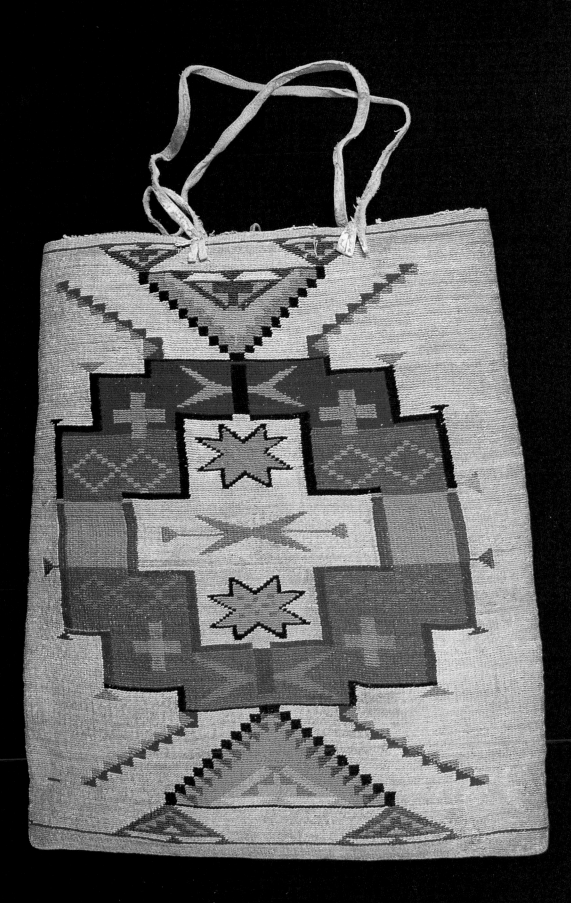

The Natural World

Nature provides humans with all the materials necessary for survival (figs. 2.6, 2.7). Native people believe that because a plant or animal has a spirit and sacrifices itself for humanity's well-being, respect must be shown by giving it thanks. Thanks is given via prayer songs, ceremonial sweathouse cleansing, and ceremonial feasts marking the first foods of each growing season. The Plateau people, as gatherers and artists, contribute their respect and thanks to the things used by maintaining a positive attitude throughout the gathering process and the handling of materials during preparation or manufacture, whether the end product is for making an object or preparing a food for consumption. A balanced frame of mind, free from envy, jealousy, or anger, while handling materials or foods during the production process is essential to the well-being of the people who will benefit from those efforts. No one would want to make someone ill by passing harmful feelings through the objects with which one comes into intimate contact.

Another form of respect is shown when adolescents, gathering their first roots or berries or becoming successful in a first hunting or fishing expedition, give the fruits of their efforts away rather than keeping those things for themselves. This is to ensure success in future endeavors, and it also reflects their regard for both the natural resource and the recipient. First-gathering accomplishments and giveaways in these life-sustaining tasks are recognized through celebration feasts for the new provider, a continuing Plateau practice from the ancient past.

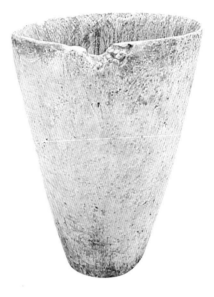

2.6 Wooden mortar and pestle, Palouse, mid-1800s. This bowl belonged to Susie Williams's grandmother (Kuk-Ish-Ton-Mi), who lived near present-day Pasco, Washington. Height: 11 in. Diameter at top: 8.5 in. Date collected: 1963. (9.5a.1)

2.7 Annie Johnson (Cayuse) using wooden mortar and pestle, 1962. Photo by D. E. Warren, Moscow, Idaho. Courtesy Bounds Foundation.

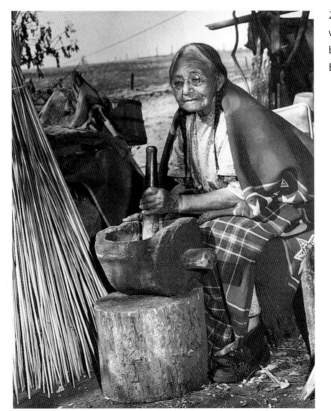

Kinship

Families are important to everyone, but in Plateau country the structure extends to more than the immediate family of father, mother, sister, and brother. Plateau family lines are traced from both the mother and the father. People on both sides of the family are recognized as being related to one another. Elders are respected because of their accumulated wisdom and experience, and they may be addressed as grandfather and grandmother by all who know them.

Grandparents are an intimate part of the nurturing of children. Each paternal grandparent has his and her own name of address different from that of the maternal grandparent. The forms of address in one Sahaptin dialect are as follows: a father's father is *pusha,* and a father's mother is *ala.* A maternal grandparent such as the mother's father is addressed as *tila,* and a mother's mother, as *kała.*

Cousins who live with another family unit separate from their own may be held as brothers and sisters, because there has always been an informal system of adoption or guardianship. Close and dear friends of our parents or family may be addressed as uncle and aunt along with those relatives from our parents' family tree. All of these people may live together in one house and call themselves a family. This type of living situation creates an extended family.

The traditional form of kinship worked to ensure security and well-being within a family. For example, when a wife died, her unmarried sister became wife to the widowed husband. When a husband died, his brother took the widow as a wife. Now, in more modern times of one husband–one wife, that concept of care is still maintained, and family concerns become the responsibility of the multiple family members.

In winter, families grouped together to share the foods and materials gathered from the previous seasons. This was a time of teaching the children through storytelling and of manufacturing needed clothing and utility items with the processed materials that had been stored away for that time and purpose. All family members had a hand in teaching the children the various tasks of daily life. In the evenings, children gathered to listen to elders who were skilled in the art of storytelling to learn about earthly phenomena and about right and wrong.

Gifting and Exchange

All close family members not only helped their own relatives but also supported small communities of neighboring families through sharing and gifting. Giveaways and feasts are celebrations acknowledging rites of passage from birth to death. Honor feasts, namegivings, first-food gath-

erings, weddings (fig. 2.8; plate 7), funerals, and memorials for the deceased are all occasions of celebratory acknowledgment. One of the most important gifting celebrations is namegiving. It is a form of respect shown to the memory of a deceased relative by gifting that person's name to a chosen recipient.

The exchange of goods with families, friends, and neighboring Native people is an ancient practice throughout the Plateau. The Columbia Basin was the focus of one of the world's most extensive and intensive trade networks. An abundance of salmon provided a dynamic resource to be traded with Native peoples from Northwest Coastal areas, as well as with western Plains people and those from central and northern California. A very important and valued trade item was, and still is, the Northwest Coast dentalium shell *(Dentalium pretiosum)*, a slender, tusk-shaped, whitish shell. These were traded to the Plateau peoples for thousands of years and continue to be an important decorative material representing wealth and high social status.

Exchanges also took place between the Plateau's river villages and interior communities, on one hand, and western Plains communities, on the other. Plateau families would form trade partnerships with families from distant locations, exchanging items made specifically for each partnership. The different forms of trade helped to supplement the items necessary for subsistence in the diverse and sometimes harsh Plateau environment.

Trade goods ranged from raw materials and finished goods such as roots, dried salmon, ocher, rawhide, and tanned skins to later products such as beads, weapons, horses, fabrics, coffee, and spices. Songs, designs, dances, games, and ideas were also exchanged and traded. Many social occasions took place when large groups came together to trade, including arranged marriages, namegivings, challenges of skill and physical strength, horse racing, stick games, and healing ceremonies.

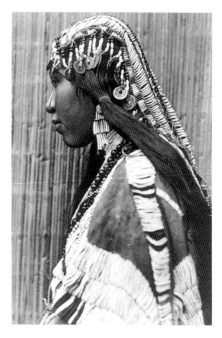

2.8 A Wishx̲am girl with wedding veil photographed by Edward S. Curtis, 1911 (plate 279). Courtesy University of Washington Special Libraries.

Flow of Time

The flow of time brought many dramatic changes to the Plateau country (figs. 2.9, 2.10). Our tribal advisors agree that these historical events must be presented in order for the general public to gain any realization of who the first peoples of this area are. History from the standpoint of the Native American has been almost wholly excluded from public education. By presenting the Plateau perspective of history, we contribute to and balance an incomplete American history. We look back to ancient times, beginning with creation and the teachings of the Animal People, including stories of mythical figures painted on rock ledges along the rivers and streams in Plateau country. We also address the westward

population expansion of non-Indians and the contributions and sacrifices the Native Americans of this country have made to its growth and development.

The importance and impact of the Plateau helper and friend, the horse, is also important to recount (plate 15). The horse was a great influence contributing to the expansion of Native movement throughout the Northwest. He was held in great esteem, as is shown in the displays of finery made to decorate his body. This animal friend became a helper in the food quest and an assistant in protection by providing transportation. Plateau gatherers were able to travel to distant locations for seasonal food harvests and for trade and exchange with other cultures.

Encouraged by government officials who advertised free land for settlement, the movement westward by non-Indians became a population explosion. Newcomers were searching for land to farm, resources to exploit, gold for wealth, and a promise of secure futures. All these aspirations came at the expense of the Native peoples who had lived upon the land for thousands of years. Native populations were impacted in turn by the fur companies, foreign diseases, missionaries, pioneers, miners, farmers, and ranchers. Tribal peoples were seen as a hindrance by those who coveted their land and resources, and they were made to give up millions of acres of land to these fortune seekers. Territorial government officials led frantic treaty negotiations that removed Indians onto reserves of land, opening their motherland immediately to white settlement.

A once free-moving Native lifestyle, which had remained unchanged for centuries, instantly became drastically limited to the boundaries of the reservations set aside as new Native homelands. Laws mandated government schools for Native children, where they were taught to dress, talk, and pray like members of the dominant white society. Indian children were prohibited from speaking their Native languages and practicing ancient spiritual ways. Plateau men and women could no longer provide for their families through traditional methods because of restricted reservation boundaries. The Native male no longer had the traditional methods to test his masculinity during his growth from adolescence to adulthood (fig. 2.11; plate 9). The jobs Native men were forced to learn were quickly outdated and totally alien to a culture where a man was used to balancing a life in rhythm with nature to support his family.

Since those treaty days, a constant watch has developed by Native leaders to keep treaty rights—the rights guaranteed to our Native ancestors—intact. This treaty watch oversees fishing, water, education, religious freedom, social health and welfare concerns, repatriation of sacred ceremonial objects and skeletal remains, and the constant threat of ter-

2.9 Time balls, Yakama, 1960s. A woman's personal item, a time ball was woven of hair and twine, with knots to remind her of important events over the years. It created a diary of her life and was buried with her at her death. Courtesy Bounds Foundation.

mination by a government ready to abolish its promises of trusteeship "until the rivers dry and the mountains crumble." Treaty and reservation concerns are recounted from historical times and are still very much a part of the contemporary business and lifestyle of the Plateau nations and their tribal leaders.

Stories about Native interaction with the environment and with new cultures, about adapting to new lifestyles, and about learning new technology speak of the evolution of the contemporary Plateau Indian. The belief of being one with nature is still inherently a part of Plateau cosmology, despite coercion to convert to Christianity.

Artistry

Traditional Plateau art exemplifies a Native togetherness, called pan-Indianism, in its borrowed design motifs and colors and in the songs and dances of the Native powwow gatherings. This traditional art also

2.10 Louise Grant, "Official Storyteller" of the Umatilla Tribe, 1970s. Bob Grant photography, Pendleton, Oregon. Courtesy Bounds Foundation.

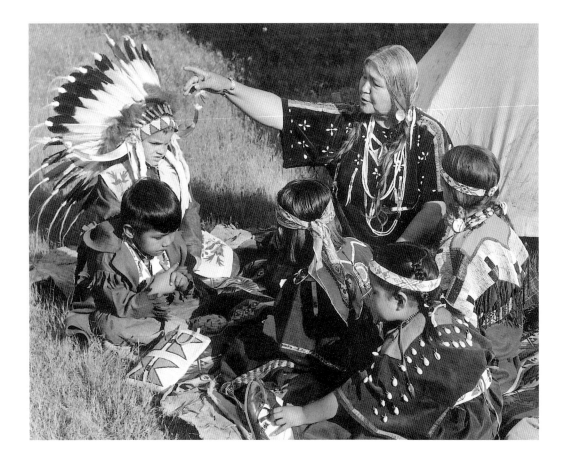

shows the Plateau adaptation to new materials that are used in the manufacture of traditional objects such as tail dresses and twined bags.

The story of artistry on the Plateau, however, is a general story of overall Plateau cultural information. People from the widely spread Plateau communities often reside hundreds of miles distant from their Plateau relations. Some speak language dialects that differ from one another; some practice slightly different ceremonies; and modes of ceremonial dress and decoration differ somewhat by region. But essentially these tribal groups share a similar worldview of creation and a similar interaction with nature in the varied environments of a mountainous high-desert homeland that bind them as one culture. Our similarities are reflected in the art of our material culture, and they tie the people of the Columbia Plateau together. Our worldview binds us as a culture and influences our art and the processes of its manufacture. Our worldview attests to our oneness as Plateau people.

Our culture is relatively unknown to non-Indian people, so we must first talk about who we are before we can build a path to other stories. It is important to underscore the adaptation and continuity of our ancient Plateau lifeways through presentation of our unique art. We want to be recognized not as the hide-dressed foragers of the past but as a people who are alive and continuing to meet the challenges of survival. We still sing our ancient songs of prayerful respect and gratitude, and we continue to gather to enjoy and share the fruits of the earth's bounty.

In these modern times, all Native nations cooperate with one another, extending help among ourselves to plan good stewardship and preservation methods so that our ancient resources and ancestral ceremonial practices will extend in good health into future centuries.

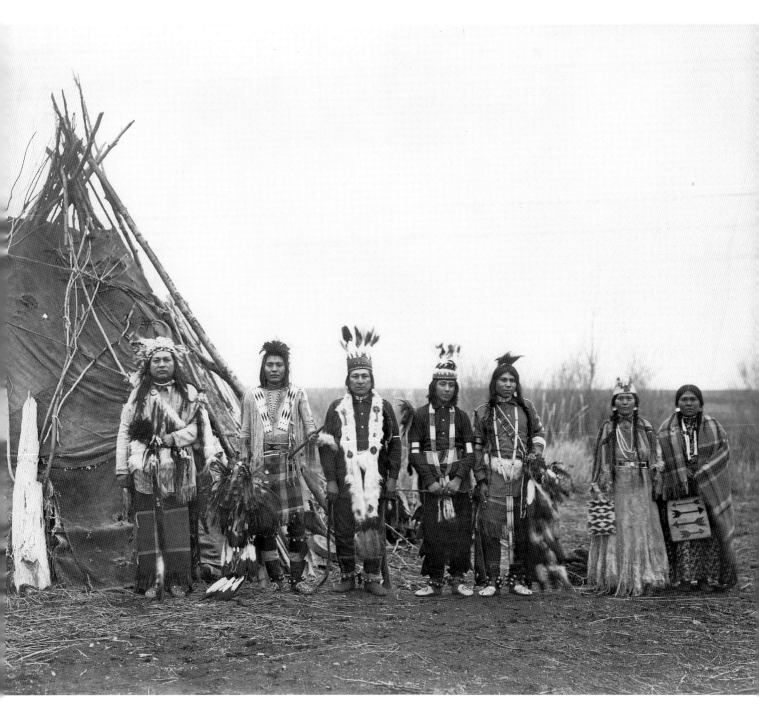

2.11 Plateau Indians, early twentieth century. This photo shows an unnamed Plateau man (second from left) wearing the shirt shown in plate 9. Major Lee Moorhouse photo, no. 4812. Courtesy Howdyshell Collection, Pendleton, Oregon.

The Plateau Culture Area and Its Arts

Toward an Understanding of Plateau Aesthetics

RICHARD G. CONN

In 1922, the pioneer American anthropologist Clark Wissler conceived the idea of "culture areas."[1] These he defined as regions whose indigenous peoples had more similarities in lifestyle with one another than with peoples in adjacent regions. In defining each area, Wissler drew elements from economy, religion, social and political institutions, and material culture. At times, he also made the lack or minimal development of some element one of his criteria. There were, to be sure, discrepancies and exceptions in this general definition. But the concept took root in general anthropological thinking and was subsequently applied to other areas of the world.

The notion of culture areas was, as Wissler himself realized, an artificial one. He meant it as an organizing device to render more comprehensible the incredible mass of factual information that was beginning to be gathered and published about Native American peoples. Even early in the twentieth century, enough data had been assembled to make it nearly impossible for any one individual scholar to digest and remember everything. The culture area concept facilitated organizing and retaining this ever-expanding base of information.

One shortcoming of the culture area notion is that it tends to emphasize generalities and blur specifics. Scholars working intensively within an area often complain that the general outline presented does not allow for the variations or individual cultural developments of particular groups.

The Land and Its People

The Plateau area, as defined by Wissler, is the region lying between the Rocky Mountains and the Cascades, comprising roughly the interior drainage of the Columbia and Fraser River systems. He mentioned its varied seasonal economy of fishing, hunting, and gathering, cited some

of its more prominent elements of material culture, and noted its comparative lack of political organization. Subsequent scholars, especially Verne Ray, would make this definition more exact.[2]

The Plateau region is, as Wissler said, an intermontane province that also includes most of the Columbia and Fraser River systems east of the Cascades. It is, however, environmentally more varied than he seemed to have realized. Along the northern, eastern, and western margins there are mountain ranges, while the central portion includes lower ranges of hills and open prairies. There are impressive mixed forests, especially in the north, as well as parklands and almost barren grasslands. The term "Plateau" seems to refer best to the tablelands seen along the central Columbia River basin in eastern Washington State.

This region is, or once was, rich in natural resources that provided a comfortable sustenance for anyone living there. In the 1830s, the Hudson's Bay Company's governor, Sir George Simpson, complained that his employees had failed to recognize the richness of their immediate surroundings and were relying too much on imported goods.[3] Although it is today thought that bison formerly existed only in the southeastern portion of the Plateau, and then perhaps for a limited time, the forests were full of every other sort of game.[4] The land offered plenty of edible wild plants such as berries and the root vegetables that the Native people prized. But it was the rivers that were the region's breadbasket. There were trout and other year-round species in plenty, plus the fine salmon that, unhampered by dams, made their way to the foothills of the Rockies each summer.

Besides these foods, there was also wood for houses, household utensils, and canoes. Native plants provided fibers for basketry and house-covering mats. Animal skins and furs could be tanned for clothing and later for horse equipment. Like the adjacent Northwest Coast region, this was an area where humans could live comfortably and easily without farming.

The Native people of the Plateau region are usually identified as being members of specific tribal groups. But in dealing with their traditional arts, this classification seems to present some difficulties that I shall explain later. Instead, let me identify the Native people as belonging to several extended Native language families. The significance of these linguistic groups is that each presupposes an ancient common origin. That is, since the individual languages and dialects of each family have identifying elements in common, it is assumed that all of them derived from an ancient "mother tongue" probably now extinct. Another example would be Latin, the source of western Europe's so-called Romance languages, including Spanish and French.

To begin, the Chinookan language group is found along the lower Columbia River. While there are several Chinookan-speaking groups

west of the Cascades, the Wishx̣am and Wasco, living near The Dalles segment of the river, are the only Plateau representatives of this family. As we shall see, these people had developed a distinct art style that appears to be the most conservative in the region. To the east of The Dalles is the large Sahaptin language group, including people such as the Klikitat, Yakama, Umatilla, Cayuse, Nez Perce, and others. Sahaptin languages seem to be unique to the Plateau region. Because of their colorful decorative arts and their bold military history in the last century, the Sahaptins are sometimes considered to be the archetypal Plateau people. North of the Sahaptins are the various Interior Salish groups, including the Okanogan, Spokane, Coeur d'Alene, and others. Like the Chinookans, the Salish family also extends west onto the coast, but it also goes farther north into British Columbia. Although probably not as numerous as the Sahaptins, the Interior Salish occupy almost half of the Plateau land mass.

Finally, on the periphery there are three groups whose language affiliations ally them to adjacent culture areas but whose lifestyle connects them to the Plateau. In the southeast corner, in what is today southern Idaho, are some Shoshonean-speaking groups related to others living in the Great Basin area to the south. In the northeast are the Kutenai of northern Idaho and neighboring British Columbia. These people speak a language that is not closely related to any other native North American tongue. And at the northernmost end of the Plateau are the Chilcotin, who speak an Athapascan language similar to those of the adjacent western Subarctic.

The Way of Life

The basic Plateau way of life was a seasonal round of food-gathering and other activities. In spring, salmon began to appear in the rivers and people moved to their family fishing stations. In addition to the fish that were eaten fresh, many were cleaned and dried for year-round consumption, a reliable mainstay if other sources of food should fail. Also in spring, the wild camas and bitterroot appeared and were gathered. The first of these were served at a ritual feast celebrating the return of good weather and the renewal of life. In midsummer, berries were ripe and some people moved into the uplands to pick them while others continued to fish. Fall was the prime time for hunting, and people took game for meat, hides, and furs. As with fish, some of the meat was eaten fresh and some was dried for later use. Around the time of the winter solstice, the major religious activities took place. At these so-called Winter Dances, people performed the dances and sacred songs their spirit guardians had given them as acts of reaffirmation and devotion.

This basic pattern changed somewhat when horses were intro-

duced in the eighteenth century. Cross-country travel became much easier, but people did not abandon their canoes, and they continued to use the rivers as highways. With horses, those people living in the eastern regions of the Plateau began to make visits to the Great Plains for trade and occasional bison hunting. In their contacts with Plains tribes, these eastern Plateau groups acquired a veneer of Plains material culture, such as tipis, but their basic cultural pattern was changed very little, if at all.

The Place of Art in Plateau Society

Native American art in general differs most from European art in its functions. Certainly, Western tradition includes works created to further the practice of religion and to enhance the glory of its social and political establishments. But it also includes, at least in recent times, works created simply for their aesthetic importance or as vehicles for the artist to express his or her views and values. Traditionally, Native arts in North America did not include examples of this latter sort. Rather, art objects were made to support some goal of Native society. Thus, the purpose of creation was to benefit a wider group, beyond the artist alone, and any expression of the artist's own thoughts was secondary. Further, in European art there is a dichotomy between "fine" and "applied" art. The former includes mostly objects made as aesthetic statements in themselves and with no further purpose. One of Rembrandt's great paintings might serve as an example. "Applied" art includes objects that may be just as beautiful and important but that also serve an added practical purpose. Here we might cite Cellini's celebrated saltcellar, which, in addition to being a masterpiece of sculpture, actually has compartments to hold salt and pepper for a royal table. Outside European art, this distinction between the purely beautiful and the beautiful-but-practical is seldom made. In Native North American art, especially, even pieces considered to be paramount artistic achievements usually serve an obvious utilitarian role as well.

One of the roles of traditional Plateau art is to serve the practice of Native religion. Perhaps the most important examples are not concrete material objects but the sacred songs and dances given in vision to individuals by their spirit guardians. These are personal property and are employed carefully in accordance with exact instructions handed down along with them. Also associated with religion are personal sacred objects made according to vision-derived instructions. These may take several forms, including assemblages of "found" objects and "medicine" bags made of animal skins and filled with personal protective charms. It is difficult to say much about these kinds of sacred art objects because few of them are available for examination. Many Native people have felt

it inappropriate to have their sacred songs recorded or their dances filmed, and the medicine bags were often buried with their owners. Another kind of sacred art that is visible will be seen among the pictographs found throughout the Plateau region. A famous example is the depiction of Tsagiglalal ("She Who Watches"), the venerable supernatural guardian of her people, near The Dalles (fig. 3.1).

A second role for traditional art has to do with proclaiming the importance of the family. Extended families are of basic importance in Plateau life, and one's place in the world derives as much from descent as from one's own deeds. There are times in life when the family comes to the forefront, such as during weddings and funerals. At these times especially, gift-giving assumes major proportions. Everyone takes part by contributing the best pieces of formal clothing, horse equipment, household objects, and almost anything else he or she possesses. Many handsome pieces of basketry, beadwork, carving, and leatherwork, some of them heirlooms, are given away. These objects, however, are not lost, in the sense that their beauty "works to the good of the family" in the prestige and respect that accrues to the givers.

Art also benefits families and individuals in a second way. On all public occasions, it is important that everyone be well dressed and make a good appearance (plates 29–32). A Spokane woman reminisced about one well-remembered time: "I was about five when I first rode in a parade.

3.1 Tsagiglalal ("She Who Watches") petroglyph along the Columbia River. Courtesy Oregon Historical Society, OrHi 95503.

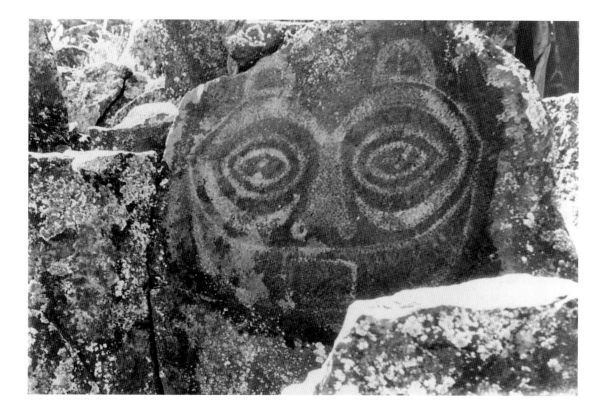

My mother and the other women got me all dressed up and they fixed the horse up nice, too. When I rode along, I felt so proud because I could hear people asking who I was and saying that my family sure must think a lot of me. I've ridden in many parades since then, but that was the time I'll always remember best."[5] This example could be multiplied many times. As one visits a powwow and watches the dancers, one ought to think of those unseen hands who made the beautiful garments so that their family members could appear in them proudly.

A final role of art in the Plateau is the simple pleasure people take in making something beautifully and well. A case in point here would be the "contour beading" to be described later. This is a variation of the basic beadwork process that requires skill and careful planning and that is much esteemed by those who can do it and those who cannot. In itself, contour beading changes the final appearance of a beaded object only slightly, but the extra work and skill are greatly admired and become a source of considerable satisfaction to the maker.

The Arts: Pictographs

At virtually any place in western North America where there are exposed basalt formations, one is apt to find pictographs. We are tempted to guess that ancient Native artists liked these surfaces because the stone was easy to cut into and because the lighter, inner layer contrasted well with the weather-darkened exterior. In the Plateau, as well as in California, the Great Basin, and farther north, there seem to have been two basic forms of pictography: references to hunting and references to religious activity. The hunting scenes show groups of animals, often deer and bighorn sheep, alone or in association with human figures. Sometimes these humans are armed with bows; sometimes not. Various explanations for these hunting scenes have been suggested, ranging from their being magical drawings meant to ensure success in a forthcoming hunting season to their being straightforward records of past successes.

The second form of pictographs includes more abstract figures, some humanlike and some basic geometric elements such as parallel lines and circles, which are assumed to have religious connotations. Interpretation of these mystical compositions seems almost impossible, for there has been very little activity in pictography in historic times. Native people respect and admire them but are quick to assure us that they do not know exactly what purpose the drawings originally served for their ancient ancestors. Yet there have been those who were ready to provide some remarkable explanations. One author insisted they were ruins left by a band of wandering Vikings who had somehow found themselves on the Columbia![6]

The fact of the matter is that those who could have told us are long

gone, and therefore we will probably never know. What we can do is admire these striking, fresh images which tell us that artistic effort in the Plateau area has been going on for some time.

The Dalles Style

The Dalles of the Columbia River, about two hundred miles upriver from the ocean, are a navigational obstruction caused by an ancient lava flow that created rapids and waterfalls running between huge stone blocks and cliffs. This made them a transition point where those traveling between the interior and the lower Columbia had to make a laborious portage. Thus, the area became an obvious place to set up a trading center, and this is what the Wishxam and Wasco people did. There they regulated trade and grew wealthy. When Lewis and Clark visited them in 1805, the explorers were surprised to find a permanent village of about one thousand people and much activity in trading.[7]

As part of their culture, these people of The Dalles had developed a unique style of art that they used in carving and for their basketry. Its most distinctive figures are skeletal humans with exposed ribs, V-shaped shoulders, and hexagonal heads (plate 8, and see fig. 4.15). These last may also appear alone or as repeated all-over patterns. There are also small animals reminiscent of pictographs and bird forms with the same rising shoulders as the emaciated humans. These figures appear on wooden bowls, cups, and grinding mortars as well as on horn bowls, cups, and personal ornaments. The artist Paul Kane sketched one he saw carved into an interior house post in the 1840s.[8] They are also seen often in the cylindrical and flat twined basketry bags produced here.

The horn bowls of The Dalles area are especially unusual. Carved from mountain sheep horns, they are hemispherical with a central raised band running from rim to rim over the curved bottom and ending in a pair of rectangular handles. The figures just mentioned, especially the human head forms, are often seen carved into these bowls.

The Dalles art gives an impression of conservatism and antiquity in style. Its typical figures look like something from a much earlier time and suggest that the style existed long before Euro-Americans encountered it. Unfortunately, there is little precise information about The Dalles art because work in this style stopped in the middle of the nineteenth century, when there were devastating epidemics of smallpox and other diseases.[9] Although some people survived and the Wishxam and Wasco still exist, the old culture and the art it produced did not. Today, a few people still make the twined bags, principally for sale, and sometimes use the designs of their ancestors.

Other Local Styles: Real or Presumed?

For some time, collectors and scholars have been trying to identify substyles within Plateau art, especially in the area of beadwork. Most of these people began their inquiries having already made some study of similar materials from the Great Plains. In that area, striking tribal styles of beadwork, painting, and so forth do exist and serve a role in those cultures by providing identity and establishing group aesthetic norms. These students have been able to identify the hallmarks of Plains decorative art with fair accuracy. But so far their efforts to assign Plateau objects to individual tribes have made little headway, and the basic question is still: are there actually such local or regional substyles in this area?

It begins to appear that there are not, at least at the tribal level. First, it must be remembered that what we today designate a tribe may in reality not be a tribe at all. The Nez Perce and Yakama, for example, are actually several independent groups of people united only by a common language. If you asked one of these people his or her tribal affiliation, you might get the reply that he or she is indeed a Yakama (as opposed to an Okanogan). But if the respondent wanted to be more precise, the answer might be, "I am actually a Penanwapam."[10] Given this situation, it is unlikely that people making basketry or beadwork would follow stylistic criteria from outside their immediate group. Another problem with identifying local styles is the very considerable amount of exchange by trade and by gift among Plateau people. At funerals and weddings, in particular, guests from far and near are given objects made locally, made elsewhere, and even made outside the Plateau. I remember seeing a Yakama woman wearing a handsome painted leather dress from Oklahoma that she had received at a wedding.

If tribal style is hard to verify, there do appear to be broad regional substyles within basketry and beadwork. These further seem to relate somehow to language groups. That is, we can often say that this or that is made more frequently by Sahaptins than by Salishans, or, if both peoples do it, that there are general differences to be noted. The following paragraphs will give some examples of these overall differences.

Basketry

Plateau weavers produce both coiled and twined basketry (plates 8, 14). Each type has a specific area of manufacture with regional variations in shape, materials, and decorative elements. Only the easternmost Salishan groups, such as the Coeur d'Alene, Spokane, and Salish tribe proper, make no basketry, having apparently abandoned it in the mid-nineteenth century.[11]

Twined basketry includes cylindrical, round-bottomed bags, the familiar flat, rectangular bags, and fezlike women's hats. The Wishx̱am and Wasco make both round and flat bags, working entirely in native materials such as dogbane (*Apocynum cannabinum,* also known as Indian hemp) and native grasses, cornhusks, and, very rarely, beargrass (*Xerophyllum tenax*). For decoration, they draw from the traditional figures of The Dalles style, especially the hexagonal heads, animals, and simple human stick figures. They also use the widespread "foot" figure known up and down the Pacific coast. Wishx̱am-Wasco twined basketry is usually done only in natural dark brown and buff fibers. Aniline dyes are seldom used.

The Sahaptins make all three of the twined forms; indeed, they alone make the hats. They use a combination of Native and introduced materials: Indian hemp and cotton string for the actual body of the bag, with cornhusks, wool yarn, mercerized cotton embroidery thread, and (at one time) beargrass for the decorative false embroidery. The oldest examples of Sahaptin flat twined bags are sometimes called "root sacks," for they were used to store camas, bitterroot, and other dried foods. These were usually twined fully of Indian hemp with decorative figures embroidered only in natural fibers. The backgrounds were not filled in.

Later examples, whether made as storage receptacles or as women's handbags, are almost fully covered in embroidery. There is usually a band of plain twining in Indian hemp at top and bottom, and the balance, covered by the false embroidery, is cotton string. These bags are very individual in design and have attracted much attention among collectors and museums. Although many of these twined bags have been collected among Salishan people, there seems to be no firm evidence that they ever made them.

Coiled baskets were made by the Sahaptins and by the Salishans with the eastern exceptions noted earlier. The Sahaptins made theirs using a splint bundle foundation and imbricated decoration. This distinctive technique is found only in the Plateau and adjacent western Washington State and is probably a Plateau invention. The best-known Sahaptin coiled baskets are shaped like pails with rounded bases. These are often called the Klikitat style, although other Sahaptin basketmakers also used the shape (fig. 3.2).

Those Salishans living north of the Sahaptins in central Washington State, who did make coiled basketry, produced works that are less consistent in shape. Elderly Native people of this area sometimes refer to "Okanogan" baskets, which they define as having oval bases and sides that curve outward at the bottom for the lowest two or three inches and then rise straight and flat. A few such baskets may be seen in museum collections—usually with no provenance.

The most striking Salishan coiled basketry comes from interior British Columbia. There, people prefer to make their baskets with rectangu-

3.2 Coiled cedar-root basket, possibly Klikitat, ca. 1890–1910. The imbrication extends onto the bottom edge. This basket has thongs for a tumpline and a flat side for carrying on horseback. Height: 14 in. Width: 12 in. Date collected: 1971. (3.3.15)

lar bases and flat, flaring sides. These northerners are familiar with bundle foundations but more often use slat foundations. Like the Sahaptins, they use imbrication freely, often fully covering the basket with it.

Finally, the Chilcotin in the northernmost Plateau make coiled basketry similar to that of the Interior Salish but frequently with an external reinforcing rod—a feature perhaps derived from the bark containers they also make. Like twined flat bags, Plateau coiled imbricated baskets are prized by collectors and much admired by many, especially the examples in so-called Klikitat style and from the Thompson River area of British Columbia. In chapter 4, Mary Dodds Schlick discusses basketry in more detail.

Leather and Beadwork

Plateau people have long been noted for their excellent skin tanning (figs. 3.3, 3.4). They use the same brain-tanning process universal in Native North America, but with outstanding results. A non-Native owner of a commercial tannery in Kalispell, Montana, once explained that this was because of the specific chemistry of the water in the region and went on to say that in brain-tanning, water is the most important ingredient.

3.3 Elk femur hide scraper, date unknown. Generally made from the femur of an elk or deer, and tempered and bent when heated, some later hide scrapers have metal blades bound to the scraping end to make the process of removing the hair easier. This scraper belonged to Susie Williams's grandmother (Kuk-Ish-Ton-Mi), a member of the Palouse tribe. According to Bounds's notes, it was over one hundred years old when collected. Length: 13.5 in. Width: 4.5 in. Date collected: 1963. (10.2.1)

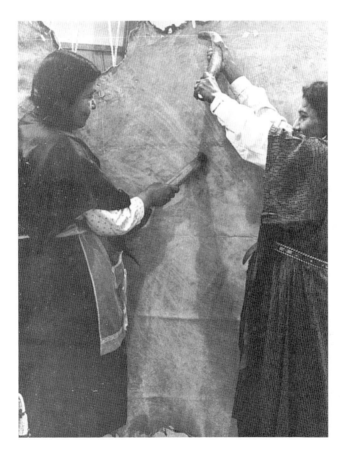

3.4 Liza Bill and Carrie Sampson (Umatilla) demonstrate hide preparation in the 1960s. Courtesy Bounds Foundation.

Much of this outstanding native leather went into clothing, and there are two garment forms that deserve special mention. First, there is the long, one-piece "tail dress" (fig. 3.5; plate 10). It is made of two large skins, preferably deer or mountain sheep, retaining their original shapes. They are sewn together horizontally from about six inches on either side of the tail out to about six inches from the ends of the hind legs. These seams make the shoulders, and the opening left at the center becomes the neck of the dress (figs. 3.6–3.8).

Next, the skins are sewn vertically from below the wearer's arms down to the bottom. These are the side seams. Then, the portions of leather above the shoulder seam are folded down over the wearer's chest and back and sewn flat to the dress. This puts the tails at center front and back, just below the neck. The tails and the undulating edge of the folded-down leather now become the basis for any subsequent decoration, with lines of beadwork following the curve of the animal's hind legs and rising up over the tail at the center.[12]

Dresses of this general kind were made along the west side of the Rockies, from the Plateau south to the Jicarilla Apache country and Taos Pueblo in northern New Mexico. From the evidence of dated examples and accounts of early travelers, the style had been established early in the nineteenth century. By the 1830s, this pattern was also being used by Blackfeet and Crow women across the Rockies.

The other special garment is the "pierced shirt." It is cut like the basic men's shirts of the region but is then perforated with many small circular or diamond-shaped holes over all or most of its surface. These openings are often arranged in simple patterns such as vertical rows and diagonal lines. Besides the piercings, these shirts frequently have other decorations, such as beaded shoulder and wrist panels, areas of painting, and attachments such as feathers or locks of hair. Paul Kane twice painted men (one Nez Perce and one Spokane) wearing such shirts.[13]

The few pierced Plateau shirts that still exist appear to have been made before the move onto reservations, and their special significance has not been recorded.[14] The Blackfeet also adopted this style of shirt but made it part of military society regalia. Since the Plateau people had no such organizations, their pierced shirts must have served some other purpose.

The Plateau people also made containers of painted rawhide. They used forms such as the folded envelope and cylinder, similar to well-known examples from the Great Plains (plates 5, 17). A detailed study of these objects has recently been made by Gaylord Torrance, whose findings in respect to the Plateau are summarized in his statement: "A number of stylistically distinct types were created by these peoples during various periods, but it is impossible to trace these production patterns

3.5 Tail dress, detail. A Plateau child's dress from the 1930s. In newer Plateau dresses, the original tail may be replaced by a representative tail design element in the beaded yoke of the dress. (6.8.2001)

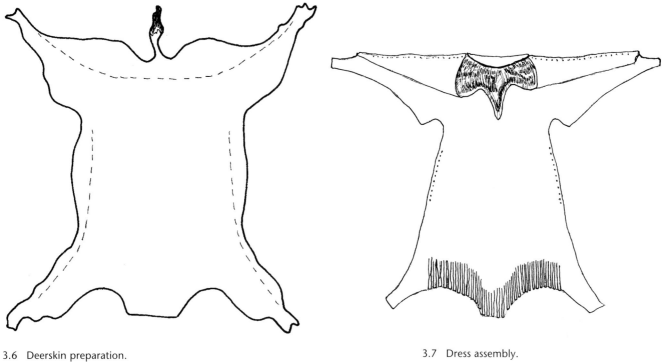

3.6 Deerskin preparation.
Courtesy Richard Conn.

3.7 Dress assembly.
Courtesy Richard Conn.

3.8 Shirt assembly.
Courtesy Richard Conn.

today because there exists no substantial basis for assigning individual tribal designations."[15]

Torrance goes on to note the roles of trade, gift exchanges, and intermarriage in compounding the situation. He is able, however, to distinguish four Plateau substyles of painted rawhide. He allies the Kutenai with the Blackfeet, although he points to some basic differences such as greater complexity of design among the former. He includes the Shoshone with the Crow in the Transmontane style but places the Nez Perce with the Flathead, Coeur d'Alene, and Cayuse in an eastern Plateau style group. Some would feel the Nez Perce should have been in the Transmontane group, and indeed some of the pieces Torrance illustrates seem to support this.

Last, there is a western Plateau substyle including the Yakama, Wasco, and Wishẋam. Within these four substyles, Torrance does not attempt to relate specific elements to individual tribal groups.

The Plateau peoples produced very little embroidery on leather with native materials such as porcupine quills or deer hair but they did create a great deal of beadwork on leather and fabric. Glass beads are, of course, an introduced medium. At first they came from Native trade networks, then from the Lewis and Clark expedition, and next from the overland fur traders—the Northwest Company and the Hudson's Bay Company—who began arriving in 1810. Their beads came from Murano, Italy, near Venice. Twenty or so years later, the Hudson's Bay Company was carrying furs to China and bringing back beads made there. The two kinds are similar in size and available colors.

Plateau beadworkers drew upon two design styles. One, considered to be earlier, was geometric and rectolinear. The other, considered intrusive, was exuberant and floral. There are two popular theories about the introduction of floral beadwork into the Plateau. The first says that Iroquois, Ojibwa, and other northeastern Indian men working as fur company boatmen showed Plateau women tobacco bags, moccasins, and other things made by their own people. These were presumably beaded in floral patterns of the styles then in vogue in the East. If so, how does one explain the relative scarcity of floral beadwork in the Plateau until the third quarter of the nineteenth century? Both documented early pieces in collections and drawings and other records made before the late 1860s contain very few examples of floral beading.

The second theory attributes everything to neighboring Plains Indians. But if that were the case, why didn't they teach the Plateau people quillwork as well? And since the Plateau people got their beads and other trade goods at about the same time the Crow and others got theirs, and Plains beadwork before 1830 tends to be very simple, what was it they had to teach?

Early Plateau beadwork, such as some of the pieces in the Spalding

Collection dating from the 1840s,[16] is really more elaborate and finer than comparable northern Plains pieces from the same decade. What we actually see is that the preponderance of Plateau beadwork made before roughly 1870 is geometric and rectilinear. Both seed beads and the larger "pony" beads were in use, and a basic range of colors was available. At some point just before mid-century, a particular kind of beadwork began to appear among the easternmost Sahaptins. This is the Transmontane style, which they shared and may have developed jointly with the Crow. It is discussed at length by Barbara Loeb and Maynard White Owl Lavadour in chapter 5.

It has also been suggested that the eastern Salishans and the Kutenai were influenced by Blackfeet beadwork design. An examination of beaded objects supports this idea to a limited degree. There is a superficial resemblance to the Blackfeet geometric style, especially among the Kutenai, but color combinations and compositions are often different.

In terms of volume, most beadwork made in the Plateau was and is floral. The first examples, seen first in the late nineteenth century, share the general hallmarks of most northern and eastern floral styles: symmetry, arbitrary (that is, nonrealistic) use of color, and stylized leaf and blossom forms. Had this happened by 1820, it would have borne out the eastern Indian boatmen theory. This early floral beadwork is usually done on a background of contrasting wool cloth.

But early in the twentieth century, some basic changes appeared. Compositions became more often asymmetrical, colors became somewhat more realistic, and on large items like horse equipment and women's handbags, the backgrounds were now filled with beading. Also, at this time women began to place human and animal figures among the blossoms. Having learned that they could reproduce almost any image in beadwork, Plateau women turned out cowboys, movie stars, George Washington, and, during both world wars, eagles and American flags.

On a more aesthetic note, Plateau women also devised contour beading, perhaps around the turn of the century. Contour beading is a method of completing the background that gives it a more integrated relationship to the flowers or other central figures. First, the worker beads in all her figures. At this point, an average beadworker would fill in the background with straight horizontal lines of beads. But in the contour method, she follows the outlines of her figures with concentric lines of beads, one after another, moving outward until the whole space is filled. The finished effect resembles ripples and gives the piece an impression of dynamism and movement. It is not as easy as it sounds. The trick is to have the background lines coming from opposite directions meet in the exact center of the intervening space (plates 18, 36). It takes a skilled, experienced beadworker to achieve this, and her fellow artists are quick to note and assay the results.

In the 1930s and 1940s, there was another development in Plateau beadwork that has drawn some criticism and question from non-Indian collectors. This was the use of transfer patterns, in particular those made up for use in tooling leather. I have seen some of these in the possession of Interior Salish beadworkers and have been told that some Sahaptin women used them as well. The patterns I saw still bore their transfer ink, the designs having been copied via carbon paper. The women who owned the transfers were proud of their collections and said they had patterns suitable for "anything you want to make."[17] They also had photos of

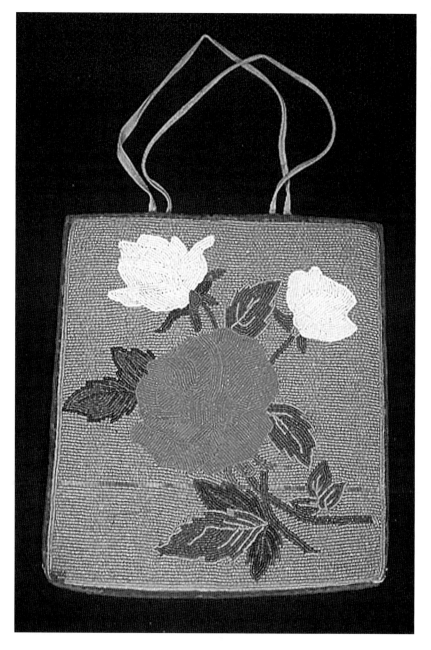

3.9 Woman's handbag with beadwork derived from a transfer pattern design, Umatilla, ca. 1890–1945. This bag was made by Susie Williams. Height: 11.25 in. Width: 10 in. Date collected: 1958. (2.6.251)

beadwork they had made using the patterns. In comparison, it was obvious that the patterns had not been copied exactly but had, rather, been used as basic frameworks with substantial innovation by the beadworker. The colors were her own choice as well, since leather tooling patterns were meant to be monochrome and included no suggestions for adding color.

When it first became known that Plateau women were using transfer patterns, dismayed dealers and collectors felt that whatever they produced by this means could not be considered indigenous. The beadworkers themselves rejected this view, saying it was no different from knitting a sweater from an instruction book and pointing out that they rarely copied a transfer exactly. It is often easy to recognize beadwork made from a pattern by elements in the composition. For example, truly original Native flowers are usually two-dimensional, with no suggestion of shading. Transfer pattern flowers, on the other hand, suggest solidity by being drawn with one petal or leaf superimposed over another (fig. 3.9). And if human or animal figures are included, they are generally drawn with some foreshortening and in a decidedly non-Indian style.

Transfer pattern beadwork frequently comes to the fore (or did in the 1940s and 1950s) in sets of matched regalia made for parades. Since many of the patterns were intended to decorate horse gear, they were adapted easily to decorating these objects with beadwork instead of tooled leather. Perhaps this is where the idea arose. But the Plateau people carried the idea further than Native Americans in other areas. A woman might, for example, wear a dress, high-top moccasins, headband, gauntlets, and other ornaments, carry a handbag, and sit upon a horse that was almost invisible under a full panoply of saddle blankets, breast collars, and saddlebags—all beaded in the same pattern and colors! The effect of these matched ensembles is incredibly striking (as it is meant to be), and beadworkers who produce them are accorded considerable respect for their industry and skill.

Conclusion

The Columbia Plateau, although too often overlooked in favor of the adjacent Great Plains and Northwest Coast areas, is a region possessing its own culture and its own artistic accomplishments. Although some of these, such as the imbricated basketry and The Dalles horn bowls, have been duly appreciated, others have been overlooked or, like much beadwork, judged by inappropriate standards. Further, many of the Plateau's finest products, such as contour beading, go almost unknown and unnoticed outside the region. When one looks at Plateau art in its own right and according to its own values, its true originality and creativity will be seen.

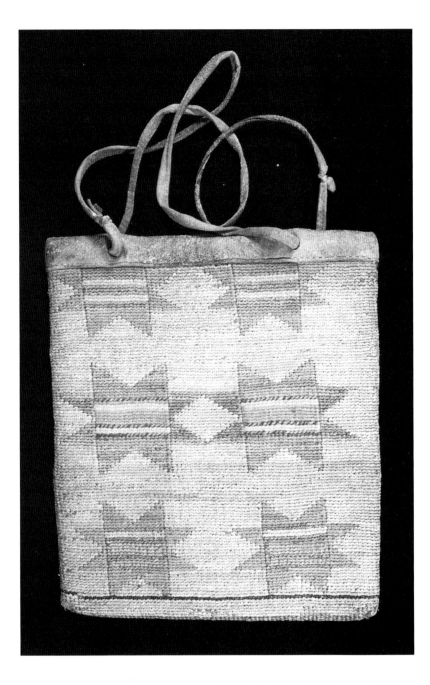

4.1 Cornhusk bag, Nez Perce, ca. 1870. This twined handbag was a gift from Doris Bounds's Nez Perce nurse before 1906. Bounds prized this bag and referred to it as her "diaper bag." The eight-pointed star is a common motif on Plateau twined bags. Height: 9.5 in. Width: 9.5 in. Date collected: 1904. (5.1.89)

Handsome Things

Basketry Arts of the Plateau

MARY DODDS SCHLICK

I t is impossible to know whether Doris Swayze Bounds's love of what she described as "handsome things" was picked up from her life among the people of the Umatilla Reservation or was influenced long before by her Nez Perce nurse in what was then Indian Territory. But her fascination with the colorful twined bags known as cornhusk bags could have had its beginnings in either place, for these portable works of beauty and usefulness figured prominently in both periods of her life.

The woman who helped Anna Miller Swayze care for Doris as a baby was one of Chief Joseph's people who had been sent to Indian Territory after his band's defeat in 1877. Throughout her lifetime, Doris Bounds prized a small cornhusk handbag (fig. 4.1). She said it had been given to her mother by this woman to be used as a diaper bag. It seems appropriate that the gift was this fine example of the Plateau peoples' traditional arts, for it was among the Native peoples of the Plateau that Bounds would spend much of her life.

About nine and a half inches square, the bag is bound at the top in white deerhide, with deerhide handles. It is finely woven of knee-spun dogbane *(Apocynum cannabinum)*, often referred to as Indian hemp, and decorated on one side with colorful stars worked in dyed cornhusk on a natural field. On the other side are stripes in bright wool yarns.

This small handbag was not the only example of Plateau basketry in the Swayze household in those early days, for Doris Bounds's mother also purchased a "handwoven cornhusk bag of large proportions" at the Far Western Shopping Center in Muskogee. This large bag "served well the purpose of a diaper bag for baby Doris," according to a brochure written nearly sixty years later for the Peace Pipe Museum in Hermiston, Oregon.[1] Although there is no record of which of the large bags in the collection was that specific bag, many fit the description (plate 12). The two cornhusk bags acquired in her infancy became objects of great pride for Bounds. With them, she began a lifetime love affair with the arts of the American Indians.

From these fine nineteenth-century Nez Perce bags to horse trappings worn in recent years in Pendleton Round-Up parades, Doris Bounds gathered around her a broad range of articles utilizing basketry techniques. The Bounds Collection includes baskets from Northwest Coast artists as well as from California, the Great Basin, the Southwest, and the Great Lakes area. The largest number, however, reflect her close relationship with the people of the Columbia Plateau.

Columbia River Basketry

Before explorers and trappers brought kettles and burlap bags and other trade items to the Native people of the Columbia, baskets woven from the products of the earth filled many household needs. Baskets were used for gathering foods and medicinal plants, for carrying harvests home from the root-digging areas or the forest, for winter storage, for holding water and cooking, and also for bathing babies. Made for practical purposes, these baskets were beautiful as well, for they were extensions of nature, reflecting the harmony with the environment that is a primary ethical value in Plateau society.

The people of the Umatilla Reservation near whom Doris Bounds lived, and their neighbors and relatives along the Columbia River and its tributaries, make five distinctive types of basketry.[2] The first are the flat twined cornhusk bags, similar to the two bags that started the Bounds Collection. Over the years, Bounds was given, purchased, or traded for more than one hundred of these important bags and other twined articles.

The largest of these flat bags were used to store dried foods and other valuables and, except for ceremonial use, have been replaced since the 1930s by other containers. Smaller bags continue to be made for handbags (fig. 4.2) and belt purses and as miniatures to be worn on necklaces or pinned to dresses. The designs are different on each side and are worked into the bags as they are woven by means of a distinctive weaving technique known as false embroidery (fig. 4.3).

Related to the flat bags are round twined bags used for holding food roots during digging or for carrying or storing medicines and other items. Weavers created designs on these bags by the techniques of full-turn twining (fig. 4.4) or with false embroidery. Also made by twining are the brimless hats Lewis and Clark noted all along the Columbia when they passed through the region in 1805 and 1806. These stately hats feature three-part zigzag designs usually worked in served-twined overlay or, later, full-turn twining.

Two traditional basket styles are made from the western red cedar (*Thuja plicata*). One is the coiled cedar-root basket frequently used for berry picking or, in earlier times, for cooking or holding water. Known

4.2 "Woa-Hopum" (Umatilla) poses for Major Lee Moorhouse, early twentieth century, with an array of twined handbags including three featuring star designs. Courtesy Smithsonian Institution, no. 2890-b-27.

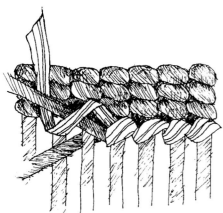

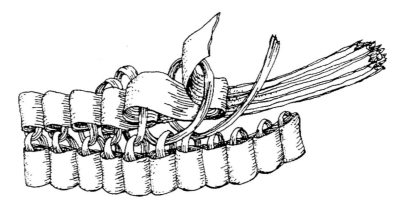

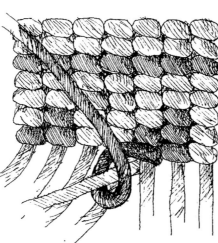

4.5 Imbrication, the folding process used to cover the coils on Columbia Plateau baskets. Reproduced with permission from Schlick, *Columbia River Basketry.*

4.3 (*above*) False embroidery technique. Reproduced with permission from Schlick, *Columbia River Basketry.*

4.4 (*right*) Full-turn twining, outside face. Reproduced with permission from Schlick, *Columbia River Basketry.*

today as Klikitat-style baskets, these containers are coiled from split roots and decorated with beargrass (*Xerophyllum tenax*) in a folding technique known as imbrication (fig. 4.5). This complex surface design method is used only by the Klikitat people and their relatives living on both slopes of the Cascade Mountains and by the Salish people to the north.

The fifth type of Columbia River basketry is an undecorated, folded cedar-bark basket that represents great ingenuity and craftsmanship. Usually made as an emergency container during huckleberry harvest when the family's coiled baskets are full, this basket is quickly and easily constructed from bark taken from western red cedar trees found near the huckleberry camps. The strong structure and decay-resistant material make it a perfect container for carrying fresh or dried berries home from the mountains.

Centuries-old scars on standing cedars in the Cascade Mountains attest to the long history of this type of basket. The scars also exemplify the respect the Native people have for all living things. When removing bark, the basketmaker does not circle a tree but rather takes only one or two vertical strips. This does not interrupt the flow of nutrients from the roots to the crown.

Although examples of all five of these types of basketry appear in the Bounds Collection, the "soft bags" made by the weaving technique of twining are best represented.

Twined Weaving of the Columbia Plateau

From her earliest years living near the Umatilla Reservation, Doris Bounds noticed the colorful flat twined bags, some as large as flour sacks, others made for handbags. She told of seeing women on horseback coming to her home on their way to the Umatilla River to get eels and salmon. "I never saw them without a bag or several bags on the saddle. Handsome things!"

She remembered watching the women unload the travois. "When I'd come home, they'd be sitting at our table with the coffee pot, visiting," she related.[3] At bedtime, they would roll up in blankets on the Swayzes' living room floor.

Flat "Cornhusk" Bags

The flat bags Bounds described were twined of dogbane or cotton string and originally were decorated in the tones of sun- and shade-dried grass. Sometimes green pond slime was used to obtain a soft green color. After corn became plentiful, the women used its soft inner husks to weave increasingly complex designs into the bags. The husks provided a strong weaving material that took dyes easily. Soaking the husks with bright cloth, crepe paper, or commercial dyes offered the weaver a rainbow of hues and, with the increased availability of bright Germantown yarns, resulted in the explosion of color seen in bags made in the last quarter of the nineteenth century.

An ancient technique, twining with false embroidery or, more descriptively, external weft wrap, is used today only by basketmakers on the Columbia Plateau and along the northern Pacific coast. Weavers among Eastern Woodlands groups formerly decorated twined bags and carrying straps in this way, but the technique died out before the early nineteenth century. Using this technique, Plateau weavers through the years have combined a great variety of colorful geometric motifs into an apparently unlimited number of arrangements that differ on either side.

Although the flat storage bags often are referred to as Nez Perce bags, they were made by all the Plateau groups, from the Nez Perce on the eastern edge of the region to those living today more centrally on the Warm Springs, Yakama, and Umatilla Reservations (fig. 4.6), as well as the northerly Colville, Spokane, and Coeur d'Alene people. Unless we know the makers, it is difficult to know for certain where the bags originated.

4.6 Mrs. Charlie Johnson (née Moses) (Umatilla) with twined bags, ca. 1900. Major Lee Moorhouse photo. Courtesy Smithsonian Institution, no. 2890-b-5.

4.7 "Wenix, sister of Donald McKay, and family," taken on the Umatilla Reservation, 1905. Note twined bags in front with bold designs. Major Lee Moorhouse photo. Courtesy Smithsonian Institution, no. 3073-b-79.

Bounds described her Cayuse neighbors as "the most colorful of all tribes."[4] Illustrating this comment are the lively color combinations on bags in the collection that her records indicate came from the Umatilla Reservation, home of many Cayuse people. One handbag is especially illustrative (plate 19). The colors within the unusual design are bright red and yellow with black accents on a background of turquoise-dyed cornhusk. It is rare to find a bag in which the background material also is dyed.

Not only this bag but also many others from the Umatilla Reservation feature innovative design arrangements (fig. 4.7).[5] The bags in the Bounds Collection offer the full range of design possibilities, from the Yakama bags that have been described as simple and dignified to the uniform symmetry of Nez Perce work and the "strange and bold" designs a Yakama elder attributes to the Rock Creek and Warm Springs people.[6]

Although the Bounds Collection records identify some of the makers, tribal provenance is unknown for many. Those purchased from Julian Smith, a trader in The Dalles, could have come from Warm Springs

or Yakama people. However, given the mobility of the bags and their makers through marriages and gatherings, trades and generosity, determining the origin, beyond the general region, is probably guesswork at best. For the Native people themselves, this was not guesswork. In earlier times they could look at the colors and designs in a bag and know who made it. But for the general observer, such specificity is impossible and unnecessary for an appreciation of the skill, artistry, and practicality of the weavers of the Plateau.

All but the naturalistic designs on twined bags consist of geometric motifs. Weavers arranged the triangle, diamond, line, rectangle, chevron, and rhomboid in rhythmic repetition on the early bags. As the new materials became available, basket makers continued to use the geometric forms in increasingly complex combinations to create the spectacular designs seen in much of the Bounds Collection (plate 20).

The organization of motifs into designs falls generally into five categories: overall, banded, central, five-part, and naturalistic.[7] Horizontal rows, vertical columns, and diagonal repetitions of a single motif are the most common expressions of the overall design (fig. 4.8). Combinations of motifs into vertical, horizontal, or diagonal bands would be described as banded designs (plate 21). In a central arrangement, the weaver coordinates several motifs around a central focus (plate 20). In a five-part design, a single design is repeated five times, with the largest in the center (fig. 4.9). All of these design schemes are represented in the Bounds Collection. Perhaps the most intriguing example of naturalistic design in the collection is a handbag with animal and human motifs attributed to the Wasco or Wishx̱am people (fig. 4.10). These designs are found more frequently on the round root-digging bags made by full-turn twining, to be discussed shortly. Such Wasco-style figures are only occasionally found on the flat cornhusk bags.

A change appears over time in the weaving materials of flat twined bags. Throughout the centuries, Native people of the Columbia Plateau have made a strong twine from the giant dogbane plant (*Apocynum cannabinum*) known as Indian hemp. The tall, single-stemmed plant grows in damp areas across North America. The people of the Plateau, like Native people in many other places, gathered dogbane in the fall, stripped off and softened the outer skinlike bark, and then spun the long fibers on their knees into string for fishnets, snares, and many other important uses. This was the foundation material for most of the soft twined bags. The gathering area, either dry land or along the river, determined the color of the spun dogbane, which ranged from a pale color to a red tone to a deep maroon.[8]

Spinning the dogbane is largely a lost art today, and most of the twined bags made after 1900 are of cotton string with dogbane found only in visible areas of the twining. Many Native families worked in the

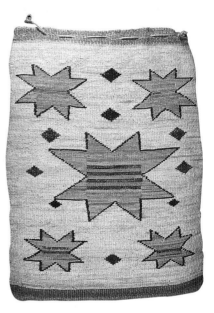

4.8 (*top*) Cornhusk bag attributed to the Nez Perce, ca. early twentieth century. This is a twined "foldover" belt purse with a naturalistic design. Height: 7.25 in. Width: 8 in. Date collected: 1970. (5.1.75)

4.9 Cornhusk bag, Plateau, ca. 1930. Five-part design on a twined storage bag Height: 19.75 in. Width: 15.5 in. Date collected: 1964. (5.1.68)

hop fields in the Willamette and Yakima Valleys, where growers from about 1910 to the mid-1940s trained the hop vines on cotton string. After harvest, this string could be gathered in great quantities and soon began to appear as the foundation material in twined weaving. By the mid-twentieth century, cotton string had replaced knee-spun hemp for all but a few weavers of flat and round bags (fig. 4.11).

The large bags for storing and transporting roots, along with smaller handbags that evolved as portable marks of identity for the people of the Plateau, are the most frequently seen examples of cornhusk work. The technique, however, also has been used to create strong and beautiful fabrics for men's vests and armbands, horse trappings, and containers for ceremonial items and other special uses.

The horse trappings in the Bounds Collection that are twined with cornhusk represent the lifestyles and important values of the people

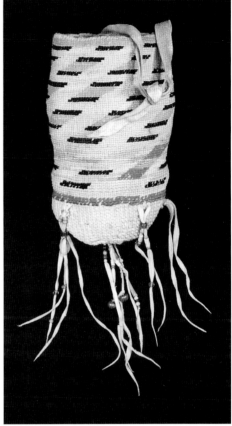

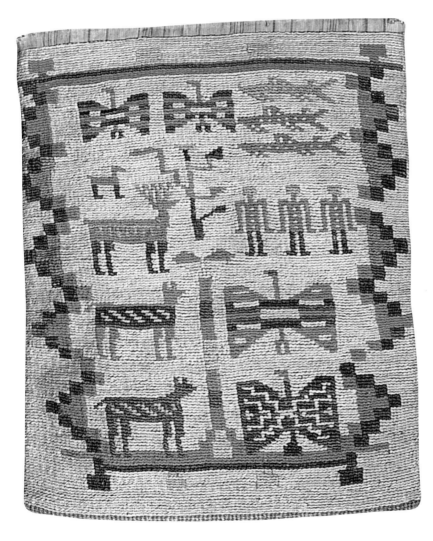

4.10 (*left*) Cornhusk bag, Plateau, ca. early twentieth century. Twined handbag with Wasco-Wishx̱am style naturalistic designs worked in false embroidery. From the collection of Native activist Jimmy James (Cherokee), who donated his collection to the Bounds Foundation upon his death. Height: 13 in. Width: 11 in. Date collected: 1971. (5.1.112)

4.11 (*above*) Round twined bag, Plateau, ca. early twentieth century. Made of cotton string and yarn, embellished with beads and fringes. Height: 9 in. Diameter: 4 in. Date collected: 1956. (5.1.34)

Bounds knew so well (figs. 4.12, 4.13; plates 22, 23). She described the Cayuse as "great horsemen . . . decked out far more than other groups."[9] The people of the Umatilla Reservation honor the horse as a "valued and beloved" creature.[10] It seems appropriate that the Bounds Collection, originating near the reservation, includes these rare examples of Plateau artistry, making them available for both appreciation and enjoyment.

Round Twined Bags

Round bags are made by the Sahaptin-speaking people of the southern Plateau using either plain twining to create simple striped patterns or false embroidery to create designs. Their neighbors, the Chinookan-speaking Wasco and Wishx̱am people, who lived near The Dalles segment of the Columbia and along the river below The Dalles, worked more intricate designs into their bags using full-turn twining. These Wasco-style bags are distinguished by stylized human and animal motifs and sophisticated geometric patterns. The people of the Umatilla Reservation also worked graceful geometric patterns into their round bags by a slightly different technique, a three-strand twining method described technically as "served-twined overlay" but referred to by the weavers themselves simply as "inside-out weave" or "the old way."[11]

　　Round bags were made in all sizes, from small containers used by children who were helping to dig the family's supply of wild food roots to very large bags that would hold a day's digging for a woman. Also

4.12　(*below*) Cornhusk horse chest band, Plateau, early twentieth century. Length: 53 in. Width: 4 in. Date collected: unknown. (8.3.13b)

(*page 65*) 4.13　Cornhusk horse chest collar, Plateau, early twentieth century. Length: 30 in. Width: 21.5 in. Date collected: unknown. (8.3.13a)

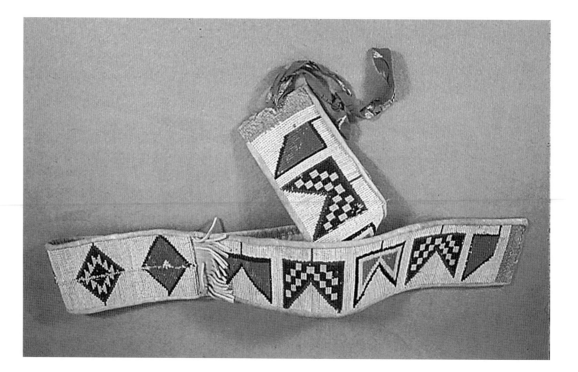

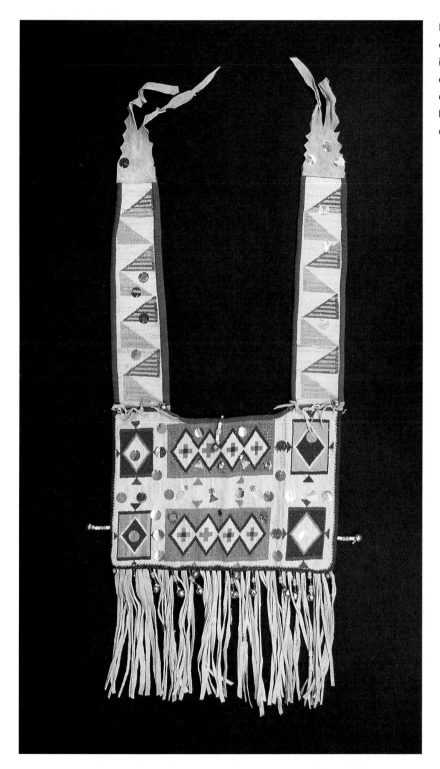

Plate 22 Cornhusk horse collar, Plateau, ca. 1890–1920s. Horse trappings worked in cornhusk and string using the technique of twining with false embroidery are objects of great pride among Plateau peoples. Height: 32 in. Width: 18.5 in. Date collected: unknown. (8.2.12)

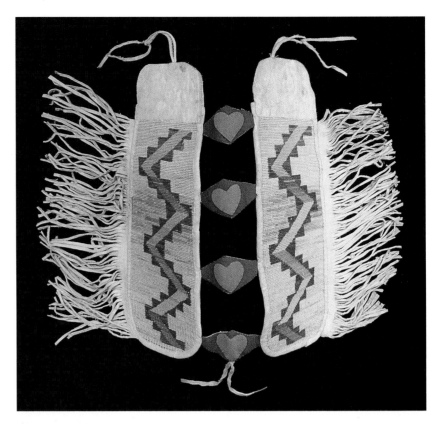

Plate 23 Cornhusk horse crupper, Plateau, early twentieth century. Length: 30 in. Width: 21.5 in. Date collected: unknown. (8.3.13c)

Plate 24 Folded cedar-bark basket, Plateau, ca. 1900. Quickly made from a single piece of fresh cedar bark, these baskets were considered temporary containers. Height: 11 in. Width: 10 in. Date collected: 1959. (3.2.6)

(*facing page*)

Plate 25 Coiled cedar-root basket, Klikitat, early twentieth century. This lidded basket is fully imbricated with beargrass and the skin of the cedar root. It once belonged to Wyam Chief Tommy Thompson of Celilo. Length: 21 in. Width: 8 in. Height: 6 in. Date collected: 1963. (3.3.13 a/b)

Plate 26 Bandoleer bag, Cayuse, ca. 1860–90. Note the red bear-claw marks on the strap. This bag belonged to Leona Showaway Smartlowit and her paternal grandfather's side of the family. Height: 42 in. Width: 16.5 in. Date collected: unknown. (8.2.1)

Plate 27 Bandoleer bag, Plateau, 1860–1910. This bag once had red wool where blue beads now fill the bear-claw stripes. The fringe, bells, and large plastic beads are also more recent. Height: 30 in. Width: 17 in. Date collected: 1989. (8.2.16)

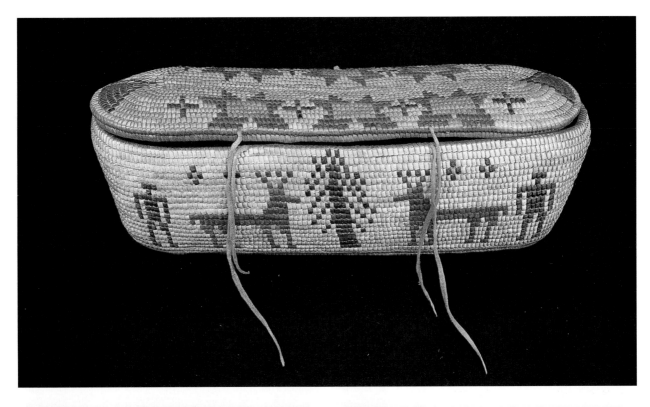

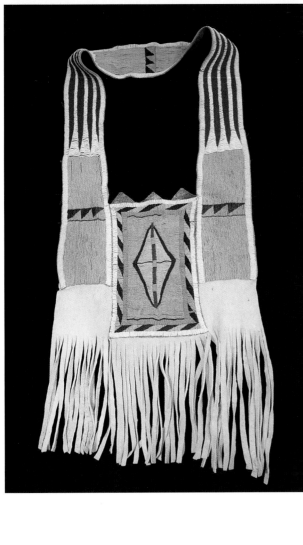

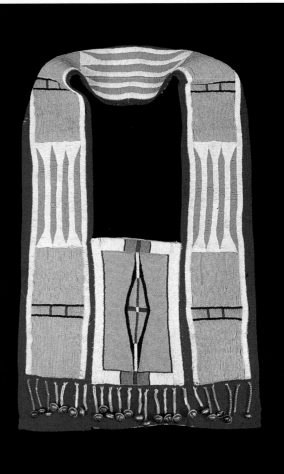

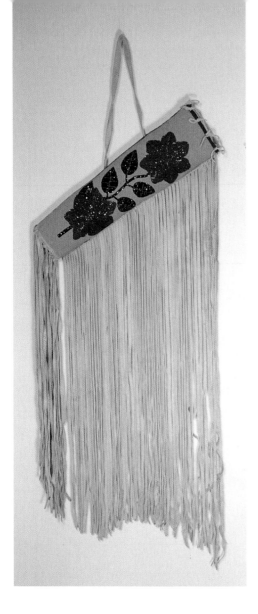

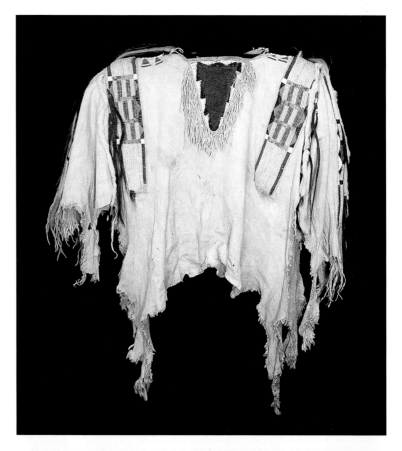

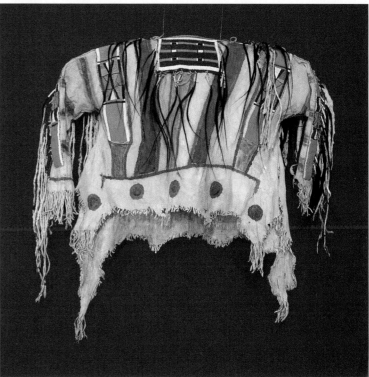

Plate 28 One of a pair of beaded bonnet cases, Plateau, ca. 1930s. These beautifully decorated canvas bonnet cases would have been carried on horseback during festive occasions. They may have been used to hold the owner's headdress when it wasn't being worn. Length: 20 in. Width: 6 in. Fringe length: 42 in. Date collected: unknown. (8.6.1a/b)

Plate 29 (*top right*) Shirt decorated in quill-wrapped horsehair, Nez Perce, mid-1800s. This shirt, from the family of Amy Halfmoon Webb, is of antelope hide. The design was created by using dyed porcupine quills wrapped around horsehair. Height: 23 in. Width: 63 in. Date collected: 1968. · (6.19.1)

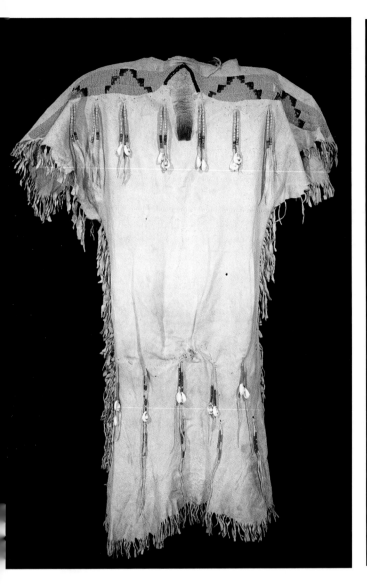

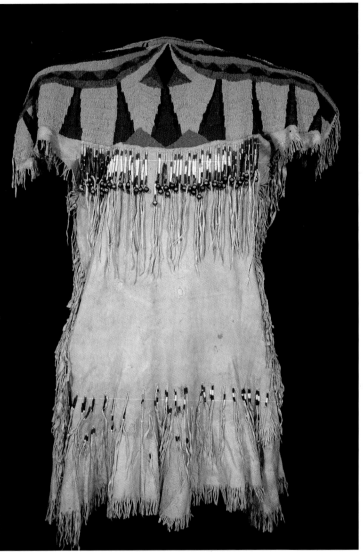

(*facing page, bottom*) Plate 30 Man's shirt, Nez Perce–Cayuse, ca. mid-nineteenth century. This unusual shirt includes both painted and beaded strips. Purchased from Mary Williams Shippen-tower and owned by three generations of her family, including her aunt, Louise Black Elk, and Mrs. Black Elk's mother, Elizabeth Long Hair. Mrs. Long Hair was first cousin to the elder Chief Joseph, who may also have owned it. Height: 63 in. Width: 36 in. Date collected: 1960. (6.19.6)

Plate 31 (*above left*) Tail dress. According to Bounds's notes, this dress belonged to Aaron Minthorne's grand-mother Quin-en-my (Umatilla). Height: 38.5 in. Width: 36.5 in. Date collected: 1971. (6.8.2001)

Plate 32 (*above right*) Tail dress, Cayuse or Umatilla, early 1900s. Made by Mary Teneche-Shuh-Pum (1821–1920) for daughter Mis-Na-Kla-Tem-Artz and later worn by granddaughter Louise Showaway. Height: 46 in. Width: 44 in. Date collected: 1972. (6.8.1005)

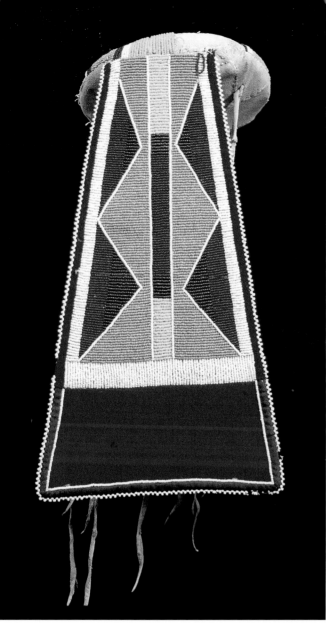

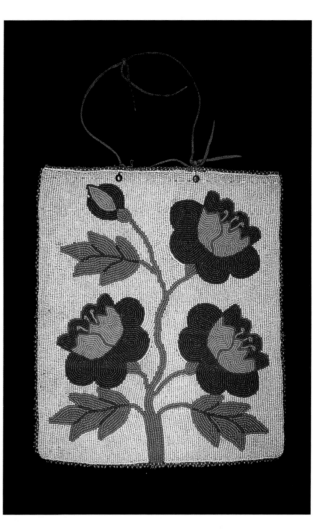

(*facing page*) Plate 33 Blanket strip on elk-hide robe, Plateau, ca. 1860–1910. Purchased from John Perard. Height: 67 in. Width: 44 in. Date collected: 1971. (6.18.9)

(*this page*)

Plate 34 Beaded pendant on woman's saddle, Nez Perce, probably early twentieth century. Pieces of decorative beadwork were often stitched to women's high-pommeled saddles. Height: 17 in. Width: 11 in. Date collected: unknown. (8.5.1)

Plate 35 Beaded bag, Umatilla, ca. 1900. This bag was given to Doris Bounds as a child by local Indians. Flat bold blossoms against a solid ground are common on bags made at the turn of the century. Height: 10 in. Width: 9 in. Date collected: 1915. (2.6.36)

(*overleaf*) Plate 36 Beaded bag, Plateau, ca. 1900. Although Bounds acquired this piece from the Umatilla Reservation, it could have been made there or elsewhere, since bags were exchanged between families and friends over the several Plateau reservations. In this superb example of background contour beading, the repetition of the contours of the flowers subtly animates them. The blossom forms and contour-beaded background together suggest Woodlands, especially Ojibwa, influence. Height: 15.5 in. Width: 12.5 in. Date collected: 1960. (2.6.1)

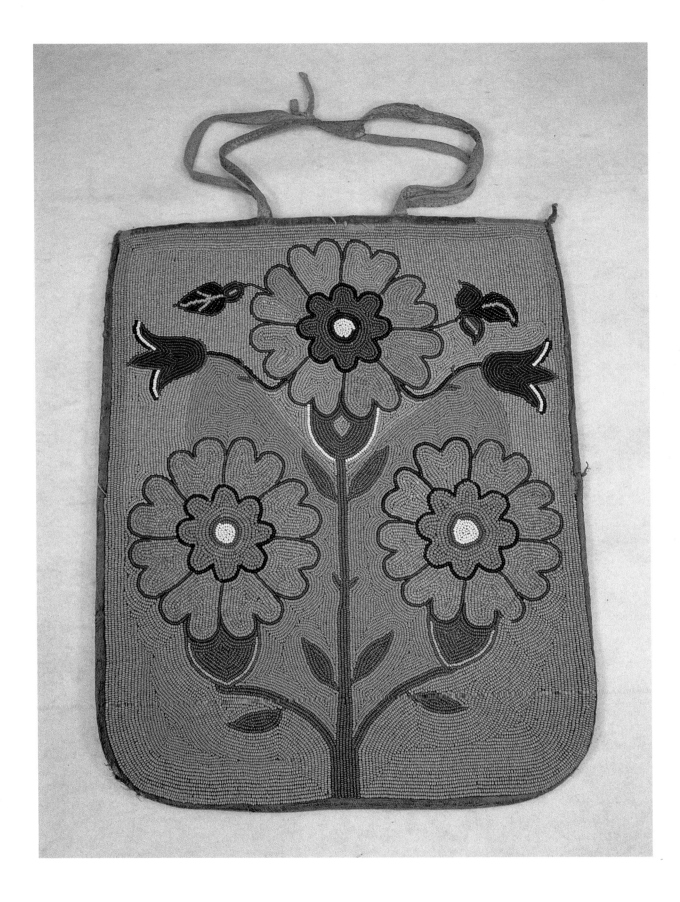

used for carrying and storing herbs, medicines, and other valuable possessions, these bags joined the flat twined bags as important containers in Native households. Many are in use today, though few weavers continue to make these bags.

The figures on the early Wasco-style round bags offer a unique view of life along the Columbia River. Images of sturgeon, ducks, frogs, salamanders, deer, elk, and other wildlife share the basket with figures of men and women and large spiritual figures that are said to represent "the old ones." These unusual motifs, often referred to as "X-ray" figures because of their skeletal appearance, are found on two bags in the Bounds Collection (figs. 4.14, 4.15).

The face motif from the larger figures is occasionally used as a decorative element on Wasco-style bags. A notable example of the use of this motif was carried back to the East in 1806 by Lewis and Clark, the first Euro-Americans to reach this part of the river.[12] Another image of particular interest, represented in the Bounds Collection, is that of a large bird.

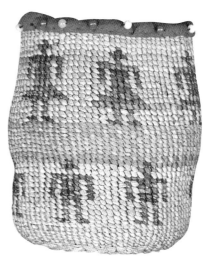

4.14 Twined bag, Wasco-Wishx̱am, 1890–1945. The stylized human figures on this bag are worked in the Wasco-Wishx̱am technique of full-turn twining. Height: 5 in. Diameter: 3.5 in. Date collected: 1959. (3.4.115)

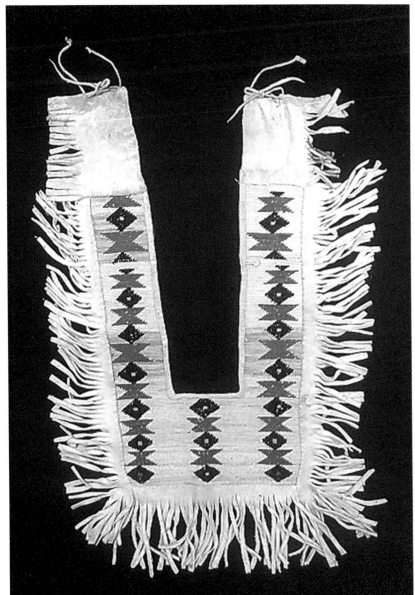

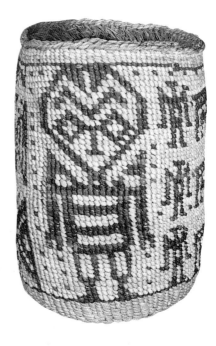

4.15 Twined bag, Wasco, ca. 1860–1890s. The large stylized human figures are said to represent "the old ones," possibly referring to ancestors. Height: 2.75 in. Diameter: 4.3 in. Date collected: 1959. (3.4.131)

According to a Wasco elder, it represents a giant condor, a species sighted by Lewis and Clark in the Columbia Gorge in 1805. By the mid-nineteenth century these great birds were rarely seen in the gorge.[13]

The art of twining these figures into the round bags recently has been revived by two Wasco weavers from the Warm Springs Reservation. The weavers, sisters Bernyce Courtney and Pat Courtney Gold, use the traditional motifs in arrangements established by their ancestors. In addition, they take the artist's prerogative of innovation, picturing fish moving up a fish ladder, a man dressed in a business suit, or a baby within a female figure.[14]

Although the representation of round twined bags is small in the Bounds Collection, there are several significant examples of Wasco-style work, as well as two bags that may have been made for men's use. At the turn of the century, Plateau men frequently posed for studio photographs with fine examples of twined weaving (fig. 4.16). Men often carried small bags for their tobacco and other personal items; usually they posed for photographs with the larger bags simply to display fine family heirlooms.[15]

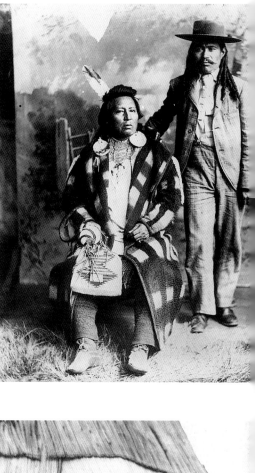

The Twined Basket Hat

The third twined basketry form found among the people of the Plateau is the brimless basket hat worn today by women for special occasions (figs. 4.17–4.21). These differ from the wide-brimmed hats worn by Native men and women on the Northwest Coast and the brimless caps worn by women in southern Oregon and northern California. In form, the Plateau hat is a truncated cone rather than a bowl. The designs in the oldest hats were incorporated in served-twined overlay. More recently, full-turn twining and false embroidery have been employed in weaving the hats. Until recent years, almost all of the Plateau basket hats displayed variations on a three-part zigzag design (fig. 4.18).

Weavers decorated the earliest of the basket hats with beargrass, a material not usually found in twined basketry on the Plateau. In the nineteenth century, the finest leaves of beargrass, woven over a foundation of dogbane, gave this special form of basketry a glossy, almost rigid surface. Hats made more recently are twined with cotton or other commercial string and with cornhusks, raffia, or woolen yarns. Occasionally, a hat is decorated with beadwork.

The Bounds Collection has several examples of these innovations. One such hat, collected by the wife of the chief engineer on the Celilo Canal about 1900, is decorated in the traditional three-part zigzag worked in cornhusk and yarn in the served-twined overlay (or old way) technique and bound with red wool (fig. 4.18). Another hat, formerly owned by Mrs. Wheeler Miller of the Yakama Reservation, is twined of red raffia with a three-part zigzag design (fig. 4.20). Two short strands of beads

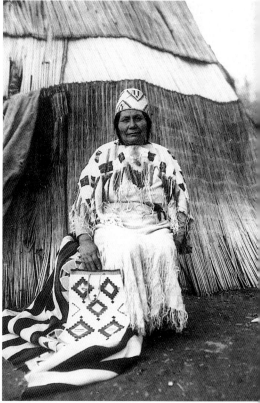

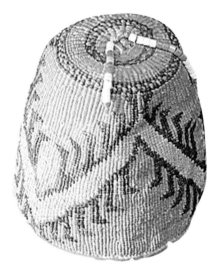

(*facing page, top*) 4.16 Chief Wolf Necklace (left) and his interpreter were photographed by C. M. Bell in Washington, D.C., in 1894. The Palouse leader holds a flat twined handbag with bold central design and a small spiral-design circular bag similar to that shown in figure 4.11. Courtesy Smithsonian Institution, nos. 52,886 and 2901c.

(*facing page, bottom*) 4.17 Edward S. Curtis photographed Edna Kash-Kash wearing a basketry hat on the Umatilla Reservation in 1900. Courtesy Smithsonian Institution, no. 76-15871.

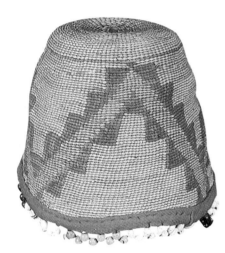

4.18 (*left*) Twined hat, Plateau, late nineteenth century. Collected by the wife of the chief of engineering at Celilo Canal about 1900, this hat features the traditional three-part zigzag or "mountain" design and an unusual beaded edge. Height: 5 in. Width: 6.5 in. Date collected: 1959. (6.11.1009)

4.19 (*left*) Jane We-nap-snoot (Umatilla) wears a basketry hat decorated in the traditional three-part zigzag design and carries a cornhusk handbag for this formal photograph by Major Lee Moorhouse. Courtesy Smithsonian Institution, no. 2890-b-24.

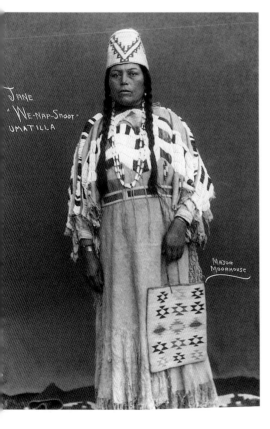

4.20 (*top right*) Twined hat, Yakama, ca. 1925. A red raffia background makes this hat from the Yakama Reservation distinctive. It originally was owned by Mrs. Wheeler Miller. The figures decorating the zigzag often are referred to as "feet." Height: 7.5 in. Width: 7.5 in. Date collected: 1959. (6.11.1006)

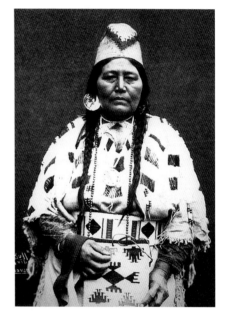

4.21 (*above*) Mrs. White Bull posed for Major Lee Moorhouse in a nineteenth-century tail dress. Designs on her twined cornhusk handbag echo the "foot" design on her basketry hat. Courtesy Smithsonian Institution, no. 2890-b-26.

hang from the crown, a common basket hat embellishment. A third example of twentieth-century innovation in the Bounds Collection is attributed to the Yakama people; it is made in the traditional shape but is of canvas covered with beadwork in a lively design.

Baskets from Cedar

Both coiled "Klikitat-style" baskets and folded cedar-bark baskets are represented in the Bounds Collection. Most of the people who utilized and traveled through the mountainous fringes of the Plateau made the folded baskets as temporary containers for berry harvests or other needs (plate 24). The coiled baskets were mostly made by those who lived along the Cascade Mountains in what is now Washington and British Columbia.

Berry baskets made by Klikitat weavers of the southern Plateau can be identified by their "pail" shape and the loops around the rim for tying down the foliage that protects the berries when the basket is being transported (fig. 4.22). Other weavers of the Cascades use a similar method of decoration, seen in a folding technique known as imbrication, but Klikitat designs generally are in a three-part arrangement, often with a zigzag design known as "mountain." The Plateau peoples' attitude of respect toward the mountains, the source of life-sustaining waters, was expressed by a Umatilla leader: "What a wonderful experience to pass a mountain. Always with a word to thank the creator."[16]

Among the coiled baskets in the Bounds Collection is a lidded

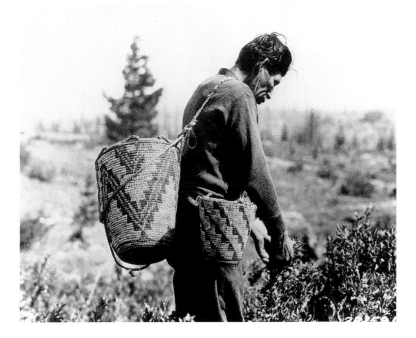

4.22 Coiled cedar-root baskets were used at the end of each summer for the huckleberry harvest. Photo taken in Sawtooth berry fields south of Mount Adams, Washington, in August 1933. Photo by K. D. Swan. Courtesy USDA Forest Service.

basket that belonged to Tommy Thompson, known as the last chief of the Wyam people who lived at Celilo (plate 25). The basketmaker imbricated figures of trees, deer, and humans similar to those found in Wasco bags into the surface of the trunklike container. Such baskets were made for special uses, possibly for a chief's ceremonial or other personal paraphernalia. They inspire a feeling of great respect not only for the basket itself but also for the skills of the basketmaker.

Basketry in Plateau Life

In Plateau society, food is honored and respected for sustaining life, and basketry has a special place because of its intimate association with food. Until very recent years, a flat twined bag was most valuable when plump with dried roots, or a beautiful coiled basket when it was full of huckleberries. Now that such traditional artistry no longer is part of everyday life, the baskets themselves have taken on value as cultural patrimony. In former times, basketry held an important place in ceremonial life. When a young girl completed her first basket, she presented it to an honored elder at a dinner given for the occasion. Another dinner would be given to celebrate a girl's first picking or digging. At those times, she would present her basket filled with the berries she had picked, or a twined bag filled with roots. These were joyous occasions, recognizing a child's growth toward maturity and her ability to contribute to the group's livelihood. At the same time, the young girl was learning to be generous to others, an important community value on the Plateau.

Families brought baskets out of trunks, suitcases, and bundles at other times for memorials, namegivings, joinings, and other ceremonies. These items were valuable in reminding later generations of family names and important occasions, for the basket's history would be passed along with it and would be remarked upon during use. As products of women's labor, baskets were often gifts given to members of the groom's family during wedding trades.

Basketry continues to be used today during ceremonial gathering and serving of the first foods of each season at feasts held in Plateau longhouses. These important uses demonstrate baskets' sustained and sustaining roles in contemporary Plateau society. On other occasions, however, they are seen only rarely, because few families still have baskets to share. Many baskets passed out of family ownership when people needed money for an emergency, such as to pay a doctor or help a friend. "They rallied when they were needed," Doris Bounds explained.[17]

Bounds identified and acknowledged the owners or makers, when known, of the baskets that came to her as gifts or through purchases. It was important to her to honor people in this way. She also felt strongly about keeping these treasures on the Plateau, where the people whose

arts they represented could see and study them and where others could learn about this important artistic heritage.[18]

Although manufactured goods have replaced basketry for most everyday tasks, these beautiful bags and baskets remain prized reminders of the old ways for the people of the Plateau. As containers for the earth's generous gifts, they continue to have great ceremonial importance. As reminders of departed family members and friends, they have great personal value as well.

When the settlement of the West brought drastic changes in lifestyle to the Native people, the number of basketmakers decreased. Despite the small number of women and men who carry it on, the art of basketmaking continues to be held in high regard today. Most contemporary basketmakers learned the art from their grandmothers or great-grandmothers and are committed to passing the tradition along to future generations. The basketry in the Bounds Collection can serve as an inspirational archive of the best of this continuing tradition for the generations of basketmakers yet to come.

Transmontane Beading

A Statement of Respect

BARBARA LOEB and MAYNARD WHITE OWL LAVADOUR
(Cayuse, Nez Perce)

The Cayuse have an old story about a man who fought and killed a grizzly bear, an animal greatly respected by Cayuse people. During this violent struggle, Bad Grizzly Bear, as the man came to be called, received many wounds. One of these cut diagonally across his chest from the left shoulder to his right side, leaving great claw marks that were deepest in the center, tapering to a point at either end. Many days later, this man began to dream about what had happened to him, and in his dreams the dead bear gave him permission to use the wounds across his chest as the mark or symbol of his bravery.[1]

Bad Grizzly Bear became a person of status, and the marks of his feat began to be stitched onto spectacular nineteenth-century bandoleer bags (plates 26, 27) that were once worn on formal occasions by men of high standing. The symbolic wounds, which are still referred to as claw marks, are located on the wide shoulder straps of the bags. Almost always red, they consist of long, parallel lines like the tracks of a bear's claws scraping down the side of a tree trunk. As in the story, they taper to a point at each end, and when the bags were donned in the traditional way, these metaphorical injuries went diagonally from the wearer's left shoulder to right hip, re-creating the path of Bad Grizzly Bear's original chest wounds (fig. 5.1).[2]

These bandoleer bags were decorated in striking patterns we now call the Transmontane style, as were many other personal possessions of the Cayuse and their neighbors. They offer a good starting point for a discussion of Transmontane beading and the issue of respect. Whenever these bags are worn, they honor Bad Grizzly Bear and the bear whose claw marks are portrayed. In addition, they pay tribute to the status of the wearer, for most bags can be traced to chiefly families, suggesting that they may once have been a special prerogative of band leaders and others of high status.[3] In a sense, they also honor the maker whose talent and industry are represented, for artistic skills are greatly respected. Thus,

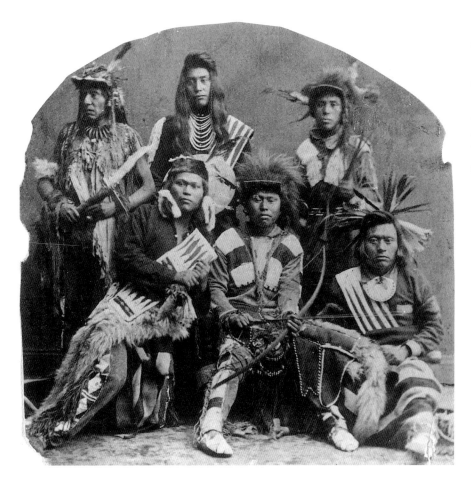

5.1 Warm Springs men, ca. 1870s. Two wear bandoleers from the left shoulder to right hip, matching the grizzly bear story. A third wears his from the right shoulder, probably to make room for his quiver and bow case. These may be scouts photographed in San Francisco in 1874 by Thomas Houseworth. Courtesy Smithsonian Institution, neg. no. 56495.

this single object touches on a complex web of esteem felt by the people of this region—for their ancestors, the animal world, their leaders, and their artists.

The culture from which these bags originally came is located in the eastern part of present-day Oregon and Washington, as well as the northwestern edge of Idaho, just west of the Rocky Mountains.[4] This is the southeastern section of the Plateau region, where the makers were primarily from the Cayuse, Nez Perce, and Palouse tribes, whose members frequently intermarried.[5] These were prosperous people who fished, hunted for game, and gathered roots and other wild foods. They also exchanged visits regularly with the Crow, or Apsaalooke,[6] Plains allies who lived east of the Rocky Mountains and also beaded in the Transmontane style.[7]

The beaded objects that came from these societies were handsome enough to attract the attention of past generations of scholars, as well as collectors such as Doris Bounds. One result has been a number of publications on the Transmontane style. Unfortunately, almost everyone outside the Plateau region attributed the beading solely to the Apsaalooke, overlooking important Plateau contributions. More recently, this misinterpretation has been reexamined,[8] but almost nothing has been written

5.2 Susie Williams (Cayuse, Nez Perce) in the Westward Ho parade during the 1945 Pendleton Round-Up, riding a paint horse and pulling the traditional travois. Courtesy Howdyshell Collection, Pendleton, Oregon.

about the powerful meanings that, like Bad Grizzly Bear's story, link the art to crucial Plateau cultural values.

In the rest of this essay, we describe Transmontane beading, using outstanding examples from the Bounds Collection, and offer a few artistic meanings, most of which have not been published before. The time period we emphasize is approximately 1850–1910.[9] The information we present draws upon the artistic experiences of Maynard White Owl Lavadour, the academic research of Barbara Loeb, and the oral histories of regional elders, especially the late Eva Williams Lavadour and Susie Williams (fig. 5.2), who were active beaders and, respectively, the grandmother and great-grandmother with whom Maynard White Owl Lavadour grew up. The elders live or lived on the Umatilla Reservation, where the United States government placed those who chose to enroll as Cayuse. Most are, however, Nez Perce and Palouse in heritage as well as Cayuse, because of the common Plateau practice of intermarriage.[10] The connections between art and respect have been taken from their teachings and stories, but the general concepts of respect are common to many Plateau people.

We wish to emphasize that this topic of respect tells only a small

part of an intricate art history, but it is one we have selected as our tribute to Doris Bounds. Respect, as well as affection, had a great deal to do with Doris Bounds's collection, for she held both the arts and her Plateau friends in high esteem, as they did her. This mutual regard was nowhere more obvious than when she attended special gatherings on the reservations and spent most of her time visiting with and embracing people.

We particularly wish to emphasize this because Doris Bounds deeply touched the lives of all of the people involved in this chapter. Susie Williams and Eva Williams Lavadour were close friends who knew and loved her for many decades and sometimes beaded for her. Maynard White Owl Lavadour grew up knowing her and often went with his grandmothers to visit her and see pieces of her collection. When he decided to become a traditional beader, she encouraged him. Barbara Loeb studied Bounds's collection in detail, learned from her stories, and also came to feel great affection for her. For these authors, Doris Bounds was a respected elder, and we will always be grateful to have known her.

Transmontane Beading

Plateau people, like most Native Americans living in the West, did not begin to bead in earnest until the early 1800s because they had few European factory goods. Beads, made in the famous glass shops of Venice, had to be shipped across the ocean and carried into the interior by horse, mule, human strength, or small boat. In the 1700s, little European commerce was reaching the region.

Before those European trade goods came to them, craftspeople—who were usually, although not always, women—most likely beautified their possessions with fringes of hair, feathers, or buckskin, as well as shells, paints made from local substances, and animal teeth and claws. They also used the quills of porcupines, which they dyed and sewed onto their garments.

To our knowledge, no personal wear from those times has been preserved, but some pieces from the Bounds Collection use techniques that may be very old. One is a buckskin shirt (plate 29) ornamented with a quilling stitch called quill-wrapped horsehair, which is done by carefully winding the flattened and dyed barbs around slender bundles of hair. Another is a dress (fig. 5.3) decorated with the precious eye-teeth, or tushes, of many elk (see fig. 6.2), a type of decoration that is still favored today. Such objects give us only hints, however, of the richness of artistry before contact with non-Native people.

The first significant supplies of European trade items came into the Plateau region in the early 1800s with explorers, fur traders, and trappers.[11] Among these goods were fine red, green, and dark blue wools

I was raised on the Umatilla Reservation east of Pendleton, Oregon, in the foothills of the Blue Mountains, and my elders taught me the survival skills of many generations. Today these skills are most commonly known as arts and crafts. My greatest influences were my maternal grandmother, Eva (Com Com Thla) Lavadour, and my great-grandmother, Susie (Tis See Saw) Williams. Eva was the oldest daughter of Susie and McKinley Williams. These two women were masters in all they taught me. Both were born near the turn of the century, in 1902 and 1919, respectively, and they were the last in my family to be raised in the true traditional manner.

I was introduced to Doris Bounds by my grandmothers at our tipi during the Pendleton Round-Up, and we visited on many occasions thereafter. Doris was not only a good friend to my grandparents and great-grandparents but also a patron of their beadwork, basketry, and sewing. It was through their friendship and Doris's love and desire to preserve my cultural heritage that many family heirlooms became small but important parts of the vast Bounds Collection.

I am truly blessed to be born into a family of master artisans who not only taught but made a living from their work and who practiced these skills on a daily basis. It is commonly believed by non-Indians that with each generation that passes, these skills and knowledge are forgotten and abandoned: this belief is not true. I am only one artist among many, preserving an important part of my Plateau ancestry.

—Maynard White Owl Lavadour

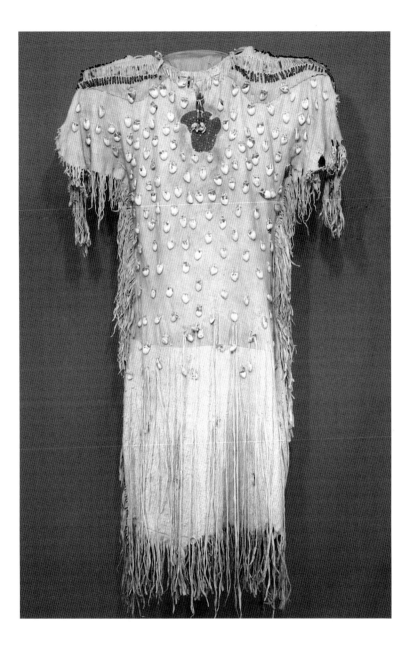

5.3 Buckskin dress with elk "tushes," Nez Perce or Salish, ca. late nineteenth century. Height: 51 in. Width: 49 in. Date collected: unknown. (6.8.1007)

called trade cloth, needles for sewing, and beads. The beads were primarily pony beads, which were approximately three centimeters across and came in black, white, and red, as well as smaller quantities of green, pink, pumpkin, purple, and translucent shades we refer to as greasy yellow and greasy blue. The Bounds Collection contains a nineteenth-century dress with a full yoke of pony beads (plate 10), probably the possession of a wealthy and socially prominent woman. We think these pony beads became the medium through which women first worked out the designs that matured into the Transmontane style. The collection

also includes a red wool and pony-beaded bridle that forecasts Transmontane-style horse gear (fig. 5.4).

By the mid-1800s, Plateau people were acquiring smaller seed beads. These more delicate bits of glass came in many shades and allowed women to develop the detailed and colorful patterns of the mature Transmontane style. All of the objects pictured in this essay, with the exception of the pony-beaded dress and horse bridle, use those tiny beads.

By this time, some groups had acquired horses, which had long been extinct in the Americas but had been reintroduced by the Spaniards and reached the Plateau by the early 1700s. From those beginnings, the Cayuse and the Nez Perce became particularly noted horse breeders, and they developed large herds that, according to elders, made them wealthy.[12] This economic power was artistically critical, for it allowed them to trade for most of the goods they desired, including the supplies needed for beading.[13]

The patterns they began to create look much like those on the bandoleer bags already pictured (plates 26, 27) or a mirror bag (plate 30), a type of man's purse that held face paints and other grooming gear and was carried at the wrist. On these objects and most others, the central motif had one or two large geometric shapes such as hourglasses, elongated diamonds, or slightly more intricate figures. These motifs had smooth edges and were usually outlined with single strands of white beads, a wider band of dark blue beads, or both, as on the mirror bag.

When a long, narrow space required decorating, the maker often constructed three-panel combinations with a decorative section sandwiched between two plain ones. This arrangement is visible on the straps of both bandoleer bags, as well as on shirt strips (plates 29, 30), blanket strips (fig. 5.5; plate 33), belts, and a number of other objects.

For color, beaders used anywhere from three to seventeen or eighteen shades on a single object, but they almost always emphasized pastels, especially rose pink and light blue. They became particularly fond of light blue, which dominates many designs. Often, they incorporated pieces of trade cloth, too, especially vivid reds. This red color fills the claw marks shown in figure 5.1 and has been incorporated in some way into almost every other Transmontane piece in the Bounds Collection.

To execute these designs, artists worked intensely and carefully, making hundreds of tiny stitches in a number of sewing techniques. They employed two-needle methods to cover large areas smoothly, using the first needle to string the beads and the second to tack them down. One of those techniques is called the overlay, or appliqué, stitch. The other has been called the Crow stitch by non-Native scholars but is called the Cayuse stitch here because it was more popular with the Cayuse than the Crow.[14] The end product was finely finished, with

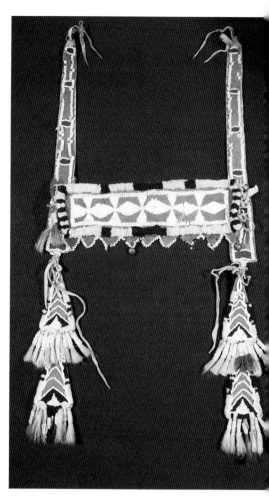

5.4 Pony-beaded headstall, Plateau, ca. 1840s–1870s. Height: 18 in. Width: 14 in. Date collected: unknown. (8.3.8b)

extra threads clipped away and most edges bound with wool cloth and delicate edge beading.

One important men's item decorated with Transmontane designs was a soft skin shirt with beaded strips (plate 30) and a lush fringe of skin, hair, or snowy white ermine. But a man might also own a gun case beaded at both ends (fig. 5.6), an elaborate otter-skin quiver with several decorative pendants, a tomahawk with beaded pendant, or a mirror bag or bandoleer bag. Some men also wore fancy belts, now called panel belts because they alternate panels of beading and bare hide.[15]

A woman might have moccasins or leggings with Transmontane designs, as well as a panel belt and various small work bags, but her most important garment was a long buckskin or wool dress. These dresses were not ornamented with Transmontane motifs, but the Bounds Collection contains many handsome dresses that were contemporaneous with the Transmontane style, so those garments are also discussed here. They were usually decorated with elk teeth, shells, or solidly beaded yokes. Beading often featured large stepped triangles called mountains (plate 32).

Women and men shared one special Transmontane item, the blanket strip. This was a long, narrow row of rectangles and circles, or rosettes, solidly covered with beaded patterns. The finished product was

5.5 Blanket strip on wool blanket, Plateau, ca. 1860–1910. Height: 69 in. Width: 54 in. Date collected: 1966. (6.18.1001)

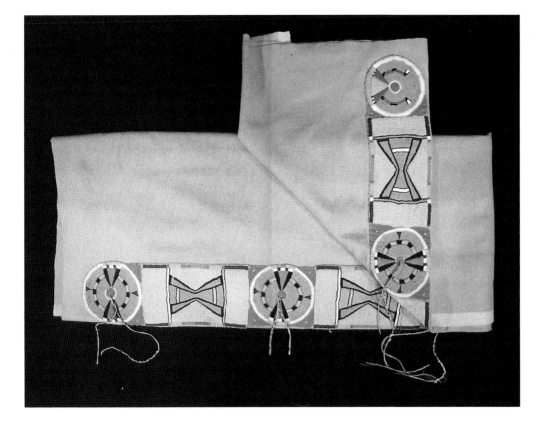

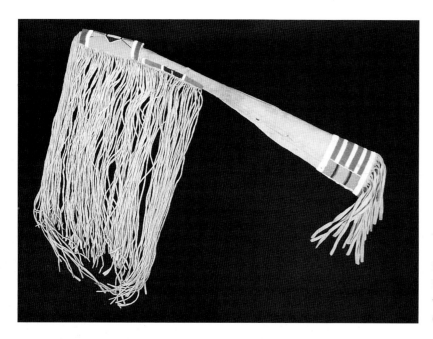

5.6 Gun case, Umatilla–Nez Perce, ca. 1860–90. Collected from John Perard, who inherited it from his father, who inherited it from Albert Dyer in 1900. Length: 52 in., without fringe. Date collected: 1971. (16.4.2)

stitched to a wool or hide robe and was worn horizontally so that it wrapped around the wearer, with the ends meeting in front. Many of these strips were made for weddings, and the blankets they were sewn to were laid on the ground for the couple to stand on or were placed around the two of them to symbolize their union.[16]

This union is also represented in the design that is beaded onto the strip. The circle of life is represented by the round rosette and almost always encloses an hourglass symbolizing a woman. The man is represented by the rectangular shapes between the rosettes. Thus, male and female are united in the circle of life. This may be understood to mean birth and death, but it also represents the mutually important roles men and women play in feeding, clothing, and generally caring for each other.

Children, if dressed in formal wear, usually wore miniature versions of adult clothing. Babies were sometimes swaddled in a particularly handsome type of cradle with a large panel of solid beading on top. This panel, in a few instances, was done in the Transmontane style.[17]

Horses were sometimes covered in the most elaborate beading of all, especially for traditional parades. They might be decked out with fancy collars that hung down to their chests, as well as beaded saddle blankets, colorful stirrups (figs. 5.7, 5.8), high-horned saddles with decorative pendants (plate 34), and long buckskin saddlebags that were thickly fringed and draped over the animal's rump. On occasion, bridles also were solidly beaded and further ornamented with a keyhole-shaped piece that lay on the horse's forehead.

Respect

All of these beaded objects required creative thought, considerable time, and costly materials, so they represented major investments and in a general way communicated the wealth and prosperity of the people who wore them. Not surprisingly, in light of their value, most were reserved for special occasions, and their designs and uses became linked with significant Plateau events and beliefs, including concepts of respect, honor, and esteem.

Respect was an important and complex part of Plateau life. Certain people held positions of status and were usually highly regarded by others in their communities. They included chiefly families, elders, and accomplished men and women such as healers, historians, interpreters, and those who knew the ceremonies important to traditional life.

At a more fundamental level, everyone and everything was to be treated with esteem. This included not only other human beings but also food, air, water, the plants and animals whose lives were taken, and all other aspects of nature. This was reinforced with the belief that respect began with one's self and that self-respect could best be demonstrated by living a good life and treating everyone and everything well—in other words, by honoring or showing respect for others. The rest of this chapter is devoted to some of the enduring Plateau relationships between respect and artistry.

The very acts of making or teaching art were highly regarded during the time when Transmontane beading was being produced. Talented artists were noted and remembered for the beauty of their creations. Teachers were almost always elders, the most esteemed members of the community because of their age and accumulated knowledge. No longer able to do hard physical work, many of these elders remained home to tend and educate the children, and those skilled in cornhusk twining, rawhide painting, or beading passed their knowledge to their young relatives. In reciprocation, new artists gave the first pieces they made to their elders, usually to those who had taught them.

Because Plateau people acknowledged and respected other living beings, they also thought about the creatures whose hides they wore for clothing, and when they put decoration on their garments they felt that they added to the beauty of the original animal as well as to themselves. Furthermore, the appearance of the hide itself was affected because women, who were usually the tanners as well as the beaders, hesitated to damage or mutilate skins by trimming and discarding parts. This included the tail and the skin from the legs, which they tried to preserve with fur intact.

From this custom they evolved the venerated and distinctive "tail dress" or "deertail dress,"[18] whose construction is discussed in detail by

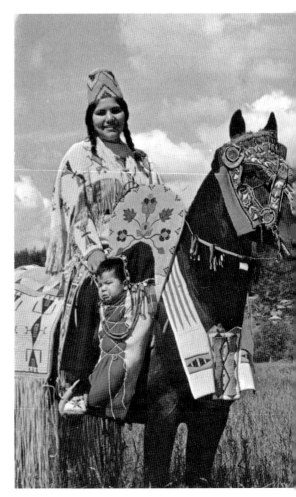

5.7 Nez Perce woman, ca. early 1900s. Notice bandoleer-style horse collar and other horse gear in use. Postcard. Courtesy Bounds Foundation.

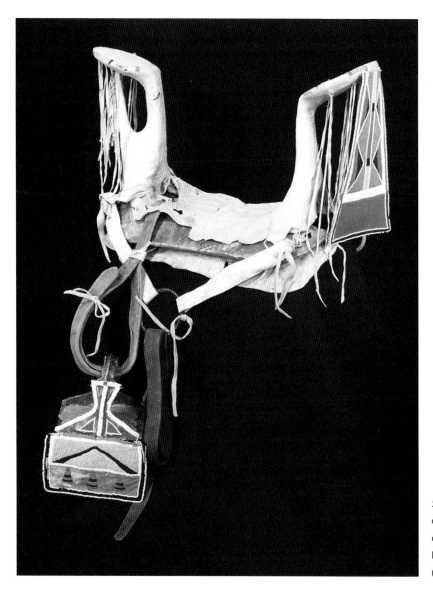

5.8 Saddle with beaded stirrups, Plateau or Crow, late nineteenth–early twentieth century. Height: 17 in. Width: 13 in. Depth: 27 in. Date collected: unknown. (8.5.3)

Richard Conn in chapter 3. Each dress was made from two animal hides; in the nineteenth century a tail dress was made with the furry tails of the two skins folding over onto the wearer's chest and spine (fig. 5.3). In modern times, this concept is preserved with a beaded version. On one illustrated example (plate 32), for instance, the tail is represented by a dark blue diamond just below the neckline.

During the nineteenth century, men's shirts also had furry tails resembling those on women's dresses, although in this case the tails were at the lower edges of the garments and were less obvious (plate 28). Additional features of the animal were carefully preserved on both shirts and dresses, and as a result, most of these garments retained irregular edges and long flaps of skin from the legs and shoulders of the animal.

To honor these creatures even further, women traditionally turned animal skins inside out when they made their dresses, so that the once-furry outer surface of the hides faced the wearer's body. By doing this, they respectfully avoided wearing the skins as the animals had, and the outer surfaces of their dresses, as a result, were usually soft and somewhat textured. In contrast, men, as hunters, claimed a direct connection with their game and assumed the privilege of wearing buckskin the original way, so the outsides of their shirts were the smooth surfaces that once had fur.

Regard for the natural world was so important that it influenced not only more modern floral and figural works (see chapter 6) but also the older abstract patterns of the Transmontane style. A diamond between two triangles was called a fish or salmon, a primary Plateau food (fig. 5.9). A split triangle represented a deer, an important source of meat and clothing. Elongated diamonds were sometimes referred to as lizards, circles as turtles, and four-triangle-and-box designs as frogs, because Plateau people, who considered children part of their wealth, admired the fruitfulness of these small and fertile creatures.

5.9 Plateau design symbols. Drawings by Maynard White Owl Lavadour.

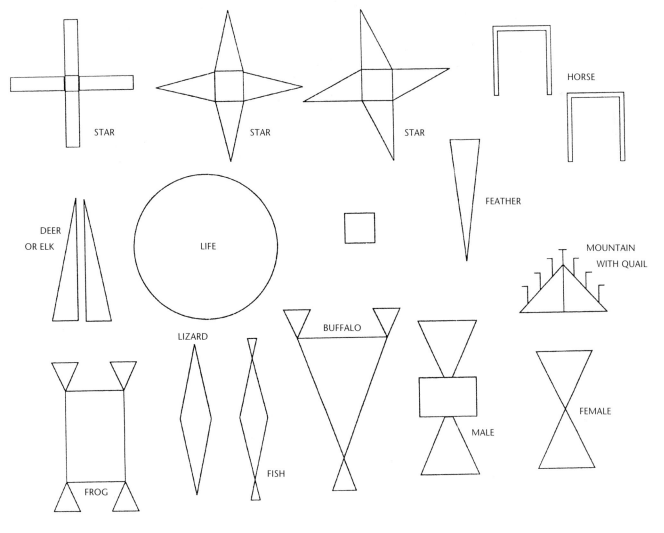

Two particularly prominent Transmontane conventions, as discussed to some degree already, are the use of dark blue borders and large areas of light blue in foregrounds or backgrounds. These unusual characteristics, which seldom appear in the beading of other regions, bring us back to the topic of people of high status and the esteem and wealth they enjoyed.

A connection between blue tones and prominent individuals appears to have begun prior to contact with Europeans in the early 1800s. According to elders from the Umatilla Reservation, there was a green pigment from eastern Oregon that could be gathered in large quantities and thus was abundantly available to regional artists of long ago. Mixed with this green, however, were smaller and rarer dark blue crystals. These were carefully picked out, ground into a powder, mixed with a binder, and formed into small balls or disks about the size of a silver dollar. In those distant times, the precious disks were reserved, say elders, for painting outlines. Even so, when paint materials were gathered locally and blue was rare, the shades were apparently available only to those of notable wealth and social prominence.

When limited supplies of beads arrived in the early 1800s, the value placed on blue paint seems to have been transferred to the beads, and affluent and respected families were again the first to acquire them. We propose that beaded, dark blue borders may have evolved from painted outlines and that borders and other blues then became a sign of the prosperity and status or respectability of the wearer.

Other people seem to have aspired to wear these prestigious colors on their garments as well, and as bead supplies increased, this became possible. As a result, almost every piece of Transmontane beading and nearly every contemporaneous dress, including those in the Bounds Collection, use large amounts of blue.

Similarly, according to Susie Williams, women in part demonstrated their respect for the men in their families by dressing them with the precious blue beads. Notable and respected women were also able to acquire those shades, often before less accomplished men. But blue, according to Williams, came to be called a man's color, along with green, which was associated with blue, and with red, which may reflect the connection between men and war. Female colors were the oranges, yellows, and whites that had been more common in the days of natural pigments. If this distinction between men's and women's colors was once widespread, however, it had declined by the period of the Transmontane style because greater supplies of blue beads had become available and everyone had begun to wear the color.

The relationship between art, gender, and status is far more complex, however, in part because a woman gained status in her own right when she dressed the men in her family well. Her artistic skills were

admired and respected, and so might have been her magnanimous act of passing the blue beads on to another, because Plateau societies placed considerable value on generosity. In addition, men and women complimented each other artistically, just as they did in most other aspects of traditional Plateau life, and men, who supplied the hides, gained status as hunters and providers when their families were well dressed. For these reasons, members of the family gained maximum respect when husbands and wives were both well dressed—the woman for her artistry and the man for the skins he had provided.

Status may also have encouraged the heavy use of buckskin fringe that characterizes this region. The fringe for one shirt or gun case alone might require a full hide, further demonstrating the hunter's success. The lush garment ornamentation adds a richly kinetic quality as the long fringes swing elegantly with each step of the horse or human wearer.

Another design characteristic pertinent to this discussion is seemingly purposeful imperfection. Transmontane designs are so carefully outlined and finished that they often appear flawless, yet they contain many subtle irregularities. Many of these developed because women customarily sketched their designs freehand, or because several worked on the same object and left their individual stylistic imprints.

Some irregularities appear, however, to have been intentional. This is particularly evident on the old blanket strips, which almost always contain at least one design or color detail that is out of step with the rest of the pattern. For example, a blanket strip from the Bounds Collection (plate 33) contains three rosettes decorated with circles of dark blue and turquoise and a fourth with a circle of dark blue and pink. Other strips in the collection contain similar small but significant shifts in color or design. These changes are too consistent to have been accidental. At this point, we do not know definitively why the irregularities occurred, but we believe they may reflect a sacred respect for the Creator. Even today, during traditional religious gatherings at the longhouse on the Umatilla Reservation, they say that only the Creator can make something perfect. To attempt to go above the Creator would be improper.

The occasions upon which these fine garments were worn or given away were numerous, and again we emphasize that we cover only a small portion of a complex subject. The examples we have chosen are ones in which beadwork was used in a direct way to honor or demonstrate respect for individuals.

During the time of the Transmontane style, as in later years (see chapter 6), fine clothing was often brought out and worn or draped over horses during traditional parades. One purpose of these spectacular public displays was to honor someone's accomplishments. Such an event might have occurred, for instance, when a man received the title of chief or when a warrior returned from a successful raid. On these occasions,

relatives and friends rode around the village on horseback with the person being recognized, and in doing so, honored that person and raised his or her status. Whenever they did this, they placed fine garments on themselves and their horses.

Parades that honored individual accomplishments were usually accompanied by feasts in which the extended family fed and gave gifts to everyone present in honor of their esteemed relative. These were enjoyable celebrations that brought the community together while emphasizing respect for the person being honored. This further enhanced that individual's status, especially if many gifts were given away. Again, beadwork played a role, for the gifts often included finished handiwork as well as raw materials such as beads and cloth.

Another type of parade occurred a year after a death, during a ceremony that served to clear the air of traces of the spirit of the deceased and allowed family members to come out of mourning and resume their normal lives. For this event, the family paraded with a horse draped in the gear and fine clothing of the deceased. This handsomely decorated mount represented and paid respect to the missing loved one.

Those who had passed on were also honored at a special giveaway during which their belongings, including fine clothing, were distributed to the guests. This is probably what happened to the shirt (plate 30) that was given to Louise Black Elk at the death of her mother and then passed on to Mary Shippentower at Louise's death. Such a gift was a reminder of the missing person, and the receiver was expected to keep it as a symbol of respect for that person.

This type of event often paid tribute to the receiver as well. In some cases, elders prepared for their own memorial giveaways by making or setting aside special possessions for individuals they cared a great deal about, and this was an honor, especially if the deceased had made the gift himself or herself. It was also an honor to receive material, beads, and other craftable goods, particularly if the person who had passed away had been a talented artisan.

In Plateau society, respect, both for self and for others, played a role in many aspects of daily and ceremonial life, but one other event is particularly relevant to our topic. This was, and is, a public ceremony during which the name of a deceased person is transferred to a younger relative. In the process, the memory of the person who had passed on was eulogized through words and the fine gifts that were given to those present. Reciprocally, the newly named recipient was also honored by inheriting the name and the distinguished characteristics of the person who had died. Beadwork again played a prominent role, for on the day of the naming the young recipient respectfully took care to dress in his or her finest clothing and, during the ceremony, would promise all of those garments to others.

Decline

Between 1835 and the end of the 1870s, Plateau people, like other Native societies, suffered greatly from contact with Europeans. The vibrant and artistic Cayuse had a particularly difficult time after 1847, when they violently attacked the Whitmans' Christian Mission and were themselves shattered and scattered by white retaliation.[19] Other groups were to experience similar distress, and group after group was forced onto reservations. In 1877, a small group of Nez Perce, including the younger Chief Joseph, attempted to preserve their freedom by fleeing to Canada. They were intercepted and violently overcome by the U.S. military. By 1880, virtually all Plateau people were confined to small reservations and economically crippled.

The desperate flight of those small bands of Nez Perce is particularly important to the story of Transmontane beading, for Chief Joseph's people first fled to their Apsaalooke friends for protection, but the Crow, fearful of being drawn into confrontation with the United States military, refused aid. This destroyed the fruitful alliance between the Crow and these bands of Nez Perce, and although many Crow and Plateau people continued to exchange visits into the twentieth century, the alliance that had led to their mutual use of the Transmontane style was weakened.

Through all these catastrophes, the people of the region managed to continue many of their lifeways, including their handsome Transmontane beading style. But by the later 1800s, disaster reached them in new forms as the United States government and others began to systematically strip Native people of old cultural values in the hope of converting them to Euro-American ways of living.

The impact of the change was calamitous. Children were forced into boarding schools and separated from the traditional teachings of their elders. Traditional medical and religious practices were outlawed. The great horse herds, once a source of pride and wealth, were lost. Families were split between those who wished to adhere to the old traditions and those who chose to follow the new ways of the Euro-Americans. Historic food resources were destroyed or claimed by homesteaders. Precious beaded heirlooms were sold to buy groceries, while more and more people had to seek jobs in the now-dominant society of non-Native people. Thus, fewer people had the time or the detailed knowledge required for old customs, including the costly and time-consuming art of beading.

By the early 1900s, the Transmontane style was in decline, and many people, especially men, turned away from traditional garments altogether, even for special celebrations, in order to live peacefully within the new culture of the Europeans. By the 1920s and 1930s, only a few

pieces were being made, usually by knowledgeable elderly women who were too old to be interested in change.

Yet the history of their art continued. They developed new styles while retaining important customs such as naming ceremonies and funeral giveaways, as will be seen in the following chapter by Kate Duncan.

They also held onto their family heirlooms when they could, and a few of these prized possessions still appear at parades and other special events. Among them are old bandoleer bags that continue to pay tribute to the story of Bad Grizzly Bear. Sometimes they can be seen swinging at the chest of a parade horse or suspended from the high pommel of a woman's horse, which was considered the place of honor.

Honoring People, Honoring Life

Floral and Figural Beadwork on the Plateau

KATE C. DUNCAN

Throughout her long life, Doris Bounds loved being with Indian people, often coming together with them for encampments at the Pendleton Round-Up and at other celebrations of many kinds. She felt honored to participate, and she herself honored special objects that Indians had made and used, by collecting, enjoying, and caring for them.

As a little girl, Bounds had a passion for beads and insisted on wearing them to school. She cherished a Umatilla beaded flat bag from the turn of the century (plate 35) that had been given to her as a child. It is not surprising, then, that as she began collecting, beadwork played a prominent role. The Doris Swayze Bounds Collection includes the whole range of beaded items from the southern Plateau—bags, dresses, cradles, moccasins, gloves, cuffs, belts, vests, and horsegear—but the beaded flat bags that she was given or purchased over the years predominate.

Glass beads have been important to Plateau peoples for more than two centuries. For generations, floral and figural beadwork has ordered, honored, and reinforced the essential connections of life—between people and nature, between people and people. Making, giving, and using beadwork—and the designs themselves—speak of deeply rooted values respecting life itself, the adaptability and individuality that one must bring to it, and the timeless importance of community. Beadwork roots the maker and user within place and tribe and family, and visually celebrates those bonds with bold imagination, color, and joy.

Today, as in the past, an heirloom beaded bag like the one Doris received as a child makes multiple references as it is carried at a community gathering such as Pi-um-sha at Warm Springs, a Veterans Day celebration on the Yakama Reservation, or the Pendleton Round-Up. Usually made by a woman, it attests to women's responsibilities within the family and community, which have for centuries included providing the ornamented containers and clothing essential for domestic needs.

As a woman's rectangular flat bag, it alludes to the history and role

of earlier bags. In the late nineteenth century the need for ornamented storage bags that could also function within an elaborate subsistence and social matrix intersected with the introduction of new foods and convenient, commercially made containers for food storage. At the same time, European-made glass beads became increasingly available in an expanding range of colors and textures, and women worked with them more and more. Over several decades, containers other than fiber bags came to assume many of the bags' storage roles, and smaller cornhusk or beaded "handbags" assumed some of their social roles. Like the earlier cornhusk bags, the handbags were given as gifts in culturally prescribed ways and were carried with pride and care on dress and ceremonial occasions.

The handbag Doris Bounds received as a child also illustrates the blend of convention and personal imagination that is a hallmark of Plateau beadwork. It uses both local and introduced materials and techniques. Like other objects customarily beaded on the Plateau, it tells in its patterning of both individual and group aesthetics and design preferences at the time and place in which it was made. It speaks, as well, of established conventions—of what is lavished with ornament and where, and what type of design is appropriate. Like the majority of beaded handbags, it is rectangular, beaded solidly and on only one side, backed and lined with fabric, and it has a narrow thong handle. The design is of flowers, a popular subject, and there is a boldness to their form and color. But the flowers come from the creative imagination of the maker, and although they may seem familiar, they are unlike those on any other bag.

Had her childhood beaded bag been acquired through a local trader, it probably would have been a pawned bag. "They were pawning them because they needed to eat, or take out a youngster's tonsils or something. They needed the money; they had no income. . . . Any excess was parted with in emergencies . . . or when friends were in need."[1] Thus, the cultural valuing of responsibility and generosity toward the group determined the history of some beadwork.

Doris's childhood bag was acquired as a gift, as were many bags in her collection, and thus it reflects the complex of social rules that have for generations dictated the giving of fine, ornamented objects on occasions such as weddings, namings, funerals, and memorials honoring the individual within the community. Like most Plateau beadwork, such a bag acquired a personal history as it moved through the years—a history often lodged in generations of memory of the one who first made and gave it, then of another who received, cherished, and used it in honor of someone and then passed it on to yet another, and so on. Doris Bounds's choice to pass this bag and the other cherished items in her collection on to The High Desert Museum as a legacy to the Native people of the Plateau fittingly continues these cultural traditions.

This bag, then, is a part of deeply embedded Plateau art traditions, some of which date to prehistoric times. It was made with care and specific intention. It mirrors both long-established cultural practices and continuities with the past and the ongoing accommodation to changing realities and possibilities that accelerated within Plateau expressive culture after Euro-American contact.

Early Beadwork on the Plateau

Early-nineteenth-century records establish the long-standing importance of beads on the Plateau. The journals kept by Lewis and Clark during their exploration overland along the Columbia River to the Pacific coast in 1804–6 provide the earliest written descriptions of Plateau people. The explorers observed that for Plateau people, personal appearance was very important; the wearing of ornaments and ornamented clothing using scarce, beautiful, and valuable materials communicated wealth and prestige. Such materials included locally handmade discoidal beads of shell, tusk-shaped mollusk shells from the Northwest Coast called dentalium (*Dentalium pretiosum*), and elk tushes—pairs of vestigial teeth in the elk's lower jaw (figs. 6.1, 6.2). The explorers also saw a limited number of much-coveted European-made glass beads that had been acquired through trade with other tribes via long-established Native trade networks. They found that the people living along the lower Columbia River called blue glass beads "chief beads."

> The Natives of the Columbia River] prefer beeds to any thing, and will part with the last mouthfull of articles of clothing they have for a fiew of these beeds, those beeds the[y] trafick with Indians still higher up this river for roabs, Skins, cha-pel-el [biscuit root] bread, beargrass &c. who in turn trafick with those under the rockey mountains for Beargrass, *quarmash* roots & robes &c.[2]

Lewis and Clark themselves brought beads and bartered them for fish and root foods.

As fur traders rushed into the country, beads, one of the staples they offered in exchange for furs, became increasingly available and important. Alexander Ross, who was employed by the Pacific Fur Company at Astoria, observed in 1811 that "Walla-Walla, Shaw Hapten [Sahaptin], and Cajouse [Cayuse] women wore garments of well-dressed deerskin down to their heels; many of them richly garnished with beads, hiquas [*Dentalium*], and other trinkets."[3]

By the time John Townsend described a young Plateau woman (either Nez Perce or Cayuse) about two decades later, trading posts had expanded the potential decorative repertoire, and a variety of new goods and ideas had been incorporated with exuberance and obvious pleasure into traditions of ornament and public display.

6.1 *Dentalium pretiosum* shell from Northwest Coast sea waters. Used widely throughout the West to decorate clothing, this shell was also highly valued as a medium of exchange. Michael Kelly illustration.

6.2 Elk tush. Two tushes grow on the lower jaw of each elk. They are of vestigial bone, not enamel. A woman would be very proud of her hunter husband for providing so many of these valued decorative items. Michael Kelly illustration.

Their dresses are generally of thin deer or antelope skin, with occasionally a bodice of some linen stuffs, purchased from the whites, and their whole appearance is neat and cleanly. . . . I observed one young and very pretty looking woman, dressed in a great superabundance of finery, glittering with rings and beads, and flaunting in broad bands of scarlet cloth. She was mounted astride—Indian fashion—upon a fine bay horse, whose head and tail were decorated with scarlet and blue ribbons, and the saddle upon which the fair one sat, was ornamented all over with beads and little hawk's bells.[4]

Riders today, like the one Townsend observed, proudly display tribal and family affiliations via the custom of parading, especially at the Pendleton Round-Up and at summer gatherings on Plateau reservations. Their beaded garments, bags, and horsegear continue to affirm blendings of influences (fig. 6.3).

In a 1991 interview, Doris Bounds echoed Townsend's observation of nearly one hundred fifty years earlier as she spoke about the Cayuses' love for horses and display. "They were a flamboyant tribe that loved lots of color, fast horses, [and were] spectacular athletes, these people . . . the early trappers were concerned about them . . . but among the Indians they were glorified because they were so colorful, and they ran their horses so fast, and they'd cheer and off they'd go."[5]

We have seen how quickly and eagerly Plateau people appropriated foreign goods that appealed to them and incorporated these into the

6.3 Plateau girl on horse, wearing beaded dress, early twentieth century. Postcard. Courtesy Bounds Foundation.

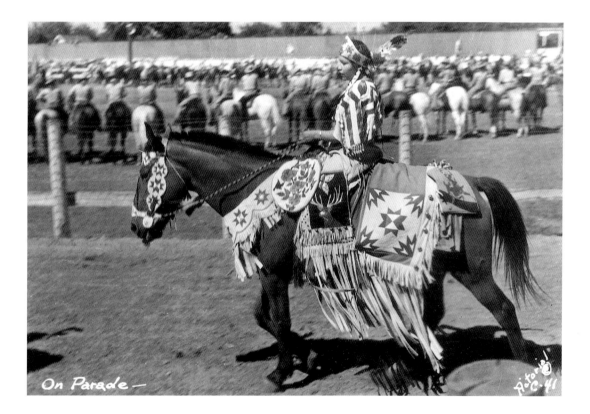

On Parade —

dress and parade clothing that spoke their identity. The rare shells and beads traded in from elsewhere that were observed by Lewis and Clark in 1805 had, by Townsend's time in the 1830s, been dramatically augmented or entirely replaced by Euro-American trade goods. As the century proceeded and Native involvement in the fur trade increased, glass beads that had once been owned and worn almost exclusively by chiefs and their families became more and more widely used.

The sketches and paintings of eastern Plateau people made by Father Nicholas Point in the 1840s picture this blending of Native and trade materials on garments. Point drew the Plateau "tail dress" mentioned by Ross and Townsend, emphasizing its distinct, broad, contoured band of ornament across the upper front and back bodice (fig. 6.4). Most of the dresses drawn by Point appear to use necklace or pony beads, although a few existing ones of the period incorporate dentalia or elk tushes. Point's paintings also record a variety of men's coats and caps on which hide and fabric, quills and beads are combined. The bags with floral-like designs pictured in one sketch (fig. 6.4) may well have been beaded, perhaps using the tiny seed or cut beads (1–2 millimeters in diameter) that would become widespread in Plateau beadwork by the last decades of the nineteenth century.[6]

6.4 "Women's Work after the Hunt," by Father Nicholas Point, 1841–47. Ink on paper. Eastern Plateau. Details on the dress (here and in other Point drawings) and on the bags suggest that Point was seeing beadwork, both floral and geometric. Courtesy DeSmetiana Collection, Jesuit Missouri Province Archives, St. Louis.

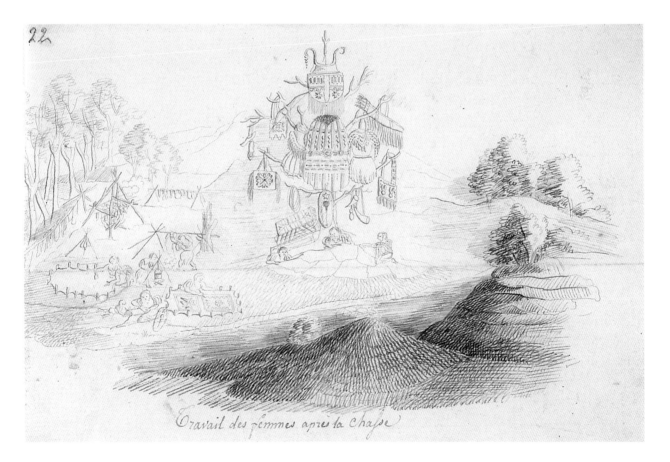

Travail des femmes après la chasse

Influences from the East

New beaded forms and design types, especially the contour-beaded floral work that was produced occasionally around mid-century and would dominate Plateau beading by the end of the nineteenth century, speak of inspiration from Woodlands beadwork. Although we know that a Swiss-Ojibwa (Métis) woman, Marguerite McLoughlin, wife of Chief Factor John McLoughlin, was teaching beading in the 1820s at the school at Fort Vancouver, Woodlands influence is not clearly documented until the late 1840s. At that same time, some Columbia River women suddenly began creating their own versions of panel bags and octopus bags, the two distinctive forms of men's firebags from the central Woodlands Algonkian-speaking peoples, the Cree and Ojibwa and the Métis (mixed-bloods) of both groups. Firebags were used by men to carry tinder and flint and steel for starting a fire, and sometimes smoking materials. Highly decorated ones were worn on dress occasions. Employing local techniques and designs, Wasco-Wishxam women loom-wove or lap-twined their own panel and octopus bags, picturing on them the birds and quadrupeds typical of Wasco-Wishxam basketry root bags.[7]

Woodlands panel and octopus bags from the same time period are beaded on wool fabric with elaborate floral designs using the two-thread couching technique (also called spot or overlay stitch). We know that some of these were present on the Plateau then, because in 1841 Lieutenant Charles Wilkes described seeing octopus bags in use by voyageurs at Fort Vancouver.[8] Hudson's Bay personnel who began retiring at that time to the nearby Willamette Valley from the Canadian Red River settlement just south of Lake Winnipeg no doubt owned some also.

Beaded Bags

In the decades after 1850, Plateau women used more and more seed beads and, possibly as early as the 1860s, developed a flat bag with rounded lower corners that Gogol (1985) has suggested was first used as a man's firebag. Simplified tripartite foliate designs beaded on fabric or hide characterize the earliest examples. Solidly beaded versions with the background as well as the motifs contour beaded were made increasingly during the last quarter of the century. A fine old bag of this type in the Bounds Collection (fig. 6.5) displays a tripartite symmetrical composition of bold, loosely organic foliate forms outlined against a solid white background. The contour beading of the background lends a subtle dynamism to the surface and animates the design.[9]

Some beadworkers continued to experiment occasionally with bag types and designs introduced into the area from elsewhere.[10] As Richard Conn points out in chapter 3, we do not yet understand all of the rea-

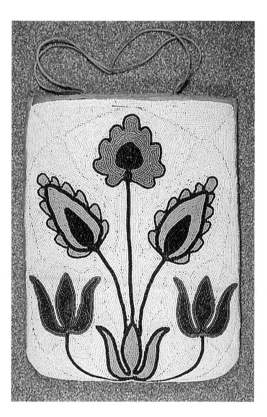

6.5 Beaded bag, Yakama-Cayuse, ca. 1900. The maker of this bag, highly skilled at background contour beading, deftly fit lines of beads together at the angles of intersection. Beaded bags may be presented to special friends and relatives after a death. This bag was received by Mrs. Essie Cornelison at Allan Patawa's giveaway in the late 1940s. Height: 13 in. Width: 10 in. Date collected: 1964. (2.6.160)

sons for the dramatic increase in the production of floral beadwork on the Plateau during the last decades of the nineteenth century, but there clearly was a meshing of circumstances and new ideas.

One circumstance involved increasing pressure from missionaries to drop the geometric designs they perceived as old Indian ones. Doris Bounds recalled that on the Umatilla Reservation, "they were using it [floral and figural design] because the old Indian designs had been denied to them. They [mission people] picked them up and burned them on the reservation, and then they were forbidden to make a beaded bag with an Indian design . . . because [the designs] were heathen, you see."[11]

The completely contour-beaded backgrounds that became important on Plateau flat bags about 1880 suggest another connection with Woodlands beadwork, again from the Canadian Cree-Ojibwa area. Other than on the Plateau, solid, completely or partially contoured backgrounds appear almost exclusively on Plains Cree-Ojibwa beadwork of the same period, particularly on a similarly shaped handbag on which there are also similarities in motifs (plate 36).[12] Objects in the Bounds Collection that may date as early as the 1880s suggest this connection, as do other, later ones. Plateau beadworkers imposed slightly more rigor to their structuring of background contour beading than did Woodlands beadworkers.

Both the incorporation of Woodlands influences and the increasing emphasis on floral and figural design in Plateau beadwork off and on throughout the nineteenth century reflect the pragmatic selectivity that women exercised as they adapted to change, sometimes under pressure, sometimes not. Across the history of Plateau beadwork, new inspirations have circulated within established ways and stimulated new directions, with pleasure in individual experimentation clearly a uniting factor.

Bags with rounded corners gave way to rectangular ones and contoured backgrounds to linear ones near the turn of the century. Bags with contour-beaded backgrounds ceased to be made about 1920, in favor of linear-background bags. Motifs continued to be contour beaded (plate 2).

As far as subject matter is concerned, flowers and animals, "which are together in nature," dominate Plateau nongeometric beadwork.[13] A bag with such motifs unites the owner and the natural world, a reminder of the importance of each to the other. On several bags in the Bounds Collection, elk are pictured with landscape elements or flowers.[14] A popular turn-of-the-century motif combines a simple flower spray or arbor with an elk or deer. One inspiration for this format may have come from pocketwatch cases such as those pictured in more than fifteen pages of the 1897 Sears Roebuck catalog (fig. 6.6).[15] A common design on both men's and women's cases pictures a stag, with profile or frontal head, standing

regally against a landscape background, the whole animal often placed behind an arbor of foliage and blossoms.

The elk, with or without foliage, has continued to be popular on Plateau bags throughout the twentieth century. A Bounds Collection bag from the 1930s (plate 37) elaborates this format into a fanciful outdoor scene in which a larger-than-life branch of flowers supporting a blue bird shelters the buck from one side while a smaller blue and yellow bird, perhaps the mate, watches alertly from a hillock across the way.[16]

By the 1930s, a sense of space and realistic detail had become a part of some scenes. Trees rooted to the ground and details of the terrain place both plants and animals within a three-dimensional space. The pink-trunked pines of a bag made by Ellen Heath about 1930 (plate 38) lend a fanciful touch to the scene of a mountain lion stalking over hillocks carefully rendered to indicate different soil colors. Fallen tree snags are detailed, even to an orange touch of rotten wood beneath.

Some beadworkers have been intrigued with rendering a truly dimensional landscape in great detail. The maker of a mid-century Umatilla bag (plate 39), by shading her colors, elaborating contours, and using longer bugle beads to suggest the rough escarpment of the cliff edge, has expertly captured the color and texture of a complex landscape in which two horses stand near a tall tree snag. Such close observation and careful translation of special details of the landscape of the region continue to be a hallmark of some Plateau beadwork.

Many Plateau bags seem to refer to particular events, recording (sometimes with humor) and honoring memorable occasions or incidents (plate 40). Rodeos are an important part of the yearly cycle for Plateau people, especially those of the Umatilla Reservation near Pendleton. The appearance of rodeo scenes on bags seems to have coincided with the establishment of the Pendleton Round-Up in 1910. The riders on bucking horses that became popular on flat bags are very similar to those in the newspaper and advertisement publicity shots that became more prominent every year. An unusual shield-shaped bag (figs. 6.7, 6.8) from 1931 in the Bounds Collection is beaded on both sides with narrative scenes. In one, a thrown rider faces a second challenge as he lands face to face with a bear. Lest we not understand, the maker has beaded in a caption detailing the specifics. The opposite side seems to record a danger that is a recurring aspect of Plateau experience, the forest fire. Water laps at the feet of a stag who has retreated to a stream and stands alert before trees and an orange-red sky. One bag (plate 41) places an Indian girl in a canoe, paddling in a landscape. Other popular themes are portraits of young Plateau women wearing the typical basketry hat and tail dress with its heavily beaded shoulder area.

American eagles, often with combinations of flags, buntings, and shields, were particularly popular after both world wars and continue

6.6 Illustrations from the 1897 Sears Roebuck catalog show that an elk standing erect against a landscape, often framed by foliage, was a popular motif on men's pocket watches at the time. They may have inspired similar scenes on Plateau bags. Photos courtesy Museum of the Rockies, Bozeman, Montana, and Chelsea House Publishers, Broomhall, Pennsylvania.

6.7 (*below, left*) Beaded bag, Umatilla, ca. 1931. The bucking horse was a popular motif after the advent of the Pendleton Round-Up. Whether the maker is describing a real situation is left to question, but she has made sure the specifics are not lost by including the caption: "After the sixth jump, Jim leaves saddle and hits the ground in front of that ole bare snoot." Height: 20.25 in. Width: 9.5 in. Date collected: 1958. (2.6.172)

6.8 (*below*) On the reverse of the bag shown in figure 6.7, a stag elk is threatened by a forest fire. (2.6.172)

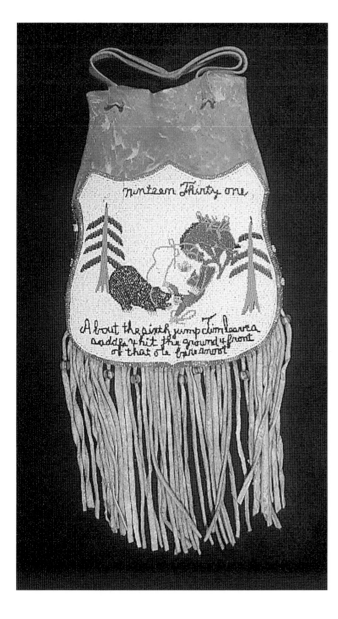

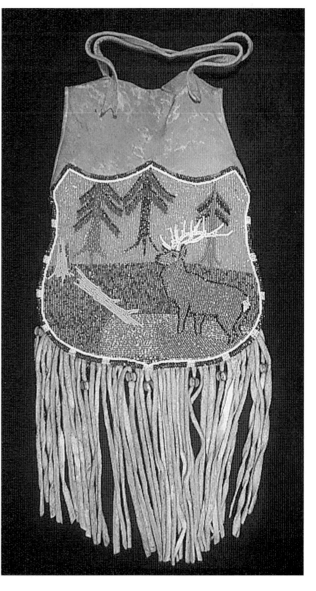

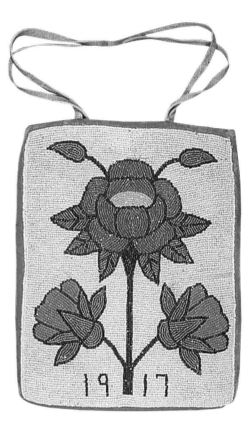

today as images of patriotism and of honor to those who have served in the military. Several Bounds Collection pieces (fig. 6.9) incorporate such images.[17]

Roses are the most popular identifiable flowers on Plateau beaded bags. On earlier examples (fig. 6.10), they are stylized into flat petals; on more recent ones they are often shaded to create a sense of dimensionality.[18] This is probably in part because more shades of a given bead color have become available with which beadworkers can experiment, but a more important factor has been the transfer pattern.

Transfer patterns had been popular on the Plateau before Yakama beadworker Celia (or Cecelia) Totus began commercializing them in the early 1970s. Although she is now gone, Celia Totus Beadwork Patterns are still sold across the continent at shops and by vendors at powwows (figs. 6.11–6.13). Comparison of Celia Totus patterns with similar beaded designs makes it clear that these patterns have been used primarily for inspiration. In addition to choosing her own colors, the beadworker often has taken considerable license with the image. Transfer pattern designs, like other images in the public sphere—those on greeting cards,

6.9 (*left*) Beaded bag, Plateau, early twentieth century. Made by Emma Jones Burke, one of the Cayuse twins photographed by Major Lee Moorhouse, and given to Bounds at Burke's death. Eagles on Plateau bags may hold similar conventional poses, but each is a bit different. Height 11.5 in. Width: 10.5 in. Date collected: 1970. (2.6.185)

6.10 (*right*) Beaded bag, Yakama, 1917. This bag is interesting because it contains some of the elements of the old-style division of the contour bag. Height: 6.5 in. Width: 8 in. Date collected: 1959. (2.6.40)

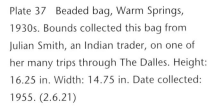

Plate 37 Beaded bag, Warm Springs, 1930s. Bounds collected this bag from Julian Smith, an Indian trader, on one of her many trips through The Dalles. Height: 16.25 in. Width: 14.75 in. Date collected: 1955. (2.6.21)

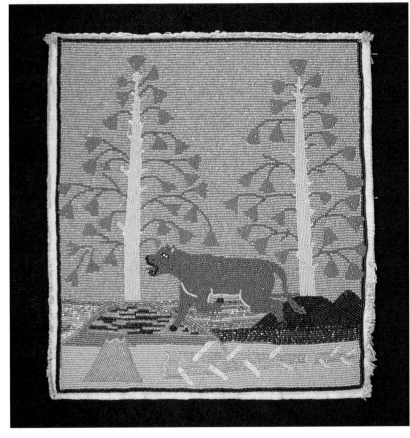

Plate 38 Beaded bag, Plateau, 1930s. Made by Ellen Heath, Warm Springs Reservation. Once entire scenes became popular on bags, Plateau beadworkers gave a great deal of attention to subtle details such as terrain colors. The tree trunks may depict red pines. "The mountain scene and the land elements show the lay of the land, and the beading is a reflection of this training" (Bill Burke, Umatilla). Height: 13.75 in. Width: 12.5 in. Date collected: 1964. (2.6.13)

(*overleaf*) Plate 39 Beaded bag, Plateau, mid-twentieth century. Purchased at Barnum's Trading Post. Beadworkers picture the landscape they closely observe and love. Here, a combination of linear and contour beading creates depth and dimensionality. Height: 11.5 in. Width: 13.25 in. Date collected: 1963. (2.6.149)

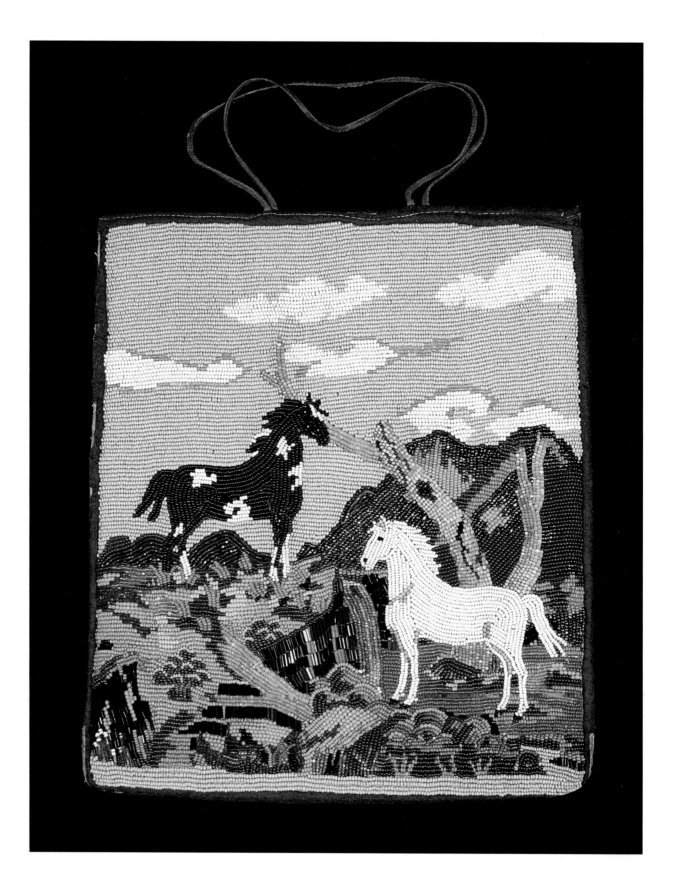

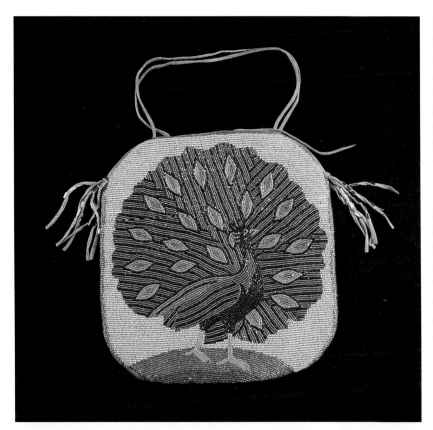

Plate 40 Beaded bag, Plateau, probably Umatilla, 1890–1945. Many Plateau beaded bags make reference to aspects of daily life. For years, strutting peacocks have been a common sight at the Maryhill Museum overlooking the Columbia River near the main road connecting the Umatilla and Yakama Reservations. Height: 10 in. Width: 9.75 in. Date collected: 1965. (2.6.151)

Plate 41 Beaded bag (front and back), Plateau, mixed dates. Acquired on the Umatilla Reservation. Beaded on both sides. The geometric side probably dates from the 1920s, the figurative side from ca. 1950. An Indian man or woman in a canoe was a popular subject at mid-century. Height: 10 in. Width: 8.5 in. Date collected: 1964. (2.6.5)

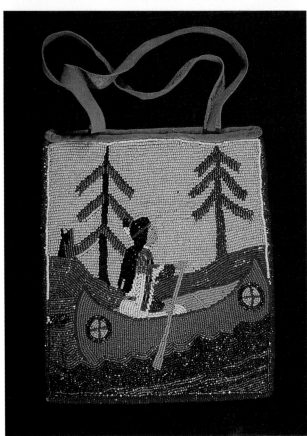

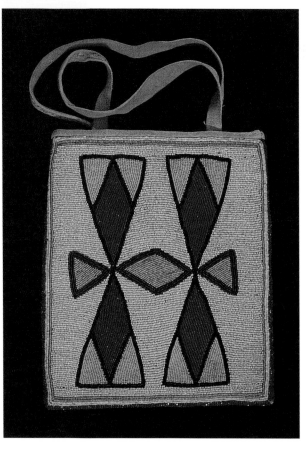

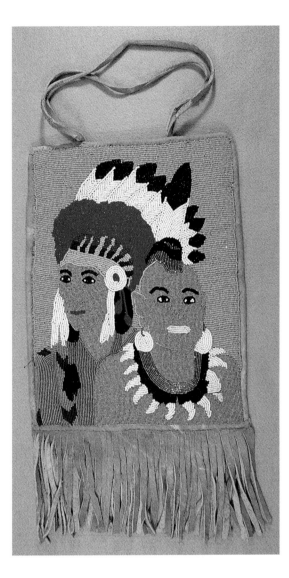

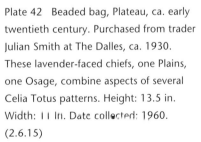

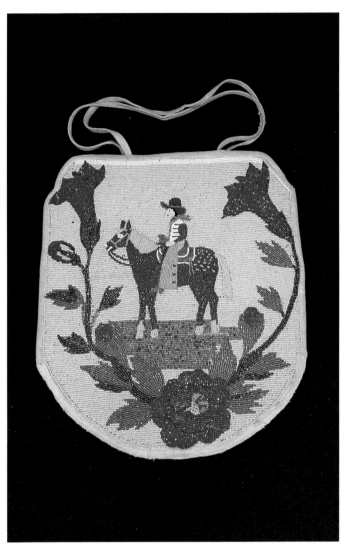

Plate 42 Beaded bag, Plateau, ca. early twentieth century. Purchased from trader Julian Smith at The Dalles, ca. 1930. These lavender-faced chiefs, one Plains, one Osage, combine aspects of several Celia Totus patterns. Height: 13.5 in. Width: 11 in. Date collected: 1960. (2.6.15)

Plate 43 Beaded bag, Plateau, 1890–1945. This bag once belonged to Narcissus McKay and was purchased from E. W. Barnum, Pendleton, Oregon. When money was needed unexpectedly, a family might pawn an heirloom at a shop like Barnum's. Because of its larger size, this bag, with its cheerful blue Appaloosa and his colorful cowboy rider, could be displayed nicely on a horse. Height: 14 in. Width: 12.5 in. Date collected: 1963. (2.6.19)

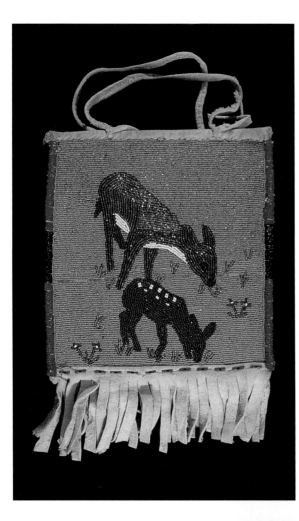

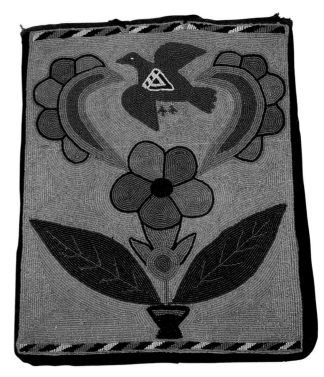

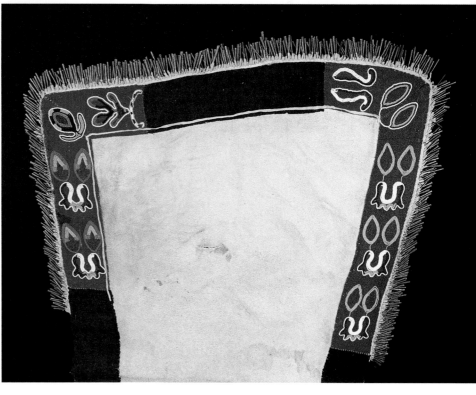

Plate 44 Beaded bag, Umatilla, 1920s–1940s. This bag was received from Liza Cowapoo Bill, who got it in a trade. Solidly beaded edging appears only occasionally on Plateau bags. Height: 11 in. Width: 7.75 in. Date collected: 1965. (2.6.143)

Plate 45 Beaded bag, Plateau, ca. 1885–95. This contour-beaded bag is very unusual in its combination of motifs and likely had a particular meaning to its maker. Height: 11.75 in. Width: 14.3 in. Date collected: 1971. (2.6.59)

Plate 46 Saddle blanket, Cayuse, late nineteenth century. Early abstract floral on bare wool background, with slots for the girth to go through. Length: 55 in. Width: 32 in. Date collected: 1961. (8.1.13)

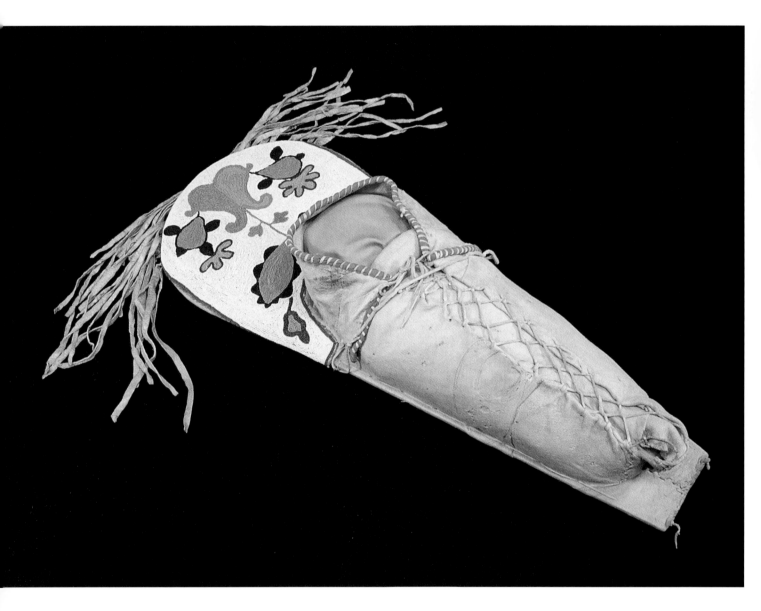

Plate 47 Cradleboard, Yakama; oldest
part, late nineteenth century; newer
additions to 1950s. This cradle belonged
to Louise Showaway's grandmother Mary
Teneche-Shuli-Pum, who belonged to the
Mid-Columbia and Yakama Tribes. It was
used by several generations of babies. The
high, rounded headboard, a popular
Plateau form, helped protect the child's
head. Height: 36.5 in. Width: 14 in. Date
collected: 1966. (9.10.4)

Plate 48 Man's beaded vest (front and back), Umatilla, 1920s–1950s. Willard Showaway's name is written inside the collar of this vest in the handwriting of his mother, who probably made the vest. She was a master tanner, and the quality of her work shows in the supple smoked buckskin of the vest back. Leona Smartlowit, Willard's sister, noted: "Willard is a veteran of the Korean War, therefore this vest was probably made about 1949–50." Beadwork is sometimes reused or put together in a new way, as is the case here. The beaded front seems to date from the 1920s, and the eagle appliquéd on the back, to the 1950s. Height: 22 in. Width: 19 in. Date collected: 1963. (6.22.11)

Plate 49 Beaded cuffs, probably Yakama, ca. 1900. Gauntlet cuffs may be worn alone by tying them at the wrist. The tiny cut beads that lend sparkle have long been beloved on the Plateau. Because they are hard to acquire today, a trader at Warm Springs has devised a method for cutting facets on round beads to attain the same sparkle. Height: 6.25 in. Width: 11 in. Date collected: 1963. (6.5.1010a/b)

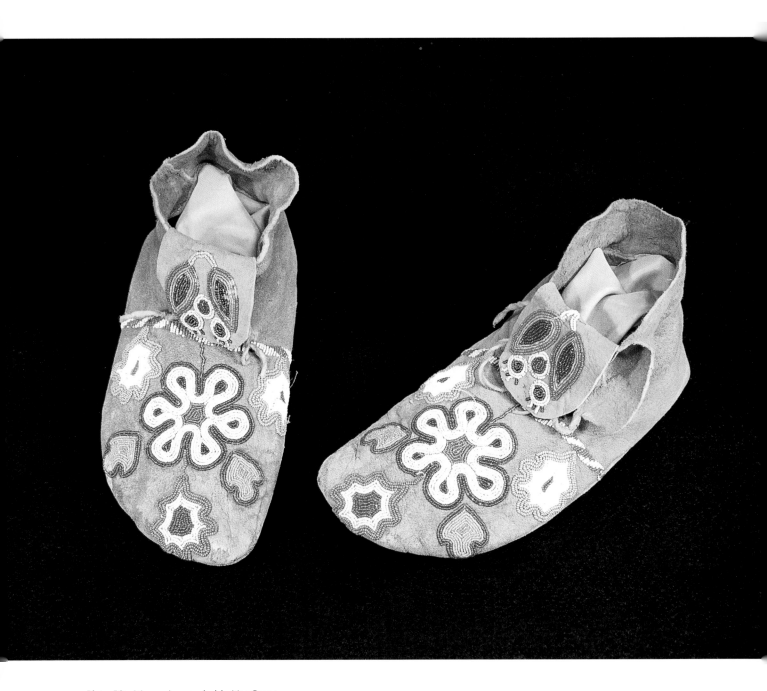

Plate 50 Moccasins, probably Nez Perce,
ca. 1900. The beaded front over-tongue
on these one-piece soft-sole moccasins is
unusual. Although Doris Bounds identified
these as Mandan, they were most likely
made on the Plateau. The motifs here are
similar to those on a pair that belonged to
Chief Moses (see Wright, *A Time of Gather-
ing,* fig. 3). Height: 10.5 in. Length: 4.5 in.
Date collected: 1963. (6.15.21)

in magazines, on fabric, and so forth—have provided inspiration and ideas but seldom have been copied slavishly. For instance, the rose on a Bounds Collection bag (plate 2) is similar to certain Totus patterns but follows none exactly. The two chiefs on one bag (plate 42) seem to have been inspired by Totus patterns, but the beader has made changes. The internal color handling of the tulips on another bag (fig. 6.14) shows that it was inspired by the same pattern as yet another in the Bounds Collection, but the overall results are different.

The Plateau aesthetic embraces bold visual statements and contrasts. Beadworkers speak of being taught that it is important that an individual create her own designs. Nowhere else in North America is there the variety and experimentation with subject matter and its rendering that is found in Plateau floral and figural beadwork. There are a number of popular subjects, but beadworkers handle each of them in their own ways (fig. 6.15).

Although the rectangular handbag has been the norm since early in the twentieth century, there has also been a continual undercurrent of experimentation with form. The bags in the Bounds Collection, particularly those from the Umatilla Reservation, demonstrate this. There are circular and oval bags, heart-shaped bags (most of which Doris acquired from the late 1940s through the 1960s), trapezoids, and polygons with five, six, or eight sides (plate 43). Idiosyncratic shapes include baskets, shields, a flapped envelope, and one example in the shape of the head of a man with a feathered headdress.[19]

6.11–6.13 Celia Totus transfer patterns. Courtesy Celia Totus Beadwork Patterns, Toppenish, Washington.

Most bags, rectangular or otherwise, have a simple carrying strap of hide thong or cord. Some, however, are attached to metal pocketbook snap closures or are zippered at the top (fig. 6.16).[20] A box-shaped purse (plate 44) from the Umatilla Reservation has been constructed by inserting a narrow band on three sides between the two flat panels and adding a carrying handle. The sides and insertion band are solidly beaded and the edges are bound with beading.

Ordering and Honoring:
Beadwork and Life's Essential Connections

Grant McCracken's observation that clothing "reflect[s] changing historical circumstances" and "creates and constitutes this change in cultural terms" clearly applies to Plateau beadwork.[21] Beaded pieces communicate cultural categories, principles, and processes. They and their use reflect the order and categories that Plateau culture has imposed on life—especially gender roles and principles of social and family ties, which are played out through established social processes. They also demonstrate ongoing accommodation to change within these culturally constructed categories.

The flat bags, cradleboards, gloves, vests, and dresses of the Bounds Collection were made within a layered cultural matrix that allowed their owners to mark special occasions and celebrate beloved people and places. Beaded items have always been produced on the Plateau as gifts and tributes to cherished friends and family. It is an honor to give and to receive beadwork, and doing so connects generations through tangible works of art. For centuries, ornamented clothing and bags have been important to the giving that often occurs in a ritual or semiritualized situation—in conjunction with marriages, namegivings, and funeral and memorial giveaways. Generosity is valued and admired, and some say it brings good fortune. As is the case elsewhere, the giving of beautifully made and appropriate items is a point of pride. The craftsmanship and beauty of beadwork and fiber items make a public statement and do not go unnoticed.

Over the years, Doris Bounds participated in many giveaway occasions and received a number of gifts. Later, when carrying a beaded bag she had received, she was careful to honor those who were a part of its history by identifying to whom it had belonged and the name of the person in whose memory it had been given.

Among the beadwork items in the Bounds Collection are several pieces that she or others received at funerals and memorials, showing those families' appreciation for her friendship. At a funeral, when possessions of the deceased are given away, a woman's cherished beaded bags may be presented or returned to her special friends or given to

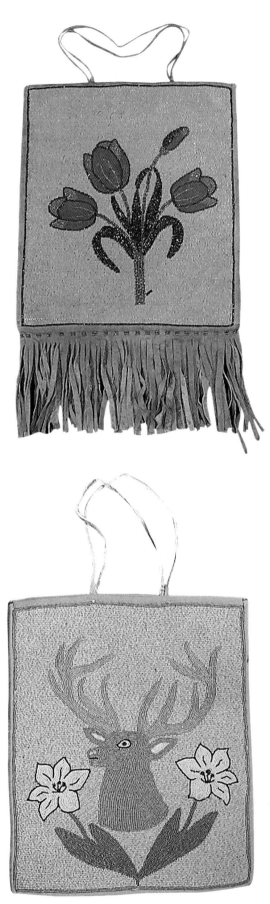

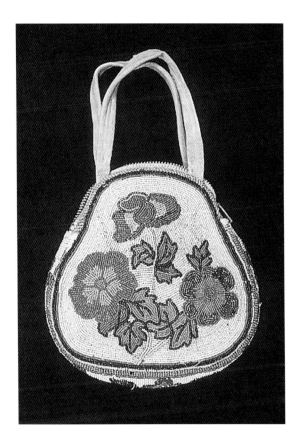 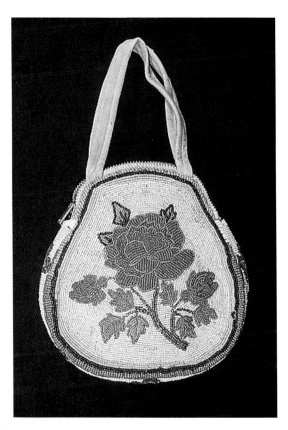

members of her family. Very valuable items such as ornamented hide dresses usually go to family. At the memorial giveaway, held a year later, both old and new articles, including beadwork, are presented to friends of the deceased.

A beaded handbag with an eagle and shield (fig. 6.9) and made about 1930 by Emma Jones Burke, one of the famous "Cayuse twins" photographed by Moorhouse in 1898 (see figs. 1.3, 1.4), was given to Doris after Emma's death. Another bag in her collection, the fine old

6.16 Front and back of beaded bag with zipper closure, Plateau, 1890–1945. Height: 7 in. Width: 6.5 in. Date collected: 1948. 2.6.28.

(*facing page, top*) 6.14 Beaded bag, Umatilla, 1920s–1940s. Flowers, real or imaginary, have been a primary subject of Plateau beadwork since its beginnings. These tulips are similar to those in Celia Totus patterns. The bag was made by Susie Williams (Umatilla), who was the grandmother of Maynard White Owl Lavadour. Height: 10.75 in. Width: 16.5 in. Date collected: 1958. (2.6.164)

(*facing page, bottom*) 6.15 Beaded bag, Plateau, early twentieth century. Notice the similarity of the elk design to the watch case designs from the Sears Roebuck catalog. Height: 15.75 in. Width: 13.5 in. Date collected: 1952. (2.6.52)

floral one discussed earlier (fig. 6.5), was received by Mrs. J. M. Cornelison at Allan Patawa's giveaway in the late 1940s and was later added to the Bounds Collection.

A naming is another occasion when beadwork is often given, honoring the continuity represented by the renewal of a name from an earlier generation. A child may be given the name of a person now deceased whom he or she resembles or whom the family admired and wishes the child to be like. When the name of someone deceased is "brought out" and given to a child, gifts are "given on the naming." Beadwork may be among the gifts presented to those who knew the name's previous owner or to other honored elders (plate 50).

Beadwork may also be a part of giveaways associated with individual accomplishments such as graduation from college or return from the service. Sometimes the event itself is referenced in a bag design. Beadwork may be given on the occasion of a "joining," when a new dancer makes a debut or an individual joins again in dancing at the end of the prescribed year of mourning after the death of a family member. Sometimes a beadworker will make a special beaded bag as a birthday gift or for some other special occasion (plate 45).

Some of the beaded items in the Bounds Collection probably at one time changed hands in a wedding trade. In a traditional wedding in earlier times, the groom's family brought to the bride's family meat and other products of hunting and other men's occupations, along with manufactured goods such as blankets, while the bride's family contributed horses, roots, and objects made by women—bags, baskets, and beaded clothing and horse gear (plate 46). The groom's family's contributions went to members of the bride's family, and those from the bride's family went to the family of the groom. The gifts from the bride's family were a public show of love for the daughter. The number of horses given on a marriage was a marker of status.

Women from each side might also decide to "trade on the wedding," exchanging bundles of similarly gender-dictated goods. Beadwork was often included in the bundles brought to trade. This is still done today, and the parts of an outfit—a shawl, beaded bag, necklace, and length of fabric for a wing dress—may make up such a bundle. Women have always been astute about equity in the trade.

Each of these interactions involving beadwork reflects the order that Plateau culture has built into societal norms and the rituals reinforcing them. Each acknowledges and reflects both the natural order and society's imposed order while at the same time honoring and reinforcing it. Beadwork honors life.

Cultural principles and processes are embedded in the way beadwork supports essential human connections. Who beads for whom reflects and reinforces kinship ties, obligations, and affections. A mother or

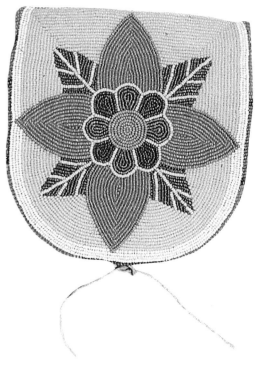

6.17 Beaded belt bag, Umatilla, Cayuse, or Nez Perce, ca. 1900. Belonged to Narcissus McKay. A small bag attached to the belt has long been a common part of a dress outfit. Most are rounded at the bottom. Stylized flowers are a popular subject. Height: 6 in. Width: 5.75 in. Date collected: 1963. (2.1.1006)

grandmother usually makes a child's cradleboard (plate 47). A grandmother may bead the needed parts of an outfit for a grandchild who wants to dance. The small belt bag shown in figure 6.17 was probably part of a child's outfit. When a girl is competing in a princess contest, several family members may participate in beading the elaborate, coordinated, old-style outfit she will need.

A woman carrying a fine bag, a husband wearing an elaborately beaded vest (plate 48), and a child dancing in his or her first beaded outfit—all make statements about pride and the gift of the makers' time and love. A daughter or granddaughter well-dressed for a competition, perhaps with matching beaded horsegear, affirms, in addition, the family's ability to afford to sponsor her. The designs on beadwork (which on dance regalia may be addressed to the taste and wishes of the recipient) and the wearing of it root one in place and time—not only in relationship to a specific event but also within family and tribe (fig. 6.18).

The traditional way of teaching beading reinforces family connections and the customary way of passing down wisdom. If a girl shows an interest in beadwork, she is allowed to try it. Even though beading is now sometimes taught at school, girls (and sometimes boys) often learn in the old way—by watching someone at home bead, imitating and learning culturally accepted ways of making beadwork, and by having early projects evaluated and sometimes torn down to be redone until the beading and sewing are right. Relatives—grandmother, aunt, or mother—are the preferred teachers.

On the Plateau, beadwork has, since its inception, been admired and valued, packed with care when transported, and carefully stored when not in use. Today, as in the past, it is an honor to create it, to give it as a special token, and to carry or wear it in public. Its images record and honor Plateau life—the beauty and bounty of its natural setting and special events that distinguish individuals while linking them to the community. When displayed, beadwork reminds one of past events; when given, of connections of affection and kinship, always embodying both the past and the present.

Doris Bounds recognized the profound importance of beadwork to her many Plateau friends. Her devotion to the art of beadwork over many years, and her decision to place her collection among its makers where they and others could enjoy and learn from it, are the tangible fruit of understanding, her way of honoring them and the parts of life she was privileged to share with them.

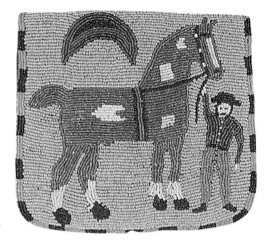

6.18 Beaded belt bag, Plateau, ca. early twentieth century. Height: 5.5 in. Width: 5 in. Date collected: 1960. (2.1.1002)

7.1 Chief Raymond "Popcorn" Burke and Junior Indian Beauty Contest winner Samantha Crane with Doris Bounds, 1980s. Courtesy Lou Levy, Pendleton, Oregon.

Being an Indian girl who was not very "knowledgeable of the world," it was sometimes a little scary to experience going to country clubs, meetings with VIPs, eating extravagant dinners with creme de menthe sundaes, and, especially, making speeches as part of the Pendleton Round-Up and Happy Canyon courts. Doris critiqued us and gave us a pat on the back about our speeches and conduct. She even gave in to us that year and attended a teen dance with Carla and me, as our chaperone. She would not let us go by ourselves. She was so young at heart.
—Lillian "Sis" Moses

Doris Bounds's Role in Contemporary Native Pageantry

BARBARA A. HAIL with comments by
LILLIAN "SIS" MOSES (Nez Perce, Yakama, Cayuse)

During the past seventy-five years, there have grown to be a number of Indian "Miss" or "Princess" competitions in which young Native American women participate, representing a particular event, their tribe, a community, municipality, or state, or the nation as a symbol of Indian womanhood. A sampling of such titles includes Miss Yakama Nation, Happy Canyon Princess of the Pendleton Round-Up, Miss Indian Milwaukee, Miss Indian Oklahoma, Miss Indian Nations, and—the most representative award ever given—Miss Indian America. Although these contests are of less importance now than formerly, they continue to exist, especially in the Plateau, probably because they serve a societal function for Indian people beyond that of simple pageantry.

During the 1960s and early 1970s, Doris Bounds was closely involved with girls who were contestants for various Indian "princess" competitions (fig. 7.1). Locally, she served as a judge for the winners of the "Junior American Indian Beauty" contest and as a chaperone for sixteen years for the "Happy Canyon Princess" contest, whose winner was selected yearly as part of Oregon's leading rodeo, the Pendleton Round-Up, and the pageant of early Indian life presented during its weekend ceremonies.

Doris Bounds also served as a judge from 1968 to 1971 at the much larger national competition, Miss Indian America, held in Sheridan, Wyoming, from 1953 through 1983, and thereafter for several years in Bismarck, North Dakota.[1] I had the pleasure of serving with Bounds as a judge in 1968 and was impressed with her knowledge of traditional dress, her enthusiasm for the event, and her personal interest in the young contestants. As everyone who knew her can attest, Bounds was outgoing and flamboyant in dress as well as personality. She created quite a stir among the more sedate judges by arriving for interviews with contestants wearing high-fashion clothing and a profusion of silver and turquoise jewelry that rivaled that worn by Navajo and Pueblo competi-

tors. Fortunately, her unabashed good humor and obvious admiration for the Native artistry that had created such excellent ornamentation won over any potential critics.

This competition, unlike the more regional ones, was not primarily a beauty or popularity contest. Instead, it was conceived of as part of a three-day annual celebration of Indian life and culture known as All American Indian Days. Its primary objectives were to promote better relations between Indians and non-Indians and to encourage Native cultural pride. To that end, each candidate was judged on her awareness of her own culture and on her proven dedication to the advancement of Indian people, in addition to scholastic ability and poise.[2] The winner traveled widely throughout the United States and sometimes abroad, making public appearances before school and civic groups and visiting reservations. It was hoped that through her efforts, the general public would be made more aware of the problems, aspirations, and unique contributions of Indian people.[3]

From the beginning, an Indian executive committee, largely from the Plains region, shared responsibility with non-Indian sponsors for the success of the celebration, and together they formulated its goals. Beyond the colorful pageantry was the serious purpose of acquainting the visiting public with Indians' needs. Further, the annual assembly of different tribes provided them an opportunity to visit among themselves and discuss common issues. Finally, the presentation of dances, ceremonies, games, and arts and crafts provided a means of preserving and honoring Indian culture.[4]

Although the broad and serious goals of the Miss Indian America competition and All American Indian Days were probably unique for their time, many other pageants still in existence enjoy wide support from both Native and non-Native groups. Often entire communities participate in ensuring their success. Private and public sponsors have included tribal councils, chambers of commerce, Shriners, nonprofit educational foundations, and the American Association of University Women. They help to pay for travel, lodging, food, publicity, and other costs of contestants, including funds to send winners of local contests to larger events.

The larger significance of such contests has been their role as cultural perpetuators among women, who value and transmit traditions of dress and material culture. The contests reinforce family linkages through the mutual commitment of parents, siblings, aunts, cousins, and contestant daughters to each other and to the contest. They inspire preservation and replication of traditional dress, with the passing down of knowledge of specific beadwork designs, techniques, and cuts of clothing. They reinforce sibling and mother-daughter roles, since both dresswear and the opportunity to compete for a title move from older to

younger siblings and also between generations. They help to develop female independence, broadening outlooks through contacts between young women of different tribes and promoting understanding between Indians and non-Indians. The experience frequently opens doors to educational or vocational opportunities.

An important corollary of such contests is the consolidation of a family around the contestant (fig. 7.2). Often the entire family travels to an event and participates in games, dancing, and other aspects of what is usually a weekend program. It becomes a time to be together, to display traditional skills, and to honor one's elders. Recently a former contestant recalled, "The only reason I did it [competed in contests] was because at the time, my mom wanted me to dress up and to do things like that. I think it was for my mom."[5]

Our family has participated in the Pendleton Round-Up as long as I can remember. We have put our tipis up and camped throughout the four days of the rodeo along with many other Indian families from all over Indian country. I participated, as did my sisters, in the Junior American Indian Beauty contest and the Senior American Indian Beauty contest held for young Indian girls during the Pendleton Round-Up. Once you win first place, you cannot compete again in that particular contest. I have friends and cousins who tried out with many other girls to be a Happy Canyon Princess. The princess or princesses preside over the Happy Canyon Night Show, part of the Pendleton Round-Up. It is a show that tells "how the West was won."
—LM

7.2 Kristen Annie Moses (Nez Perce, Yakama) with grandmother Dolores Moses and aunt Teresa "Gussie" Moses, wearing one-hundred-year-old Nez Perce dress in Senior American Indian Beauty contest, Pendleton, Oregon, 1987. The family of a contestant played an essential role in preparing her to compete: making or selecting the costume, helping her to dress, and accompanying her to events. Dress and photo courtesy Duane Alderman.

The family supplies the contestant's dress and, when required, a horse decorated with fine horse trappings for her to ride. Such paraphernalia might be either carefully preserved family heirlooms or items newly made for the occasion, perhaps based on remembered designs. Some are borrowed. Doris Bounds recalled, "I have loaned dresses from our collection to princesses who did not have family costumes. . . . This doesn't happen very often, however. . . . We usually tried several to select the best fitting one."[6]

Replicas of old dresses that are too fragile to wear are sometimes made by a skilled family member or close friend, thus preserving knowledge of traditional designs and cuts. One Miss Indian America contestant brought the attention of the judges to the beaded designs in her deerskin dress and to her involvement with her mother in learning about them. She said her dress was "authentic Spokane, as my mother made it," and added modestly, "I helped out here and there."[7]

Some families seem to learn how to compete successfully and have multiple winners. In the Moses family of Pendleton, Oregon, three sisters and five of their daughters have gained the Happy Canyon Princess title, and one became the first honor attendant to Miss Indian America, 1968. Dresses are often handed down in families, each girl wearing it when it becomes her turn. "We went in steps," said Lillian "Sis" Moses.[8] Daughters sometimes succeed their mothers in competing for titles. In 1976, the first runner-up for Miss Indian America XXIII was the daughter of Miss Indian America I. Her two small sisters appeared at the contest in beaded dresses also, and probably looked forward to competing in their older sister's place—and possibly her dress—when their turn came.

An important aspect of such contests is the pan-Indian networking that takes place. Miss Indian America contestants often listed "meeting people from other tribes" as their primary reason for entering. New friendships and understandings among young women of different tribes broadened their perceptions. Reunions of prior Miss Indian Americas continued for many years as former contestants returned to observe the ongoing competitions, and some lasting relationships resulted.

Another positive result of the contests voiced by several Miss Indian America contestants was the genuine honor they felt at symbolically representing other Indian people. An Oneida contestant wrote of her desire "to preserve our Indian culture, and to present myself at all times in the best example of young Indian womanhood."[9] Another contestant thought it a "wonderful opportunity to meet members of other tribes, and to present my story of my people, the Northern Cheyenne tribe."[10] A Hopi girl said, "I believe by my entry I will have set an example for other girls. I feel it is vital for a young person to be a good representative for our Indian people, not just the tribe you belong to, but for the whole Indian Nation in general."[11]

The Pendleton Round-Up had "cowgirls" who became the queen and her court, and the Happy Canyon had Indian girls for the princesses. The Happy Canyon court mostly consisted of two princesses, though sometimes there was only one princess. My younger sister, J. Michele (Titto) Moses, was one of the two princesses one year and was asked to be a princess by herself a second year. I tried out to be a princess the year of 1968, not knowing exactly what I had to do or what was to be expected. All I knew was that it was enjoyable to do as many Indian functions as possible and that my mother enjoyed watching her children participate in dances, plays, and competitions.
—LM

Finally, these contests serve as inspiration to young women for future achievement. In a press interview in Rhode Island during her tour of New England colleges, Miss Indian America of 1968 stated that "the Miss Indian America pageant has had a psychological effect on Indian girls, giving them something to strive for." She added that an Indian Olympics would similarly benefit "the spirit" of young Indian men.[12]

"Miss" contests stemmed from both Indian and non-Indian needs. They were most vigorous in the 1950s, 1960s, and 1970s. There seems to be less interest in them now, reflecting a change in societal attitudes and greater opportunities for young Native people. Mixed feelings about young women's "Miss" competitions in non-Indian society have been mirrored in similar competitions among Native American groups. Feminist sensitivities to the objectification of women have influenced attitudes about the appropriateness of young women's contests based in part on physical attributes. Additionally, in recent years there has been an increasing determination among Indian people to be in charge of their own history and culture. With this has come a desire for detachment from Anglo-sponsored events that reinforce Indian stereotypes such as the "Indian princess."

At the same time, patronage relationships are fading, and there are fewer sponsors from business and community organizations willing to serve as financial supporters and chaperones. Some events, like the Happy Canyon Princess contest, require the girl to travel to a series of rodeos throughout the region during the season. In the early days, the expense of transporting a horse was shared by sponsors, but in recent times it seems to fall on the girl's family. Two Happy Canyon winners of the 1960s recalled that in their time, with Doris Bounds as chaperone, they felt that they "were being taken care of, whereas now it's a lot of your own expense. You even have to haul your own horses. . . . [It's] a lot of traveling. . . . Before, Doris took care of everything and kind of watched over us."[13]

Such pageants among Native Americans grew from real needs and became a means of extending traditional mores, customs, and skills to the present. During the middle years of the twentieth century, they were one of the few highly visible means of expressing cultural values and communicating them between Indian and non-Indian. Doris Bounds's close involvement with such contests at that time exemplified her long-standing and very personal commitment to Native people.

Doris and I also went through hardships together. She always listened to me during our visits and offered sound, healthy advice. We could depend on her to be our friend. Traveling through Hermiston when Doris was alive, I always felt comfortable even when I did not stop to visit her. I felt a part of Hermiston just because I felt close to Doris.

I realize what the mourning process is all about. I have experienced several losses in my family. Doris seemed to make both Pendleton and Hermiston much more important places. Any place I go where Doris and I have been together (as I traveled through Sheridan, Wyoming, this past summer), I think of her. I feel her presence . . . she's the wind, beautiful sunset, and white shining moon.

Doris knew so many Indian people all over Indian country and they loved her. Her love of the Indian people and culture shows through her collection of Indian artifacts and art. In many ways she has preserved our history and traditions and I thank her greatly. I am proud of her and proud to have known her. She has made me more proud of my rich heritage and culture. I met a lot of wonderful people during my reign as a Happy Canyon princess but none so grand as Mrs. Bounds. Words cannot describe my love for Doris. She always walked in beauty.

—LM

Afterword

VIVIAN M. ADAMS (Yakama)

Many changes have occurred in Plateau Native cultures since the time the earth was made ready for them by the Animal People. Their lessons, retold in story form, helped guide humans to a balanced and sharing lifestyle that saw only moderate cultural change through millennia up to historic times. But the arrival and settlement of this territory by Euro-Americans forced cataclysmic changes in Plateau culture within a relatively short time.

Because White people did not understand a culture that did not exploit the environment for individual profit or call a piece of ground its own possession, there was plenty of "unowned" land available for White settlement in Plateau country. Thus came the flood of immigrants seeking real estate, natural resources, and opportunity. Treaties were hastily negotiated for the removal of the Native people onto reservations, and the pristine Plateau lands were immediately opened for settlement.

Native people were taught that it was better to look, speak, learn, work, worship, and live in imitation of the white man's lifestyle. Government mandated these cultural changes, and Native people had to assimilate quickly for survival.

In the late nineteenth and early twentieth centuries, the federal government began to notice the drastically depleted Native populations and the radical cultural changes the Native people had been forced to make. Again, hasty mandates by government were made, this time for its institutions to pursue the collecting of Native objects to hold as mementos of the new country's diminishing numbers of indigenous peoples and their disappearing Native lifestyles.

Frenzied and competitive collection efforts produced the collections now found throughout the United States and worldwide in museums and in private ownership. Very few of the early collectors were sensitive to, or understood, the peoples from whom they amassed their objects. Often, collectors made no concentrated effort to appreciate the

people who made the objects they collected or those objects' cultural significance.

United States history has only recently begun to include the Native perspective of how this relatively young country came into being and the sacrifices its First People made toward its development. Nor are great numbers of people aware of treaty rights, reservations, sovereign nations, tribal governments, Native worldview, and the continued struggle of the First People to protect and preserve their lands, resources, and traditional lifeways.

Times change, and so do sensitivities to cultural awareness. A few hundred years have passed since the Native peoples adapted their lifestyles to those of White society. Today, hundreds of Native cultures continue to practice the beliefs that have always connected them to the earth and her creatures—inherent beliefs that have sustained them through enforced and dramatic changes.

Fortunately, some non-Native people have taken the time to learn about Plateau lifeways on their own. Those who have followed their interests to learn about these indigenous cultures find understanding and create friendships among their Native neighbors. This, to me, is what Doris Bounds's collection represents—objects exchanged in friendship and respect. The impression I receive when listening to people who knew Doris and called her "friend" is that she was a caring, appreciative patron and supporter to her Plateau neighbors. The gifting and exchange of the objects in her collection, and the stories she noted in her cataloging of those items, reflect the mutual understanding, respect, and love they shared.

This type of sharing and friendship is surfacing as the foundation of contemporary museum interpretation. An emerging scholarship combines the anthropological and art historical disciplines and more closely reflects the inherent Native worldview expressed in their material culture. During the last decade, museums have begun to present cultural exhibitions that include a Native viewpoint, a Native voice, and a welcomed sensitivity to cultural considerations. Cooperative efforts like these are steadily growing between museums and Native cultures. A great and flowing understanding is taking place because of this new attitude.

Native perspective is being included in the planning phases of exhibitions, in the implementation process, and in accompanying public programming. These presentations fill an educational void to enlighten the general public about indigenous peoples' histories and lifeways—subjects often neglected in our educational system.

Museums, historical societies, galleries, and similar organizations are working with Native consultants to construct more fully developed presentations. No longer are scholars who study Native cultures and ob-

jects ignoring the spiritual attitude intrinsic to the production of Plateau art, or the cultural context within which the art is used. By adding that information, they give the public a deeper insight into Plateau beliefs and customs. Researchers are beginning to realize that through cooperative investigation with Native peoples, they may uncover new inter-pretive information, not only in present tribal practices but also in past academic recordings that were ignored or went unnoticed by early-twentieth-century scholars.

Art historians and the art world in general have come to recognize and acknowledge indigenous artifacts as works of art. But Native art has never been art made for art's sake. Instead, the objects were and are made in a spiritual manner, they hold meanings that may symbolize beliefs or emotions, and they have particular uses in daily life. The academic and art worlds are beginning to grasp the Indian belief that beauty is not separate from function but is an intricate part of any object.

Native American attitudes and opinions are also changing in regard to the display of their cultural artifacts. Museums are bringing some balance back into the Natives' slanted opinions of museums caused by the early frantic collecting. Some ceremonies and their accompanying art objects were lost forever to Native peoples. Happily, though, some objects kept in museum storage that were related to documented ceremonies have now been returned to Native owners, resulting in a revival of those ceremonial rituals. Early ethnographic recordings, as well as a changed national perception of Native cultures as reflected in changes to the law, have assisted in these revivals. The new cooperative and culturally sensitive attitudes of museums, and the changing perception of museums by Indians, will result in presentations that benefit all of society.

We will all benefit through enhanced cultural self-esteem, pride, and mutual respect. A cultural awareness of America's indigenous peoples, never before experienced within the educational realm, can result from such efforts. We Native Americans must dedicate ourselves to that educational process and continue to assist, share, and cooperate in cultural ventures designed by these new-attitude organizations. In this manner we help our own people through preservation of our lifeways, by correcting a stereotypical image of Native Americans, and by balancing a lopsided and misrepresented history of the United States and its First People.

When people become enlightened to anything different, such as another culture, eyes are opened, minds learn, and friendships may develop. It is this ideal that the objects in the Doris Swayze Bounds Collection have come to serve—a purpose I believe she fully supported and an ideal that was foremost in her many wonderful relationships with her Plateau friends.

Notes

Acknowledgments

1. "Yakama" is the preferred original treaty spelling (and is closer to the actual Sahaptin pronunciation of the word) for those of Yakama Nation heritage and of the reservation in eastern Washington. The nearby town of Yakima and the Yakima River retain their historic spelling of the original Indian word. Throughout this book, tribal affiliations for those of Native American heritage appear in parentheses.

Chapter 1: Doris Swayze Bounds

1. Janet Catherine Berlo, ed., *The Early Years of Native American Art History: The Politics of Scholarship and Collecting* (Seattle: University of Washington Press, 1992).

2. Bounds's knowledge was firsthand and intimate, owing to her having been raised near the people of the Umatilla Reservation. Note that the primary academic research on Plateau culture was not published until the 1930s–1950s (see "Selected Readings on Plateau Culture," this volume).

3. Doris S. Bounds to Maudie C. Craig, July 16, 1965.

4. "Resume of Pioneer Days of Hermiston" (Bounds Foundation Archives, unpublished manuscript, no date, unknown author). According to this description, the town of Maxwell was created by Traffic Passenger Officer A. C. Maxwell, and water for the town was originally supplied by the Maxwell Land and Grant company. In 1907 it was formally incorporated as Hermiston, named for Robert Louis Stevenson's unfinished novel, "The Weir of Hermiston." Frank B. Swayze was named to the first city council, which chose the town's first slogan, "Hermiston, Home of the Happy Hustlers." The Swayze-Bounds family has the longest known continuous residence in the town.

5. R. A. Long, who owned lumber companies across the West, was also the founder of the lumbering town of Longview, Washington.

6. "Bank Traces Roots to Dream of Irrigation Development," *Tri-City (Washington) Herald,* April 27, 1972.

7. Kyle Kenniston, "The History of the Inland Empire Bank" (unpublished manuscript, Hermiston, Oregon, 1982), and "Banking: A Tradition in the Swayze

Family," *Pioneer Trails* (Pendleton, Oregon: Umatilla County Historical Society, 1982), vol. 6, no. 4: 8–12.

8. Video documentary: "Doris Bounds: A Portrait" (Hermiston, Oregon: Inland Empire Bank, 1994).

9. Frank B. Swayze was known as "Pop" Swayze by friends and townspeople, but his children and grandchildren knew him as "Pops."

10. Virgil Rupp, *Let 'Er Buck: A History of the Pendleton Round-Up* (Pendleton, Oregon: Round-Up Association, 1985).

11. Poker Jim's (1843–1936) Native name was Sap-at-kio-ni or Sap-ut-ka-low-nee, meaning "white swan," but he was nicknamed Poker Jim after an unusual poker game win. The father of Clarence, Richard, and Bobby Burke, he presided at the Happy Canyon events associated with the Pendleton Round-Up from 1910 until age prevented him from performing those duties. His friendship with the Swayze family extended over a quarter of a century. Each fall the two families would go to the huckleberry camps together. Poker Jim's son Clarence Burke was born on the Umatilla Reservation in the later part of the 1800s. Though he was sent to an Indian boarding school, he retained his native Walla Walla language. Clarence spent many years as ceremonial chief of the Round-Up. His first wife was Susie Williams. He later married Jeanette Jones, sister of the famous Cayuse twins photographed by Major Lee Moorhouse. Bobby Burke, his brother, married Emma Jones Luten, one of the twins.

12. *Pendleton Record,* August 7, 1969.

13. The *Hermiston Herald,* April 15, 1921, documented Bounds's outstanding scholarship during her junior year of high school.

14. Kevin Wallace, "Slim-Shin's Monument," *New Yorker,* November 19, 1960.

15. Roger Jackson Bounds was born in Maryland on September 9, 1903, and died in Hermiston, Oregon, on January 28, 1960.

16. Kenniston, "History of the Inland Empire Bank."

17. Tommy Thompson was the last chief of the Wyam tribe, which lived on the south side of the Columbia River at The Dalles near Celilo Falls. Doris Bounds's friendship with his wife, Flora Thompson, extended over many years. Flora and a Warm Springs Indian who was Tommy's first cousin used to come down to Umatilla to get eels, and they would stay with Doris for a few days. They would bring her huckleberries and salmon and sit around the coffee pot and laugh a lot. As Flora got older, Doris would go get her to take her to the dances she loved to watch. Tommy Thompson died at the time The Dalles Dam was built, at age 111. Doris S. Bounds, interview with author, 1994.

18. Berlo, *Early Years of Native American Art History.*

19. The *Sun* (Umatilla, Oregon), August 6, 1953.

20. The *Oregonian,* August 30, 1959.

21. Stories about the life of Doris S. Bounds can be found in the *East Oregonian,* December 30, 1958; Web Allison, "Doris Bounds, Banker," *Northwest Ruralite* 12, no. 10: 12–13, 24; "Hermiston Woman Continues Her Family's Banking Tradition," *Pacific Powerland* (Pacific Power and Light Company, 1973), vol. 1, p. 8; and Barbara Reynolds, "Doris Bounds: Money Power," *Pacific Powerland* (June 1981), p. 38.

22. PEO is an international philanthropic and educational organization devoted to providing scholarships and opportunities for women. Doris's mother was a founding member of Chapter CV in Hermiston, and Doris and her close friend Fern Cramer were later both members of that chapter.

23. *East Oregonian,* May 19, 1961.

24. Maud Alexander, "Peace Pipe Museum, Hermiston, Oregon," *Western Wonderland* 3, no. 4 (April 1964): 4–6; Bounds Foundation, "Peace Pipe Museum: The Roger J. Bounds Indian Collection Historical Display" (Hermiston, Oregon: Bliss Litho Printing, 1962); and the *Oregonian,* October 2, 1969.

25. Ralph Friedman, *Oregon for the Curious* (Portland, Oregon: Pars Publishing, 1970), 108.

26. "Hermiston's Doris Bounds Initiated into Blackfeet Tribe of North American Indians," *East Oregonian,* July 14, 1965.

27. Eugene Hunn, with James Selam and family, *Nch'i-Wana "The Big River": Mid-Columbia Indians and Their Land* (Seattle: University of Washington Press, 1990), 217.

28. *Hermiston Herald,* January 12, 1969.

29. Jack Mills, personal communication, 1995.

30. Phil Lane, Jr., to Doris S. Bounds, November 26, 1990.

31. The Bounds Foundation directors in 1990 were David Rhoten of Salem; Mary Anne Normandin of Portland; and Fern Cramer, Teresa Moncrief, Roger and Karen Bounds, and Doris S. Bounds of Hermiston.

32. *The Plateau: The Roger J. Bounds Foundation, Inc., Collection Exhibition* (Cody, Wyoming: Buffalo Bill Historical Center, 1989).

33. *The Columbia and the Plateau: The Roger J. Bounds Foundation, Inc., Collection Exhibition* (Walla Walla, Washington: Sheehan Gallery, Whitman College, 1990).

34. See also Susan Harless, "Safe in the Care of Sacred Star Woman," *Southwest Art* (February 1993): 63–67.

35. Ivan and Carleen Sherk, personal communication, 1991. The Bounds Collection contains twenty-eight pieces known to be crafted by Mr. Sherk and nine more that he assumes are pieces he originally made but that have been altered by others. This type of collection may serve as a valuable resource for others seeking to document pre-Columbian pieces.

36. *Oregon Journal,* September 9, 1970.

Chapter 2: In a Spiritual Way

1. Ella E. Clark, *Indian Legends of the Pacific Northwest* (Berkeley: University of California Press, 1953).

Chapter 3: The Plateau Culture Area and Its Arts

1. Clark Wissler, *The American Indian: Introduction to the Anthropology of the New World* (London: Oxford University Press, 1922).

2. Verne Ray, "Cultural Relations in the Plateau of Northwestern America," *Publications of the Frederick Webb Hodge Anniversary Publication Fund,* vol. 3 (Los Angeles: Southwest Museum, 1939).

3. Sir George Simpson, *Fur Trade and Empire* (Cambridge, Massachusetts: Harvard University Press, 1968).

4. Bryan Hodgson, "Buffalo, Back Home on the Range," *National Geographic* 186, no. 5 (1994): 64–89.

5. Ella McCarthy (Spokane), personal communication, 1964.

6. Olaf Opsjon, "Painted Rocks Were Work of Early-Day Teutonic Explorers," *Spokane Chronicle,* July 18, 1919.

7. Elliott Coues, ed., *History of the Expedition under the Command of Lewis and Clark* (New York: Dover Publishers, 1965).

8. J. Russell Harper, ed., *Paul Kane's Frontier* (Ft. Worth, Texas: Amon Carter Museum, 1971), plate 37.

9. Leslie Spier and Edward Sapir, "Wishram Ethnography," *University of Washington Publications in Anthropology* 3 (1930): 151–300.

10. Melville Jacobs, "A Sketch of Northern Sahaptin Grammar," *University of Washington Publications in Anthropology* 4 (1931): 85–292.

11. H. K. Haeberlin, James A. Teit, and Helen H. Roberts, "Coiled Basketry in British Columbia and Surrounding Regions," *Forty-first Annual Report of the Bureau of American Ethnology* (1924), 119–615.

12. Richard G. Conn, *Robes of White Shell and Sunrise: Personal Decorative Arts of the Native American* (Denver: Denver Art Museum, 1974).

13. Harper, *Paul Kane's Frontier,* fig. 141, plate 33.

14. For example, there is a Spokane pierced shirt in the Burke Museum at the University of Washington and a Wasco example at the Field Museum of Natural History.

15. Gaylord Torrance, *The American Indian Parfleche: A Tradition of Abstract Painting* (Seattle: University of Washington Press, 1994), 225ff.

16. Robin K. Wright, *A Time of Gathering: Native Heritage in Washington State* (Seattle: University of Washington Press, 1991).

17. Personal observations made in 1962–65 at Nespelem and Wellpenit, Washington, and at Worley, Idaho.

Chapter 4: Handsome Things

1. "The Peace Pipe Museum: The Roger J. Bounds Indian Collection Historical Display" (Hermiston, Oregon: Bliss Litho Printing, 1962).

2. For a more complete discussion of Columbia River basketry, see Mary Dodds Schlick, *Columbia River Basketry: Gift of the Ancestors, Gift of the Earth* (Seattle: University of Washington Press, 1994).

3. Doris S. Bounds, personal communication, 1994.

4. Doris S. Bounds, personal communication, 1991.

5. Schlick, *Columbia River Basketry,* p. 168.

6. Schlick, *Columbia River Basketry,* p. 168.

7. G. Lynette Miller, "Flat Twined Bags of the Plateau" (Master's thesis, University of Washington, 1986), 156.

8. Elizabeth Jones, personal communication, 1992.

9. Doris S. Bounds, personal communication, 1994.

10. Jacqueline Cook, personal communication, 1994. A section of the new tribal museum has been dedicated to the importance of the horse in Plateau culture.

11. David W. Fraser, *A Guide to Weft Twining and Related Structures with Interacting Wefts* (Philadelphia: University of Pennsylvania Press, 1989), 94; Elizabeth Jones, personal communication, 1992; Maynard White Owl Lavadour, personal communication, 1995.

12. Mary D. Schlick, "A Columbia River Indian Basket Collected by Lewis and Clark," *American Indian Basketry* 1, no. 1 (1979): 10.

13. Ira N. Gabrielson and Stanley G. Jewett, *Birds of the Pacific Northwest* (New York: Dover Publishers, 1970), 180–81.

14. I refer to Pat Courtney Gold's twined bag entitled "Springtime Is Baby Time," 1994.

15. Johnson Meninick, personal communication, 1975.

16. Bill Burke, personal communication, 1992.

17. Barbara Loeb, typescript of interview with Doris S. Bounds (Hermiston, Oregon, 1991), 3.

18. Doris S. Bounds, personal communication, 1994.

Chapter 5: Transmontane Beading

1. This story comes from oral communications in the 1970s between Maynard White Owl Lavadour and his grandmothers, as well as other Cayuse elders. Leona Smartlowit (Cayuse) referred to the same story, calling the man "Hanish Hanish," or Mean Grizzly (The High Desert Museum documentation records for Bounds Collection, item 8.2.1.).

2. The claw marks are always arranged in sets of three, four, or five. Bear paws have five claws, but three or four gouges are usually visible after a bear scratches an object such as a tree trunk—so three, four, and five all represent realistic choices (oral communication between Barbara Loeb and grizzly bear expert Kevin Sanders, August 9, 1994, Big Sky, Montana).

3. Leona Smartlowit calls the wide strap a "chief's 'royal' sign" (The High Desert Museum documentation records for Bounds Collection, item 8.2.10).

4. After the forced moves to reservations and the flight of some Nez Perce in 1877, some people intermarried with or claimed land among the Flathead of western Montana. This may explain why the Transmontane style also appeared in that area, although in a somewhat altered form.

5. Both of us have found the Cayuse and Nez Perce central to this art form. The Palouse, who are usually neglected in the literature, may also be important because they commonly intermarried with the Cayuse and Nez Perce. Plateau custom generally encouraged intermarriage, as well as habitual trading of gifts and information between the varied Plateau regions, so that tribal and artistic boundaries are blurred. For more discussion of the artificiality of tribal boundaries, see chapter 3.

6. Crow is the name given to this Plains group by outsiders. Apsaalooke is the name they still use for themselves, especially when speaking their own language.

7. "Transmontane," meaning "across the mountains," refers to an old beading style shared by the Crow on the east side of the Rocky Mountains and several Plateau groups on the west side. At one time, these patterns were widely referred to as the Crow style, and the term is still used to some extent today. In the 1980s, the style was also referred to as the Intermontane style.

8. Bill Holm, "The Crow–Nez Perce Otterskin Bowcase-Quiver," *American Indian Art* 6, no. 4 (1981): 60–70; Barbara Loeb, "Mirror Bags and Bandoleer Bags: A Comparison," *American Indian Art* 6, no. 1 (1980): 46–53, 88; and Barbara Loeb, "Crow and Plateau Beadwork in Black and White: A Study Using Old Photographs," in *Crow Indian Art* (Mission, South Dakota: Chandler Institute, 1984), 15–26.

9. When photographers began working in the West in the 1870s, the

Transmontane style was already elaborately developed, leading us to believe it was probably in process at least by 1850.

10. Although many Plateau people descend from several groups, they were forced to claim a single tribe when the United States government established reservations. Those families who chose to be identified as Cayuse were placed on the Umatilla Reservation in Oregon, along with the Umatilla and Walla Walla. Those who enrolled as Palouse were sent to the Yakima Reservation in Washington, and those claiming Nez Perce heritage went to the Nez Perce Reservation in Idaho or the Colville Reservation in Washington.

11. For another discussion of this commerce, see chapter 3.

12. The Nez Perce and their neighbors frequently traded with the Apsaalooke, and scholars have assumed that they used their wealth of horses to trade for finished Apsaalooke beadwork. If true, this would account for the presence of Transmontane style beading among both groups. However, elders on the Umatilla Reservation have said that they traded their horses to the Crow for manufactured goods and did their own beading (oral communications to Maynard White Owl Lavadour during the 1970s). This fits with early literature picturing the Crow as, in a sense, go-betweens trading Plateau horses to Hidatsa and other village tribes on the eastern Plains for manufactured goods. These in turn would have been carried west to the Plateau.

13. The Cayuse and their neighbors traded first for guns and second for beading supplies, but they neither wanted nor needed other manufactured goods (oral communications in 1970s between Maynard White Owl Lavadour and elders on the Umatilla Reservation).

14. The term "Cayuse stitch" is Maynard White Owl Lavadour's.

15. Of these men's items, all except the otter-skin quiver are represented in the Bounds Collection.

16. Several elders from the Umatilla Reservation spoke of the custom of placing the decorated blanket on the floor. Susie Williams described the custom of wrapping it around the wedding couple (oral communication to Maynard White Owl Lavadour during the 1970s).

17. Although the Bounds Collection does not include one of these cradles with Transmontane designs, it contains a superb example with floral images (item 9.10.4; plate 47)

18. In recent years, many scholars have used the term "deertail" dress, published first by Richard Conn in *Robes of White Shell and Sunrise*. This term aptly describes many garments of the twentieth century because Cayuse and Nez Perce people, barred from their traditional hunting grounds, often had only deer to hunt. However, they preferred antelope hides and in the early years used skins from that animal whenever possible. For this reason, we employ the more general term, "tail dress."

19. According to Eugene S. Hunn (*Nch'i-Wana*, 32, 51, 54), the Cayuse considered this attack self-defense against those who exposed them to scarlet fever, measles, whooping cough, and other deadly diseases.

Chapter 6: Honoring People, Honoring Life

1. Doris S. Bounds, interview with Barbara Loeb, May 2, 1991.

2. Bernard DeVoto, ed., *The Journals of Lewis and Clark* (Boston: Houghton Mifflin, 1953), 293.

3. Alexander Ross, *Adventures of the First Settlers on the Oregon or Columbia River, 1810–1813* (Cleveland, Ohio: Arthur H. Clark, 1910). Reprint (Lincoln: University of Nebraska Press, 1986), 137.

4. John K. Townsend, "Narrative of a Journey across the Rocky Mountains to the Columbia River, 1833–34" (Philadelphia: Henry Perkins, 1839). Reprinted as vol. 21, *Early Western Travels, 1846–47,* Reuben G. Thwaites, ed. (Cleveland, Ohio: Arthur H. Clark, 1905), 254.

5. Doris S. Bounds, interview with Barbara Loeb, May 2, 1991.

6. Nicholas Point's drawing "Travail des femmes après la chasse" (Jesuit Missouri Provincial Archives IX-C9-94) includes an array of bags along with a quiver, a dress, a jacket, and assorted other hide items displayed upon antler-like branches. The fanciful curvilinear designs on several of the bags seem to indicate floral designs. The artist's paintings have been published in Father Nicholas Point, *Wilderness Kingdom: Indian Life in the Rocky Mountains, 1840–1847,* translated by Joseph P. Donneley, S.J. (reprint, New York: Holt, Rinehart, and Winston, 1968).

7. Marguerite McLoughlin began to teach beading to girls in the school at the Hudson's Bay Company's Fort Vancouver sometime after her arrival in 1825. Coming from Rainey Lake in central Canada, she was no doubt familiar with both floral beadwork and the Cree-Ojibwa-Métis bag forms; however, we cannot be sure she was teaching these. When discussing beadwork, the Chinookan women Esther Warren interviewed for her 1877 book *The Columbia Gorge Story* (The Dalles, Oregon: Itemizer-Observer Press) mentioned only belts and headbands. These were most likely loom woven. Whatever their training using beads, Chinookan women were already experienced at weaving root bags when they saw the Woodlands panel and octopus bags brought into the area. In a typically Plateau pragmatic fashion, they combined new and old to create their own new art form. For an extended discussion of the history of this development, see Mary D. Schlick and Kate C. Duncan, "Wasco-Style Woven Beadwork: Merging Artistic Traditions," *American Indian Art* 16, no. 3 (1991): 36–45. For an explanation of the dispersal of the octopus and panel bag forms across North America, see Barbara Hail and Kate C. Duncan, *Out of the North: The Subarctic Collection of the Haffenreffer Museum of Anthropology* (Bristol, Rhode Island: Haffenreffer Museum of Anthropology, Brown University, 1989).

8. Charles Wilkes, U.S.N., *Narrative of the United States Exploring Expedition* (Philadelphia: Lee and Blanchard, 1845), 370.

9. Other Bounds Collection examples of contour-beaded backgrounds include bags 2.6.1, 2.6.59, and 2.6.74 and cradle 9.10.4.

10. Several beaded bags in the Maryhill Museum, Goldendale, Washington, on the Columbia River, can at first be mistaken for eastern Great Lakes bags until one realizes that they are larger and that discrete details of the designs don't quite ring true. They appear to be Plateau-made versions of their eastern counterparts. Their documentation associates them with women of the Wasco-Wishxam Underwood family who were also experimenting with woven bead octopus and panel bags (Schlick and Duncan, "Wasco-Style Woven Beadwork," note 3). Maryhill Museum pieces interesting in this regard include bags 44-77 and 44-80, as well as women's legging 44-86.

11. Doris S. Bounds, interview with Barbara Loeb, May 2, 1991.

12. Other than on Plateau handbags dating about 1880–1920, fully contoured backgrounds appear elsewhere almost exclusively on flat handbags with rounded lower corners and often an upper flap, made by Ojibwa and possibly

Cree women. What little documentation there is on any of these bags places them as having been made in the western Canadian Cree-Ojibwa-Métis area from the late 1880s into the early twentieth century. Examples include Field Museum 207772; American Museum of Natural History 50/7134; National Museum of the American Indian, Heye Collection 11/8036, from Shell River, Saskatchewan; Los Angeles County Museum A7415.59-1; and Glenbow Museum AP 2298 (collected 1880s). Photos of Plateau people with this particular type of Ojibwa bag have not been found, but there are those that show them using typical Ojibwa bandoleer bags alongside Plateau-made beadwork bags (Duncan 1991, 194.) An Ojibwa bandoleer bag in the Hood Museum, Dartmouth College (985.47.26579), is unusual in that the solidly beaded background of its pouch panel is entirely contour beaded. Limited background contouring also occurs at rounded corners and occasionally in tight areas between motifs on other beadwork attributed to the Plains Cree-Ojibwa (pad saddles, knife cases, etc.).

13. Schlick, *Columbia River Basketry,* 21.

14. Bounds Collection bags that combine elk or deer with landscape include 2.6.21, 2.6.37, 2.6.52, 2.6.148, 2.6.172, and 2.6.178.

15. *1897 Sears Roebuck Catalog* (reprint, Bozeman, Montana: Museum of the Rockies and Chelsea House Publishers, 1993). I wish to thank Ellen Moore and Terry Blumer for drawing these to my attention.

16. Bird and flower combinations include Bounds Collection handbag 2.6.2 and belt bag 2.1.1014.

17. Bounds Collection pieces with patriotic images include bags 2.6.185 and 2.6.218, belt bag 2.1.1017, gloves 6.10.2 and 6.10.6, and dance apron 6.3.8.

18. Bounds Collection examples with shaded petals include 2.6.67, 2.6.141, 2.6.195, and 2.6.208.

19. Nonrectangular bags in the Bounds Collection (with her attribution) include the following heart-shaped bags: 2.6.18, 2.6.155, 2.6.202, 2.6.223, 2.6.226, and 2.6.229 (Plateau), and 2.6.236, 2.6.221, and 2.6.222 (Umatilla). Angular polygons include these specimens: five-sided, 2.6.75 (Umatilla); six-sided, 2.6.130, 2.6.135, and 2.6.34 (Plateau); eight-sided, 2.6.271 (Plateau); trapezoidal, 2.6.218 (Walla Walla); and round, 2.6.306 (Umatilla). Other nonrectangular shapes in the collection are as follows: envelope with foldover flap, 2.6.159 (Umatilla); basket profile including handle, 2.6.142 (Warm Springs) and 2.6.207 (Umatilla); upside-down teardrop, 2.6.156 (Umatilla); and shield, 2.6.172 (Umatilla) and 2.6.29 (Yakama). The large Horwitch Collection of Plateau bags on loan to the Heard Museum, Phoenix, AZ, includes an even broader range of individuated shapes (*Glass Tapestry: Plateau Beaded Bags from the Elaine Horwitch Collection,* Heard Museum, 1993).

20. Bounds Collection bags with metal pocketbook closures include 2.6.133 and 2.6.60. Bags with zippers are 2.6.28, 2.6.55, 2.6.34, 2.6.171, 2.6.37, and 2.6.23.

21. Grant McCracken, "Clothing as Language: An Object Lesson in the Study of the Expressive Properties of Material Culture," in *Culture and Consumption: New Approaches to the Symbolic Character of Consumer Goods and Activities* (Bloomington: Indiana University Press, 1988), 57–70.

Chapter 7: Doris Bounds's Role in Contemporary Native Pageantry

1. This competition is no longer held.

2. "All American Indian Days" (brochure), 1968.

3. E. D. Mygatt, correspondence to potential donors requesting support for the North American Indian Foundation, a nonprofit educational foundation providing funds for travel and other expenses of Miss Indian America, August 1967 (Barbara Hail personal collection).

4. "All American Indian Days" (brochure), 1967.

5. Lillian "Sis" Moses, former Happy Canyon Princess, winner of the Junior and Senior American Indian Beauty contests, and first honor attendant to Miss Indian America XV, 1968. Interview with Susan Harless, March 14, 1994.

6. Doris S. Bounds to Barbara Hail, July 24, 1991.

7. Darlynne McCarty, oral communication, August 2, 1967.

8. Interview with Susan Harless, March 14, 1994.

9. Victoria Patterson, Oneida, in answer to the question, "Why do you wish to compete?" on application form for Miss Indian America, 1967.

10. Patricia Littlewolf, Northern Cheyenne, application form for Miss Indian America, 1967.

11. Bernita Pehueyestewa, Hopi, Miss Indian America first runner-up, 1967, application form for Miss Indian America, 1967.

12. Tomasine Hill, Crow-Pawnee, in the *Providence Journal,* January 10, 1969.

13. Lillian "Sis" and Judith Moses, interview with Susan Harless, March 14, 1994.

Selected Readings
on Plateau Culture

Ackerman, Lillian Alice

1982 "Sexual Equality in the Plateau Culture Area." Ph.D. diss., Washington State University, Pullman.

1996 *A Song to the Creator: Traditional Arts of Native American Women of the Plateau*. Norman: University of Oklahoma Press.

Aikens, C. Melvin

1978 "Plateau." In *Ancient Native Americans*, J. D. Jennings, ed., 164–81. San Francisco: W. H. Freeman.

Allen, John Eliot, Marjorie Burns, and Sam C. Sargent

1986 *Cataclysms on the Columbia*. Portland, Oregon: Timber Press.

Benson, Robert, ed.

1973 "Map of Indian Languages." In *A Historical Atlas of Early Oregon*, Judith A. Farmer, ed. Portland, Oregon: Historical Cartographic Publications.

Browman, David L., and David A. Munsell

1969 "Columbia Plateau Pre-History: Cultural Development and Impinging Influences." *American Antiquity* 34: 249–64.

Brunton, Bill B.

1968 "Ceremonial Integration in the Plateau of Northwestern North America." *Northwest Anthropological Research Notes* 2(1): 1–28.

Campbell, Sarah K.

1989 "Post-Columbian Culture History in the Northern Columbia Plateau, 1500–1900." Ph.D. diss., University of Washington, Seattle.

Cheney Cowles Memorial Museum

1974 *Cornhusk Bags of the Plateau Indians*. Cheney, Washington: Eastern Washington State Historical Society.

Clark, Ella E.

1953 *Indian Legends of the Pacific Northwest*. Berkeley: University of California Press.

Coale, George L.

1956 "Ethnohistorical Sources for the Nez Perce Indians." *Ethnohistory*
 3: 246–55.

1958 *Notes on the Guardian Spirit Concept among the Nez Perce.* National
 Archives of Ethnography, 48. Washington, D.C.

Confederated Tribes of the Warm Springs

1984 *The People of Warm Springs.* Warm Springs, Oregon.

Conn, Richard G.

1955 "A Classification of Aboriginal North American Clothing." M.A.
 thesis, University of Washington, Seattle.

1972 "Indian Arts of the Intermontane Region." In *American Indian Art:
 Form and Tradition*, 71–75. Minneapolis: Walker Art Center.

1972 "The Pony Bead Period: A Cultural Problem of Western North
 America." *Society for Historical Archaeology Newsletter* 5(4): 7–13.

1974 *Robes of White Shell and Sunrise: Personal Decorative Arts of the
 Native American.* Denver: Denver Art Museum.

1979 *Floral Design in Native North America.* Claremont, California:
 Claremont Colleges.

1979 *Native American Art in the Denver Art Museum.* Denver: Denver Art
 Museum.

Coues, Elliott, ed.

1965 *The History of the Expedition under the Command of Lewis and Clark.*
 New York: Dover Publishers.

Crawford, Mary

1936 *The Nez Perces since Spalding.* Berkeley, California: Professional
 Press.

Cressman, Luther S.

1936 *Bibliography of Publications on the Indians of Oregon.* Oregon State
 Museum of Anthropology, Information Bulletin 1. Eugene,
 Oregon.

Curtis, Edward Sheriff

1911 *The North American Indian*, vol. 7: *The Yakima, the Klickitat,
 Salishan Tribes of the Interior, the Kutenai.* Norwood, Massachusetts:
 Plimpton Press.

1912 *The North American Indian*, vol. 13: *The Nez Perces, Wallawalla,
 Umatilla, Cayuse, the Chinookan Tribes.* Norwood, Massachusetts:
 Plimpton Press.

Duncan, Kate C.

1991 "Beadwork on the Plateau." In *A Time of Gathering: Native Heritage
 in Washington State*, Robin K. Wright, ed., 189–96. Seattle: Univer-
 sity of Washington Press.

1996 "Beadwork and Cultural Identity on the Plateau." In *A Song to the
 Creator: Traditional Arts of Native American Women*, L. Ackerman,
 ed. Norman: University of Oklahoma Press.

Elmendorf, William W.

1965 "Linguistic and Geographic Relations in the Northern Plateau
Area." *Southwestern Journal of Anthropology* 21: 63–78.

French, David H.

1956 "An Exploration of Wasco Ethnoscience." *Yearbook of the American
Philosophical Society*, 224–26.

1961 "Wasco-Wishram." In *Perspectives in American Indian Culture
Change*, E. H. Spicer, ed., 337–430. Chicago: University of Chicago
Press.

French, David H., and Kathrine French

n.d. "Wasco-Wishram." In *Handbook of North American Indians*, vol. 12:
Plateau, J. Deward Walker, ed. Washington, D.C.: Smithsonian
Institution. Forthcoming.

Gidley, Mick

1979 *With One Sky Above Us: Life on an American Indian Reservation at
the Turn of the Century*. Seattle: University of Washington Press.

Gogol, John M.

1979 "Basketry of the Columbia River Indians." *American Indian
Basketry* 1(1): 4–9.

1980 "Rose Frank Shows How to Make a Nez Perce Cornhusk Bag."
American Indian Basketry 1(2): 22–30.

1980 "Cornhusk Bags and Hats of the Columbia Plateau Indians."
American Indian Basketry 1(2): 4–11.

1984 "American Indian Art: Values and Aesthetics." *American Indian
Basketry* 4(4): 4–30.

1985 "Columbia River/Plateau Indian Beadwork, part 1: Yakima, Warm
Springs, Umatilla, Nez Perce." *American Indian Basketry* 5(2): 4–28.

1985 "The Golden Decade of Collecting Indian Basketry." *American
Indian Basketry* 5(1): 12–29.

1990 "The Archetypal Columbia River Plateau Contour Beaded Bag." In
Eye of the Angel: Selections from the Derby Collection.
Northhampton, Massachusetts: White Star Press.

Hail, Barbara, and Kate C. Duncan

1989 *Out of the North: The Subarctic Collection of the Haffenreffer Museum
of Anthropology*. Bristol, Rhode Island: Haffenreffer Museum of
Anthropology, Brown University.

Haines, Francis D.

1955 *The Nez Perces, Tribesmen of the Columbia Plateau*. Norman:
University of Oklahoma Press.

Hanson, Charles E., Jr.

1989 "Pound Beads, Pony Beads." *Museum of the Fur Trade Quarterly*
25(4): 1–5.

Harless, Susan E.

1992 "Gift of Native Artifacts." *Northwest Parks and Wildlife* 2(4): 43–45.

1994 "Safe in the Care of Sacred Star Woman." *Southwest Art* (February), 63–67.

Harless, Susan E., and Caryn Talbot Throop

1992 "Oregon's Native Cultures: Past Lifeways, Living Traditions." *Oregon Magazine* (September).

Heard Museum

1993 *Glass Tapestry: Plateau Beaded Bags from the Elaine Horwitch Collection.* Phoenix, Arizona: Heard Museum.

Holm, Bill

1981 "The Crow–Nez Perce Otterskin Bowcase-Quiver." *American Indian Art* 6(4): 60–70.

Horse Capture, George P., and Terry Melton

1989 *The Plateau.* Cody, Wyoming: Buffalo Bill Historical Center.

Hunn, Eugene S.

1990 *Nch'i-Wana "The Big River": Mid-Columbia Indians and Their Land.* Seattle: University of Washington Press.

Josephy, Alvin M., Jr.

1965 *The Nez Perce Indians and the Opening of the Northwest.* New Haven, Connecticut: Yale University Press.

1968 *The Indian Heritage of America.* New York: Knopf.

Kearney, Kathleen, and Janet Miller

1994 "Defining a Nez Perce Feminine Dress Style." *Northwest Anthropological Research Notes* 28(1).

Kent, Susan

1980 "Pacifism: A Myth of the Plateau." *Northwest Anthropological Research Notes* 14(2): 125–34.

Kirk, Ruth, and Richard D. Daugherty

1978 *Exploring Washington Archaeology.* Seattle: University of Washington Press.

Kroeber, Alfred L.

1953 *Cultural and Natural Areas of Native North America.* Berkeley: University of California Press.

Lanford, Benson L.

1984 "Beadwork and Parfleche Designs." In *Crow Indian Art,* 7–14. Mission, South Dakota: Chandler Institute.

Lehman-Kessler, Marcia N.

1985 "The Traditional Nez Perce Basketry Hat." M.A. thesis, Washington State University, Pullman.

Lewis, Albert B.

1906 "Tribes of the Columbia Valley and the Coast of Washington and Oregon." *Memoirs of the American Anthropological Association* 1: 147–209.

Linn, Natalie

1993 *The Plateau Bag: A Tradition in Native American Weaving.* Pittsburg,
 Kansas: Johnson County Community College.

Lobb, Allan

1978 *Indian Baskets of the Northwest Coast.* Portland, Oregon: Graphic
 Arts Center Publishing.

Loeb, Barbara

1980 "Mirror Bags and Bandoleer Bags: A Comparison." *American
 Indian Art* 6(1): 46–53, 88.

1983 "Classic Intermontane Beadwork: Art of the Crow and Plateau
 Tribes." Ph.D. diss., University of Washington, Seattle.

1984 "Crow and Plateau Beadwork in Black and White: A Study Using
 Old Photographs." In *Crow Indian Art,* 15–26. Mission, South
 Dakota: Chandler Institute.

Loring, J. Malcolm, and Louise Loring

1982 *Pictographs and Petroglyphs of the Oregon Country,* part 1: *Columbia
 River and Northern Oregon.* Los Angeles: Institute of Archeology,
 UCLA.

Lowie, Robert H.

1923 "The Cultural Connection of Californian and Plateau Shoshonean
 Tribes." *University of California Publications in American Archaeology
 and Ethnology* 20: 145–56.

McBeth, Kate C.

1908 *The Nez Perce since Lewis and Clark.* New York: Fleming H. Revell
 Company.

Miller, Christopher L.

1985 *Prophetic Worlds: Indians and Whites on the Columbia Plateau.* New
 Brunswick, New Jersey: Rutgers University Press.

Miller, G. Lynette

1986 "Flat Twined Bags of the Plateau." M.A. thesis, University of
 Washington, Seattle.

Nelson, C. M.

1973 "Prehistoric Culture Change in the Intermontane Plateau of
 Western North America." In *The Explanation of Culture Change*,
 C. Renfrew, ed. London: Duckworth.

Nolan, Edward W.

1959 *A Bibliography of the Yakima.* Seattle: University of Washington
 Press.

Pace, Robert E., ed.

1977 *The Land of the Yakimas.* Toppenish, Washington: Yakima Indian
 Nation Tribal Council.

Painter, H. M.

1946 "The Coming of the Horse." *Pacific Northwest Quarterly* 37(2):
 155–57.

Penny, David W.

1991 "Floral Decoration and Culture Change: An Historical Interpretation of Motivation." *American Indian Culture* 15(1): 53–77.

Peterson, Jacqueline, and Laura Peers

1993 *Sacred Encounters: Father DeSmet and the Indians of the Rocky Mountain West.* Norman: University of Oklahoma Press.

Pree, Donna Marie Demering

1970 "Nez Perce Feminine Aboriginal Clothing." M.A. thesis, Washington State University, Pullman.

Ramsey, Jarold

1977 *Coyote Was Going There: Indian Literature of the Oregon Country.* Seattle: University of Washington Press.

Ray, Verne F.

1936 "Native Villages and Groupings of the Columbia Basin." *Pacific Northwest Quarterly* 27(2): 1–54.

1938 "Tribal Distributions in Eastern Oregon and Adjacent Regions." *American Anthropologist* 40: 384–415.

1939 "Cultural Relations in the Plateau of Northwestern America." *Publications of the Frederick Webb Hodge Anniversary Publication Fund* 3: 1–54.

1942 "Culture Element Distributions, no. 22: Plateau." *University of California Anthropological Records* 8(2): 99–258.

1974 *Ethnohistory of the Joseph Band of Nez Perce Indians: 1805–1905.* New York: Garland Publishing.

Relander, Click, ed.

1955 *The Yakimas.* Toppenish, Washington: Yakima Indian Nation.

Roe, Frank G.

1955 *The Indian and the Horse.* Norman: University of Oklahoma Press.

Ruby, Robert H., and John A. Brown

1965 *Half-Sun on the Columbia: A Biography of Chief Moses.* Norman: University of Oklahoma Press.

1972 *The Cayuse Indians: Imperial Tribesmen of Old Oregon.* Norman: University of Oklahoma Press.

1992 *A Guide to the Indian Tribes of the Pacific Northwest.* Norman: University of Oklahoma Press.

Rupp, Virgil

1985 *Let 'Er Buck! A History of the Pendleton Round-Up.* Pendleton, Oregon: Master Printers.

Schaeffer, C. E.

1959 "Indian Tribes and Languages of the Old Oregon Country: A New Map." *Oregon Historical Quarterly* 60(1): 129–33.

Schlick, Mary D.

1980 "Art Treasures of the Columbia Plateau." *American Indian Basketry* 1(2): 12–20.

1985 "Wasco-Wishxam Basketry: Who Were the Weavers?" *American Indian Basketry* 5(4): 21–27.

1994 *Columbia River Basketry: Gift of the Ancestors, Gift of the Earth.* Seattle: University of Washington Press.

Schlick, Mary D., and Kate C. Duncan

1991 "Wasco-Style Woven Beadwork: Merging Artistic Traditions." *American Indian Art* 16(3): 36–45.

Schuster, Helen H.

1975 "Yakima Indian Traditionalism: A Study in Continuity and Change." Ph.D. diss., University of Washington, Seattle.

1982 *The Yakimas: A Critical Bibliography.* Bloomington: Indiana University Press.

Shawley, Stephen D.

1974 *Nez Perce Dress: A Study in Culture Change.* University of Idaho Anthropological Research Manuscript Series, 44.

1975 "Hemp and Cornhusk Bags of the Plateau Indians." *Indian America* 9 (Spring): 25–30.

Slickpoo, Allen, and Deward E. Walker, Jr.

1973 *Noon Nee-Me-Poo (We, the Nez Perces): Culture and History of the Nez Perces.* Lapwai, Idaho: Nez Perce Tribe of Idaho.

Sperlin, O. B.

1916 "The Indians of the Northwest as Recorded by the Earliest Journals." *Oregon Historical Quarterly* 17(1): 1–43.

Spier, Leslie

1936 "Tribal Distribution in Washington." *General Series in Anthropology* 2: 1–43.

Spier, Leslie, and Edward Sapir

1930 "Wishram Ethnography." *University of Washington Publications in Anthropology* 3: 151–300.

Spinden, Herbert J.

1908 "The Nez Perce Indians." *Memoirs of the American Anthropological Association* 2 (part 3): 165–274.

Stern, Theodore

1993 *Chiefs and Chief Traders: Indian Relations at Fort Nez Perces, 1818–1855,* vol. 1. Corvallis: Oregon State University Press.

1996 *Chiefs and Change in the Oregon Country: Indian Relations at Fort Nez Perces, 1818–1855.* Corvallis: Oregon State University Press.

Stowell, Cynthia D.

1987 *Faces of a Reservation.* Portland: Oregon Historical Society Press.

Strong, Emory

1959 *Stone Age on the Columbia River.* Portland, Oregon: Binfords and Mort.

Strong, William D., W. Egbert Schenck, and Julian H. Steward
1930 *Archeology of the Dalles-Deschutes Region.* University of California
 Publications in American Archaeology and Ethnology, 29(1).
Suphan, Robert J.
1974 "Ethnological Report on the Wasco and Tenino Indians Relative
 to Socio-Political Organization and Land Use." In *Oregon Indians
 II.* New York: Garland Publishers.
1974 "Ethnological Report on the Umatilla, Walla Walla, and Cayuse
 Indians Relative to Socio-Political Organization and Land Use." In
 Oregon Indians II. New York: Garland Publishers, Inc.
Swanson, Earl H., Jr.
1962 *The Emergence of Plateau Culture.* Occasional Papers of the Idaho
 State College Museum, 8.
Taylor, Colin
1981 "Costumes Decorated with Quill-Wrapped Hair: Nez Perce or
 Crow?" *American Indian Art* (Summer), 43–53.
Teit, James A., ed.
1928 *The Middle Columbia Salish,* vol. 2. Seattle: University of Washing-
 ton Press.
Trafzer, Clifford E.
1992 *Yakima, Palouse, Cayuse, Umatilla, Walla Walla, and Wanapum
 Indians: A Bibliography.* Metuchen, New Jersey: Scarecrow Press.
Trafzer, Clifford E., and Richard E. Scheuerman
1986 *Renegade Tribe: The Palouse Indians and the Invasion of the Inland
 Pacific Northwest.* Pullman: Washington State University Press.
1987 *Chief Joseph's Allies: The Palouse Indians and the Nez Perce War of
 1877.* Sacramento, California: Sierra Oaks Publishing Company.
Travis, Helga Anderson
1951 *The Umatilla Trail: Pioneer Days in the Washington Territory.* New
 York: Exposition Press.
Uebelacker, Morris L.
1984 *Time Ball: A Story of the Yakima People and Their Land.* Yakima,
 Washington: Yakima Indian Nation Media Program.
Wheeler-Voegelin, E., ed.
1956 "Umatilla Reservation." *Ethnohistory* 3: 163–79.
Wight, E., et al.
1960 *Indian Reservations of Idaho, Oregon, and Washington.* Washington,
 D.C.: U.S. Department of Interior, Bureau of Indian Affairs.
Wildschut, William, and John C. Ewers
1959 *Crow Indian Beadwork.* New York: Museum of the American
 Indian, Heye Foundation.
Willis, Park Weed
1937 "Early Recollections and Impressions of Umatilla County,
 Oregon." *Pacific Northwest Quarterly* 28(3): 301–11.

Wissler, Clark

1922 *The American Indian: Introduction to the Anthropology of the New World*. New York: Oxford University Press.

Wright, Robin K., ed.

1991 *A Time of Gathering: Native Heritage in Washington State*. Seattle: University of Washington Press.

Zucker, Jeff, Kay Hummer, and Bob Hogfoss

1983 *Oregon Indians: Culture, History, and Current Affairs: An Atlas and Introduction*. Portland: Oregon Historical Society Press.

About the Contributors

VIVIAN M. ADAMS is an enrolled member of the Yakama Nation, where she has lived most of her life. She worked for many years in Bureau of Indian Affairs and Yakama tribal offices. She holds an Associate of Fine Arts degree in museology/two-dimensional art from the Institute of American Indian Art in Santa Fe, a B.A. in art history from the University of New Mexico, and an M.A. in Native American art history from the University of Washington, Seattle. Since 1993 she has been the curator of Native heritage at The High Desert Museum in Bend, Oregon, and curator of the Doris S. Bounds Collection. She also lectures and serves as a Plateau cultural consultant, striving to meet her professional goal of disseminating Plateau artistic and historical information to the general public through her presentations.

RICHARD G. CONN is chief curator emeritus of the Denver Art Museum. He received his Master of Arts degree in anthropology in 1955 from the University of Washington on the classification of aboriginal North and South American clothing. He began his career in Denver as curator of Indian art and from there went to the Eastern Washington State Historical Society as curator and later director, to the Manitoba Museum of Man and Nature as chief of the Division of Human History, and to the Heard Museum as director, before returning to Denver. He is the author of *Circles of the World: Traditional Art of the Plains Indians,* published by the Denver Art Museum. He has taught and published extensively on Native American art throughout his career.

KATE C. DUNCAN, a professor of art history at Arizona State University, also teaches in the Museum Studies Program in the Department of Anthropology. She has written widely on Subarctic and Plateau beadwork. Her books include *Northern Athapaskan Art: A Special Gift* (written with Gwich'in elder Eunice Carney) and *Out of the North* (coauthored

with Barbara Hail). She is currently working on a book and exhibition about Ye Olde Curiosity Shop in Seattle, Washington, its influence on early-twentieth-century museum collecting, and its role in the development and perpetuation of enduring concepts about Northwest Coast and Alaskan Native art.

KATHRINE S. FRENCH received her Ph.D. in anthropology from Columbia University in 1955 and is associated with Reed College in Portland, Oregon, as an adjunct faculty member. She and her late husband, David H. French, who was an anthropologist on the Reed College faculty, began their studies of the cultures and languages of the Indian people of the Warm Springs Reservation in 1949, an undertaking that became a lifetime occupation, resulting in numerous publications. Today, Dr. French conducts contract ethnographic research and continues her work on Plateau ethnography.

BARBARA A. HAIL, deputy director and curator of the Haffenreffer Museum of Anthropology, Brown University, is trained in history and anthropology. Her special interest is in historic Native American material culture, especially that of the Great Plains and Subarctic. Her books on these subjects include *Hau Kola!, Out of the North* (with Kate Duncan), and *Patterns of Art: The Rahr Collection of Native American Art* (Dartmouth College). Most recently, she authored a chapter in *Passionate Hobby: Rudolf Frederick Haffenreffer and the King Philip Museum* (Brown University). She has served as a consultant for numerous museums, including the Smithsonian's National Museum of the American Indian.

SUSAN E. HARLESS is a natural and cultural history writer who lives in Bend, Oregon. She was with The High Desert Museum for more than thirteen years, beginning as a volunteer and later becoming curator of exhibits. During that time she participated in the acquisition of the Doris Swayze Bounds Collection and curated several Native American exhibits, including "Treasures of the Plateau," "Peoples of the Sage," and "Woven in Time." Her long association with Doris Bounds formed the basis for this biography.

MAYNARD WHITE OWL LAVADOUR (Cayuse, Nez Perce) was raised on the Umatilla Reservation, east of Pendleton, Oregon. His maternal grandmother, Eva (Com Com Thla) Lavadour, and great-grandmother, Susie (Tis See Saw) Williams, the last in his family to be raised traditionally, were his instructors. From a family of artisans, he has mastered the skills and knowledge to be internationally recognized for his beadwork and

artwork. He has published many articles on beadwork, gives presentations and demonstrations, and enters competitions with his beautiful beadwork pieces.

BARBARA E. LOEB is an associate professor of art history at Oregon State University, where she teaches courses in Native American art. She earned her Master of Arts degree from the University of Texas at Austin in 1974, specializing in Native arts. After graduating, she attended the archaeology field school of the University of Colorado. She completed a Ph.D. in Native American art history at the University of Washington in 1984, with a dissertation on Crow and Plateau beaded arts. Subsequent publications include several essays on Plateau beading. She presently spends part of her year teaching in Oregon and part in Big Sky, Montana. She and a longtime Crow friend are currently coauthoring the life story of a Crow elder.

LILLIAN "SIS" MOSES (Yakama, Nez Perce, Cayuse) lives on the Umatilla Reservation in northeastern Oregon. A former Happy Canyon Princess (1968) and runner-up for Miss Indian America, she and her family have long associations with the Swayze-Bounds families. She is a well-known artist and is currently employed by the St. Andrews Mission on the reservation.

MARY D. SCHLICK is a writer and basketry scholar who lives in Mt. Hood, Oregon. She has studied the arts of the Plateau as a resident of the Colville, Warm Springs, and Yakama Reservations, as well as in museums and libraries across North America. Author of *Columbia River Basketry: Gift of the Ancestors, Gift of the Earth* (1994), she was a friend of Doris Bounds and has worked with The High Desert Museum staff to enlist the aid of Native people in interpreting the Bounds Collection.

Index

Page numbers in boldface italic type refer to black-and-white illustrations; color illustrations are indicated by plate number. Special caption information is marked with a (c).